The Technique

JOHN W. MILLS

B T Batsford Limited · London

of *Sculpture*

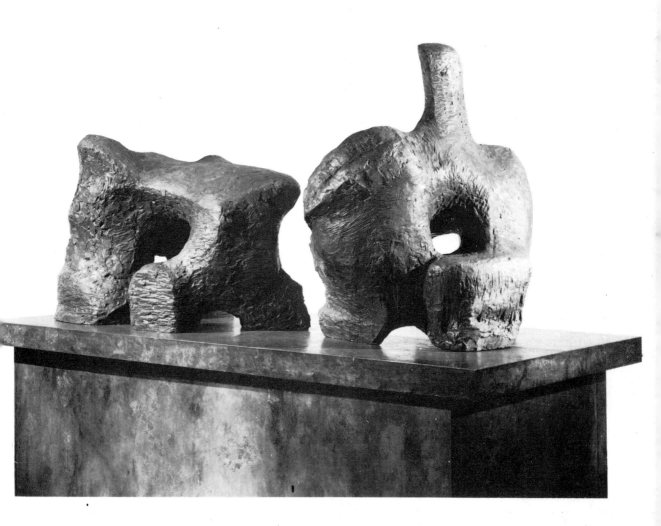

Title page
'Two Piece Reclining Figure' by Henry Moore in bronze
showing the texture of the tools used on the plaster
original The Tate Gallery, London

ISBN 0 7134 3051 6 (cased)
ISBN 0 7134 2509 1 (paperback)

Filmset by Keyspools Limited, Golborne, Lancs.
Printed in Great Britain by
Butler & Tanner Limited, Frome
for the publishers
B T Batsford Limited
4 Fitzhardinge Street
London W1H 0AH

Contents

Acknowledgment

I would like to acknowledge my debt to all those persons who so far have afforded me every help and encouragement.

My mother for her faith in my choice of career and my wife who gives me now both the criticism and devotion necessary to me and to my work. The teachers and tutors who taught me so much, so well, I am greatly indebted to; particularly Keith Godwin, Jack Matthews, Robert Carruthers, and Mr Davies, casting instructor at the RCA Sculpture School, who taught me in passing so much about sculpture. To Henry Moore every English sculptor owes a great deal, for blazing such a trail and setting such a high standard; I would like to acknowledge this, and his generosity and hospitality to me when I visited him at his studios, armed with a camera.

The debt to history and to museums, for what we can learn in them is obvious too, and I am grateful for their very existence.

The artists and collectors who have allowed me to use pictures of their sculptures, and the photographers who supplied me with the necessary prints, I would like to thank. For Thelma M Nye of Batsford, whose gentle guidance in putting this book together in the form from which a printer can work, I have nothing but admiration. I hope that this book will prove, in some small way, the worth of the time spent on me by those who taught and encouraged me, and will in turn be encouraging and useful to others.

JWM

Digswell House 1965

Since this book was first published I have had the pleasure of extending my learning of sculptural techniques through discussion with other sculptors, and with industrial craftsmen, particularly foundrymen. My experiences in the United States working with John Pappas and Jay Yager at EMU, Michigan have resulted in a greater involvement in bronze casting, experience which I am pleased to pass on to my students, and to my readers.

My position at The Hertfordshire College of Art and Design, has allowed me a degree of research time, and I am grateful for this continued encouragement.

JWM

Hinxworth Place 1975

Introduction

One must have a consummate sense of technique to hide what one knows
Rodin 1850–1917

The sculptor must at all times be free to manifest his ideas. To be able to do this his understanding of the means available to him should be as great as possible, otherwise the inevitable compromise between idea and material will be of the wrong proportion, and in consequence, what may be a good idea, is inhibited by a poor sense of technique, resulting in a poor image.

Students should make themselves conversant with many processes and techniques to be confident that the image finally realised allows the idea maximum impact and is in the material best suited to it. It should be stressed that methods and materials should be taught and sought after as early as possible in training, and this knowledge absorbed in order to avoid the danger of the means becoming more important than the idea—becoming in fact a kind of religion. That the technique is the means to the end cannot be too greatly emphasised. The means should be so understood that the end is a hundred per cent the sculptor's intention.

Accumulative technical thought should not be the sole province of industry and science, but of the artist, too. The confidence that greater understanding of the craft of any art gives is such that absolute freedom and command enables the progress and maturing of ideas and images to develop without compromise. Also with such deep knowledge of technical means, the possibility of transcending known techniques is greater. Thus the rules are broken, and the means and range of expression of sculpture are extended.

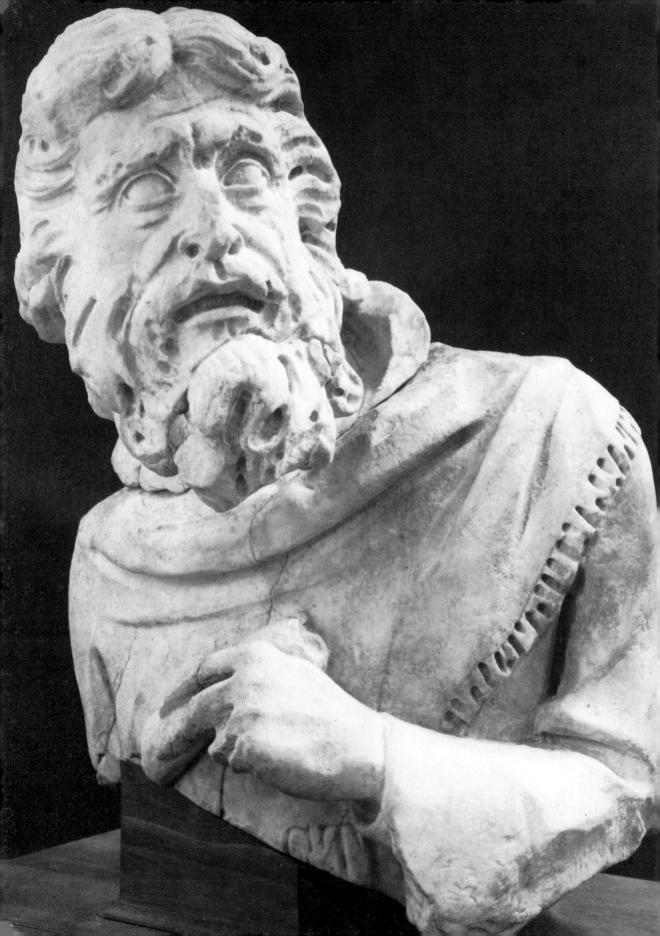

Sculpture

Sculpture is three-dimensional form, in the round or in relief.

To explain sculpture is an almost impossible task because any attempt inevitably becomes an academic discussion of idiom and materials. Perhaps one can say that any three-dimensional design which has no function other than to decorate a building, or make tangible a symbol or image of a man's ideas, may be regarded as sculpture. The *Concise Oxford Dictionary* describes sculpture as 'that branch of the fine arts which is concerned with producing figures in the round or in relief, by carving, by fashioning in some plastic material, or by making a mould for casting in metal'. To this description must be added the techniques of 'assembling manufactured or found objects to make a three-dimensional image' and 'assembling various media to create three-dimensional experiences'.

Personal bias and opinion towards one idiomatic or stylistic means of expression or another may cause certain aspects of sculpture to be disregarded as merely tricky or clever, but we all must have the right to choose for ourselves, and need the range of works and idioms from which to make our choice.

In this book I am concerned only with stating as many techniques as possible. Aesthetics cannot be taught, only discussed. Personality and the individual's need to express himself are so diverse that all one can teach are the means with which to express ideas. I will include brief descriptions of sculptures that in my view illustrate a particular marriage between image and technique, and are therefore worth examining critically to some advantage.

Form in the round is free-standing form which occupies a particular space and may be viewed from all sides. Consequently the sculpture must be considered in this light, and every view composed according to the idea.

Successful sculptures in the round are more than just forms which have four sides, in fact a four-sided form is a bastard form in that there is an interruption of statement at each face so that all one has is a sum of four sides, simply four reliefs. Well-composed free-standing sculpture should occupy the space it stands in with the kind of presence that an organic form has. There should be a progression from one form to another which creates visual and structural strength. This is often achieved by the juxtapositioning of the axis of masses, creating shapes which spiral and appear to grow to the final image. Close study of organic growth and the principles of natural structures is invaluable to the sculptor and student in helping to further understand form in the round.

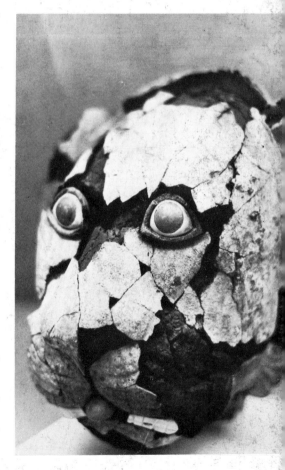

Marble carving by Giovanni Pisano, showing the skilful use of the bow drill and the drawing in the marble
Victoria and Albert Museum Crown Copyright

Lion's head, Sumerian. From Ur 2600 BC.
Copper over bitumen covering a basic wooden form
British Museum Photograph: John W Mills

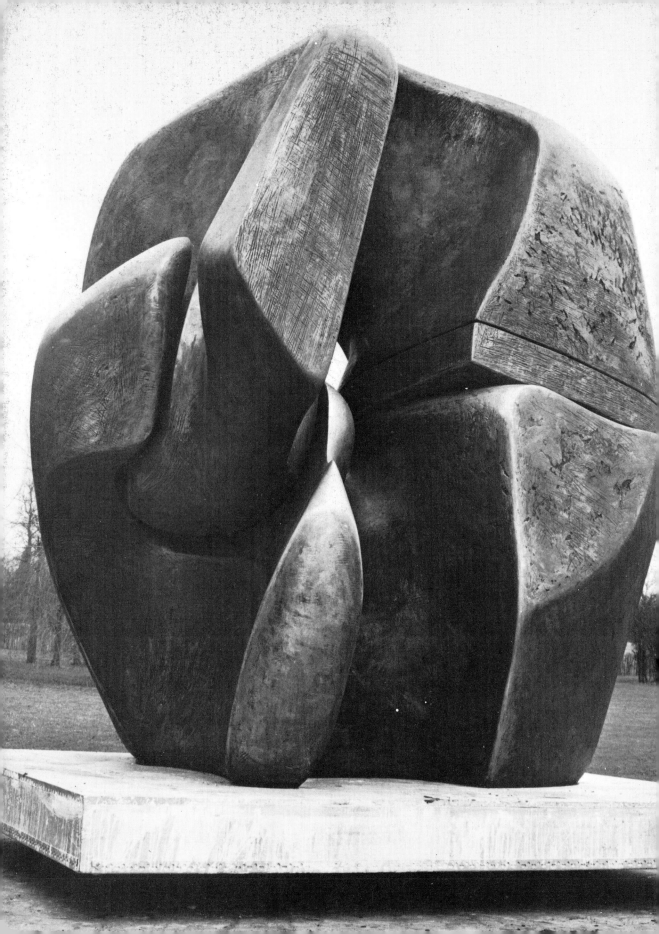

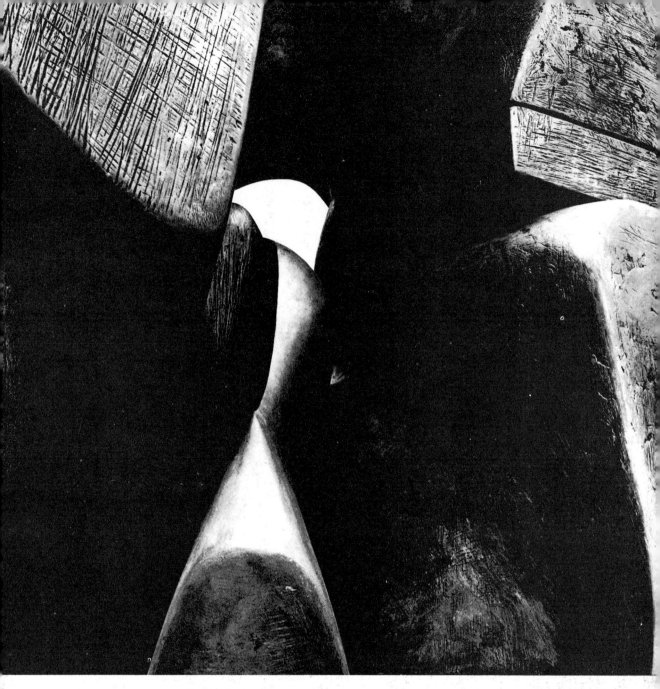

Henry Moore's sculptures, *Locking Piece* and *Archer*, illustrate this
understanding. These works embody qualities equivalent to some
organic forms and gain visual and structural strength thereby.

Plaster master cast of 'Locking Piece' by Henry Moore.
Made to look like bronze it gives the foundry a clear idea
of colour and patina to be achieved on the final cast. The
sculpture was built up in direct plaster. The surface
textures were arrived at by working with specific tools
Photograph: John Hedgecoe

'Locking Piece' detail
Photograph: John Hedgecoe

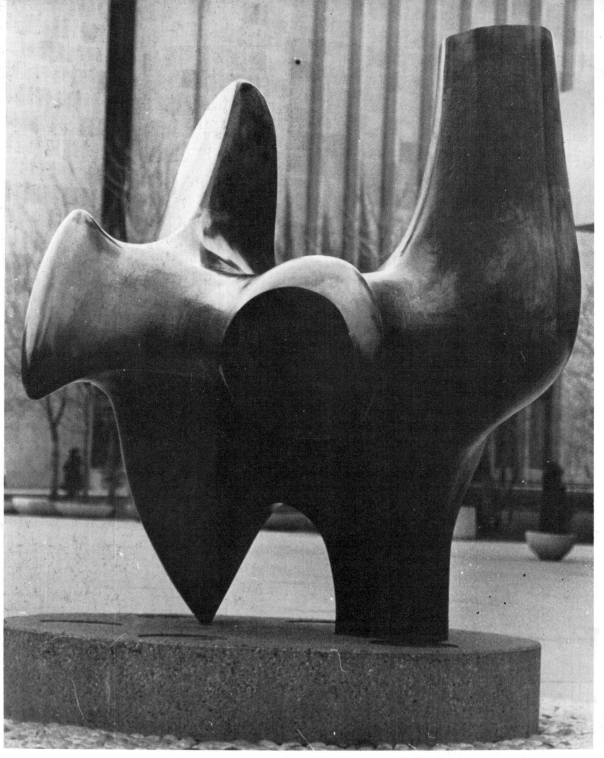

'Archer' in bronze by Henry Moore
Civic Centre, Toronto Photograph: John W Mills

Examples of sculpture of equal strength but of totally different character, influenced by manufactured or machined qualities, are Bernard Rosenthal's *Cube* and David Smith's *Cubi IX*: sculptures of great strength and evocation with definite physical and visual power.

'Cubi IX' in steel by David Smith
Photograph: The Museum of Modern Art, New York

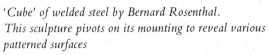

'Cube' of welded steel by Bernard Rosenthal.
This sculpture pivots on its mounting to reveal various
patterned surfaces
Collection of University of Michigan, Ann Arbor
Photograph: John W Mills

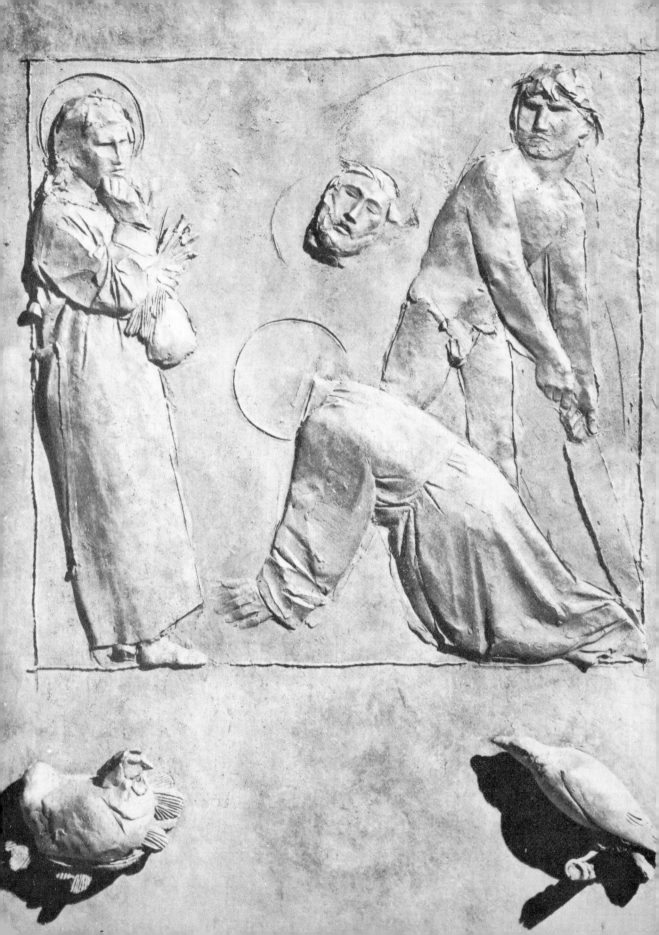

Relief sculpture

The relief is the projection or recession of a design from a flat surface retaining the flat surface as an integral part of the composition. Relief may be incised or cut back from the flat surface (*intaglio*). This was practised with great refinement by the ancient Egyptians and forms a great part of the sculptural language of that culture. Intaglio relief is perhaps one of the first developments from the drawn line or mark on a flat surface, and examples of prehistoric man's incised drawings indicate this fact. Today the incised letter and inscription is the most common form of intaglio relief.

Projected relief falls into three major categories. The first is the low relief (*stacciato relievo*), in which the projection is very slight indeed. It is the lowest possible relief of the flat surface and is supported by finely drawn incised lines. In fact it may be regarded as being the most exacting trial of the sculptor's ability to draw, expressing an understanding of the exact turn of the form and the speed of that turn away from the artist. The reliefs of Giacomo Manzu are examples of this drawing skill, and are as fine as any. The marks that outline the figures are precisely explained by the form between the lines. The Assyrian Palace reliefs illustrate this skill too and indicate its tradition.

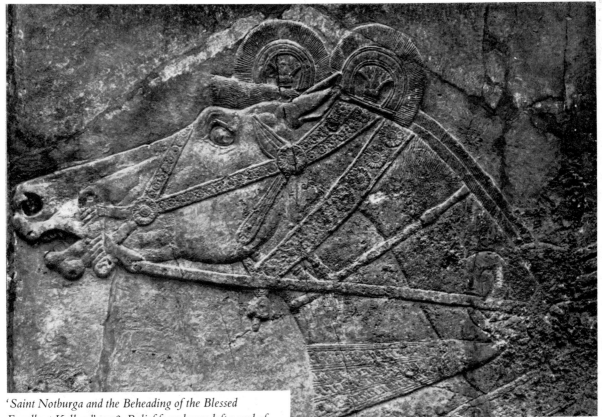

'Saint Notburga and the Beheading of the Blessed Engelbert Kolland' 1958. Relief from lower left panel of door of Salzburg Cathedral by Giacomo Manzu
By permission of the Artist

A head of a horse from an Assyrian palace low relief, seventh century BC British Museum

The next progression from the flat surface is the bas relief (*basso relievo*). The projection from the background in this kind of relief may be as much as half the volume of the form but made without undercuts, the breaking up of the light across the surface into strongly patterned areas is an essential part of the bas relief. That known as *mezzo relievo* is similar to the bas relief, generally a little higher in relief and making use of the undercut form to further indicate the roundness of the full form. High relief (*alto relievo*), the third progression, is using the complete form in the round, but keeping it attached to the background. Lorenzo Ghiberti, when he made the panels for the doors known as the 'Gates of Paradise' on The Baptistery in Florence, employed the relief in all its variations; becoming incidentally a major influence in Western European painting and sculpture.

These categories of sculptural form may be achieved in any material which is three-dimensional and in any of the methods dealt with in this book; they may be carved, modelled or assembled. But again one must take warning that technical skills should be merely an extension of the person towards the expression of ideas and never an end in themselves.

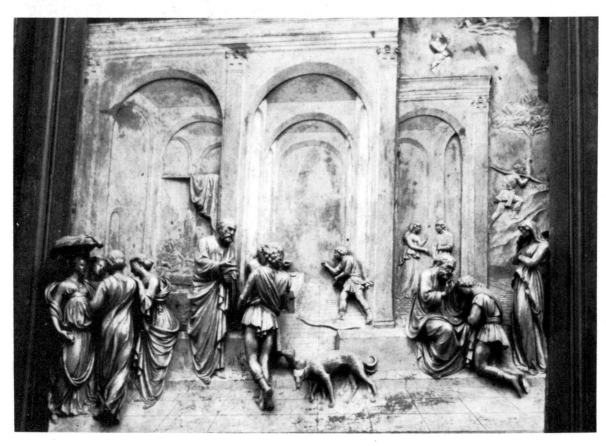

'Gates of Paradise: Isaac' by Lorenzo Ghiberti. Detail
from The Baptistery, Florence Photograph: John W Mills

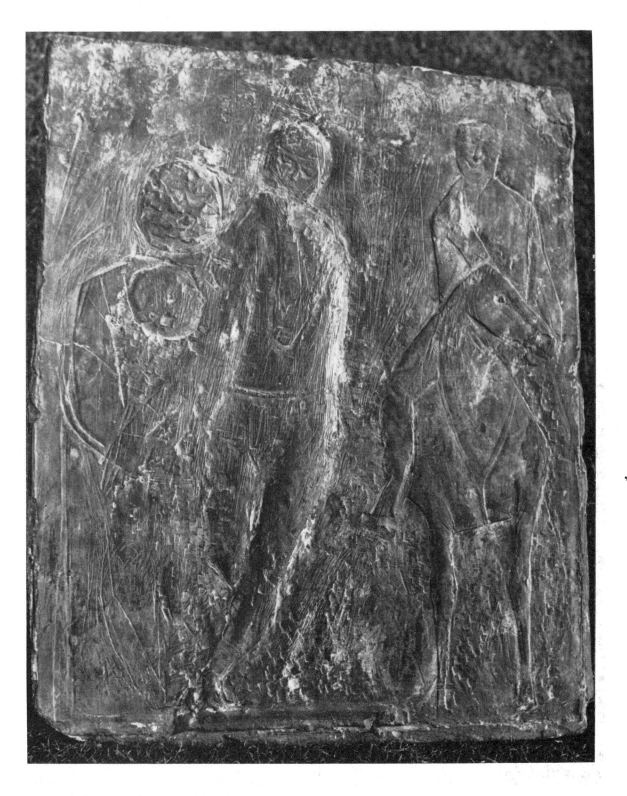

A low relief in bronze by Marino Marini

Collection of M Goldman, London

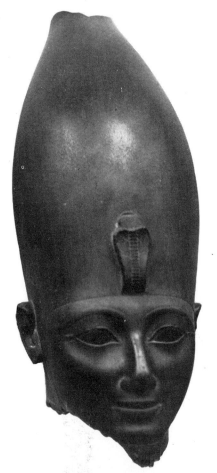

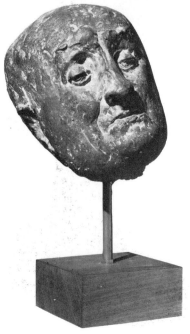

The materials of sculpture

The materials from which sculpture can be made are infinite in variety, in fact whatever solid comes to hand may be coerced into some kind of three-dimensional image. Historically only the materials which have stood the test of time and the elements have survived, thereby seeming to limit the range of materials for sculpture to just stone, bronze (non-ferrous metals), fired clay and, the least durable, wood. These were the most long lasting materials, all others were more vulnerable to damage and decay. The weaker materials were used only as vehicles to make the form which was later to be reproduced in a more suitable substance, or were made into images which were to have a relatively short life.

Today of course these traditional materials have been added to, so that we now have a much greater range. To the historical *élite* must now be added cements, polyester resins, plastics of many kinds, new metal alloys and the treatment of erstwhile corrosive metals and the limitless number of protective media which make wood and the weaker materials more lasting. It must be realised that the range of new materials is being added to almost every day, and it is inevitable that before this book is published new materials will be available which it has not been possible to mention here. However, a description is given of those materials which have already been tried and proved.

It is extraordinary the way the civilised world has conditioned itself to appreciating those sculptures made from the materials which have stood the test of time, and now regard them as being the only true sculptures, and these materials as the only ones suitable for sculpture. Hence the old academic dichotomy of opinion regarding for instance carving (stone) and modelling (clay), and also the compulsion to assess a new material by how well it can be made to imitate one of the old *élite*. Michelangelo regarded clay as a very inferior medium suitable only for maquettes; bronze was loathsome to him as well as inferior. These opinions vehemently expressed by a great man, completely involved with stone and the marble he loved, seem to have been taken at their face value, and indeed sum up the attitude towards sculpture of the majority of people until the turn of this century. The shock to the narrow minded by the daring mixtures of materials used successfully by primitive peoples, whose art was being discovered at that time, helped cause an idiomatic release for modern art, and the materials began once more to suit the idea and vice versa. We enjoy idiomatic freedom, but we need greater freedom and emancipation for new materials to stand in their own right as being worthy media in which new ideas may be expressed in new ways, thus widening the active range of the sculptor, and indeed any artist wishing to make three-dimensional images.

Materials regarded as traditional have been written about and explained in great detail by accomplished sculptors and writers in the past, especially stone and wood. Although I write about stone and wood as materials for sculpture today, I will not try to emulate these

works but will recommend those which I know to give the most informed and relevant information. I intend to deal mainly with media that have hitherto received scant attention or ill-informed explanation of little use to the sculptor, and with new materials which have come to notice and are beginning to make their presence felt. My intention is to make the information as valid and as useful to the sculptor and the student as possible, with the emphasis upon carrying out work in the studio, gaining the maximum control over the sculpture, that will bear the mark of that studio and sculptor. I will give formulae for the various materials mentioned when these materials cannot be bought, but with the vast range of technical products, and the willingness of manufacturers to give the aid of their own laboratories and staff, most things that in the past have been unobtainable (and therefore demanded that the artist make his own, if he chose to use them) are today available, and may be obtained by post with a minimum of delay. Sculptors require as much time as they can manage actually making the image, and time saved from experimenting with formulae, which may be obtained less painfully by taking advantage of this technological age, is time gained for developing sculpture. It must be stated here, however, that although industrial research is important, and that industrially developed materials are good, the artist usually has to ignore industrial methods and invent his own. Industry is geared to producing a long run of identical items to a given standard. The artist is interested only in his own individual mark, which in terms of industry may be wrong, but in terms of art is correct.

A description, other than just the titles, of the materials which form the basic media for sculpture today is necessary I feel, and may help towards understanding the inherent quality of any one of these materials.

Stone, wood and clay These are of course all natural materials abundant in most parts of the world, and require little or no description. The varieties in which these occur are as varied as the geological and geographical patterns of the earth, and most of the varieties may be used in some way.

Non-ferrous metals These are metals which do not contain iron and are consequently less vulnerable to atmospheric corrosion. They range in kind and quality and resistance from the noble metals to the base metals, gold to zinc. Although sculpture can be made from any metal, those most commonly used are the alloys; bronze, brass, aluminium, also lead. There are literally hundreds of alloys on the market and in use in industry, but their qualities often lie in their

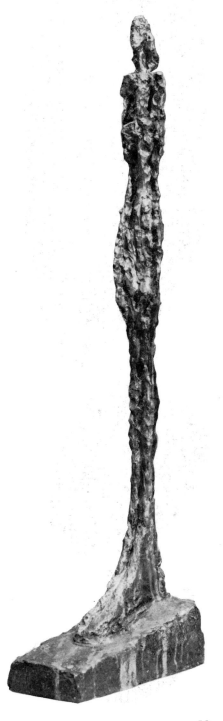

Royal head, possibly Tuthmosis II, Egyptian eighteenth dynasty, 1500 BC. A fine example of rubbed stone sculpture British Museum

'Paul Claudel' in bronze by Ivor Roberts-Jones
The Tate Gallery, London

'Woman, Venice IV' in bronze by Alberto Giacometti
The Tate Gallery, London

composition and suitability for definite industrial applications, whilst their colour remains similar to other alloys of their kind. The properties most important for a sculptural application are the metal's structural strength and durability, its resistance to atmospheric corrosion, ease of casting with a fine dense surface, colour, and the ability to take a patina.

Iron Iron is almost invariably used as a material for constructing sculptures, being wrought, brazed or welded. It may be cast of course, but because of its high melting point and great shrinkage upon solidifying it is not a fine medium. It is extremely malleable when in a red-hot state and can be easily wrought and shaped. It has a very low resistance to atmospheric corrosion. It is possible to obtain a very fine patina on iron, because it will oxidise readily. Today there are a number of preparations which may be applied to the surface to make it more resistant, and therefore extend its possible use in the open air. A recent development in the steel industry, useful to sculpture is that of Core 10. This is weldable steel that, once the surface has oxidised, resists further rusting, and so becomes stable, requiring no treatment. The Picasso *Head of a Woman*, in Chicago, is a welded sculpture made by a construction company in the United States from the artist's maquette. The overall height is 19·5 m (65 ft), a scale readily achieved by welding.

Plaster of paris Together with clay this material is the most widely used in sculpture. It is suitable only as an intermediary material or for interior decoration, but because of its wide use, needs describing more fully. Its use by sculptors has been traced back as far as Ancient Greece and Egypt, and it has been used and continues to be used in similar

'Susannah' reclining figure in bronze by Giacomo Manzu
The Tate Gallery, London

'Head of a Woman'. Welded sculpture by Pablo Picasso
Civic Centre, Chicago Photograph: John W Mills

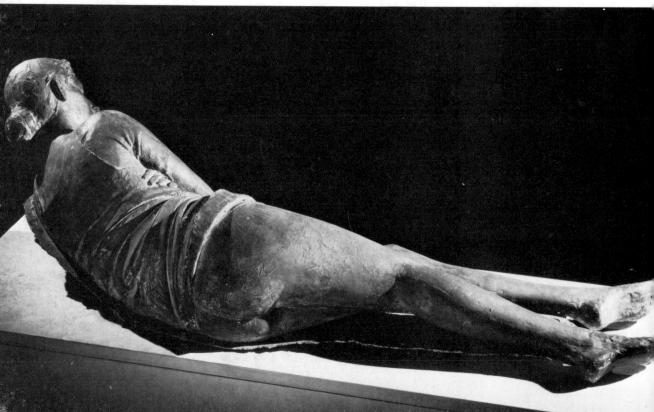

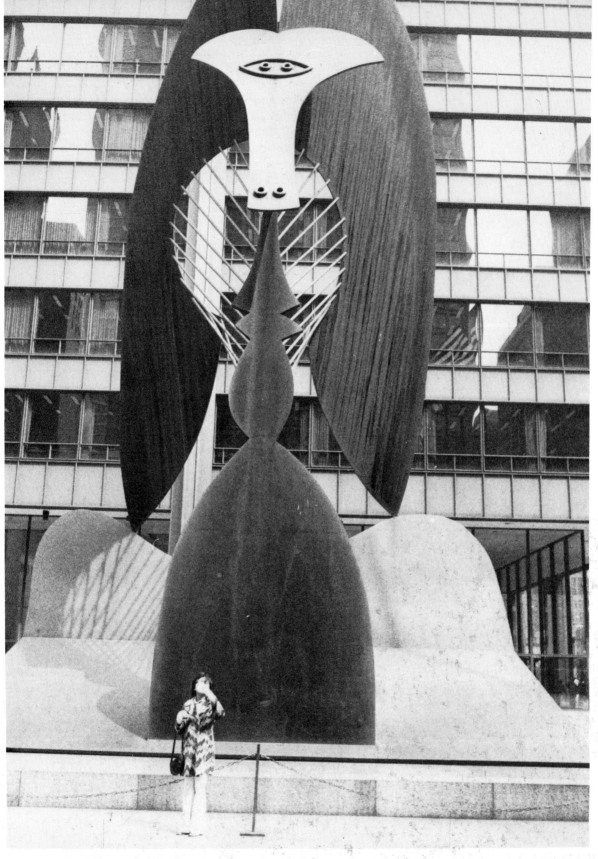

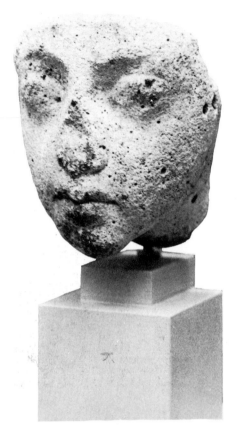

ways to those of the ancient sculptors. It is made from gypsum; the name plaster of paris derives from the Montmartre, Paris region where gypsum was quarried to make this plaster for modern usage. Gypsum is now quarried in most parts of the world from large underground deposits. It is a solid, crystalline in nature, which is heated to dehydrate and decrystallise, then crushed and finely ground to make the plaster. When the powdered plaster is mixed with water, it re-crystallises to return to an orginal gypsum state, hard and solid and very adaptable.

The uses to which it is put are varied indeed; it may form the original or master cast, it may be built direct over a strong armature, or cast from a number of different types of mould. It is used to make waste moulds, piece moulds, and mould jackets and as an investment material for bronze casting. Industry today also uses plaster of paris in many ways and as a result a very great variety of plasters are manu-factured: accelerated plasters, retarded plasters (long setting time), plasters which have a great degree of hardness, and others which are softer and porous. In fact any need a sculptor may have for a particular plaster, industry has too, and the necessary type is sure to be in production and obtainable. Plaster of paris is not resistant to atmospheric corrosion.

Cements Cements are used extensively as a sculptor's medium, and form the basic material necessary for a number of things such as concrete and cast stone. Cement is made in the same way as plaster, by roasting and then grinding. Calcium aluminium silicate is used to make portland cement, and cements of that kind. Portland cement is named after the stone from Portland which it is made to simulate, and is used generally in the building industry, and are in ready supply all over the world. The raw material alumina is used to make aluminous cements, such as *ciment fondu*. This is most commonly used today by sculptors because of its speed in setting and hardening, which is extreme and achieved in a very short time. Materials made using cements are fairly resistant to atmospheric corrosion, as indicated by the very wide application of this material for building. It is cheap, and relatively easy to handle.

Wax Wax has always been used to make images. Its use can be traced back to antiquity, and one often comes across formulae used to make a practical modelling wax. Today, the problem of a suitable modelling wax has been solved by industry. The refining of petro-leum produces many by-products, one of which is micro-crystalline wax, and this has superseded any other known modelling wax. It is finer than any other, and can be obtained fairly easily. It can be made soft or hard according to a specific need. Wax may be used as a final

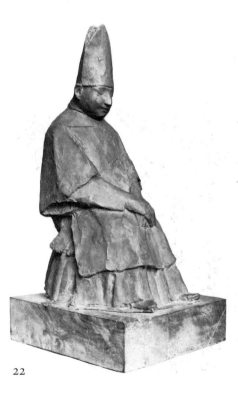

Plaster life mask, Egyptian eighteenth dynasty, 1370 BC. Believed to be the daughter of Akhenaton

'Cardinal' in bronze by Giacomo Manzu. Modelled direct in wax for cire perdue *casting*
The Tate Gallery, London

medium, the completed sculpture though has to be put under glass or some similar material to protect it from changes in temperature and damage. More commonly it is used as the vehicle for making the empty negative form of a sculpture into which molten metal is poured to make the image permanent. This is called the *lost-wax method*, *cire perdue*. The wax form may be cast from a mould or modelled directly. Wax may be used as moulding material and is especially useful for casting delicate shapes which would be harmed by chipping out with a mallet and chisel. It is useful, too, for making moulds from dry clay. It is resistant to atmospheric corrosion but is too fragile to be used for any permanent large image.

Polyester resins Polyester resins are synthetic resins which when set are hard and insoluble in water. They vary considerably in chemical formula and are manufactured for specific applications. Some of their industrial uses are for car bodies, boat hulls, windows and drainpipes and all kinds of building components. Their wider application in the fine arts has yet to be fully explored. Resins may be transparent or opaque, coloured or filled with metal powders to simulate metals; and inorganic fillers of many kinds may be used to achieve many different effects. They are brittle, and are commonly used with fibreglass added to give greater tensile strength. Sculpturally, they can be built up directly over an armature, cast from a mould or painted over the surface of an otherwise vulnerable material to make it impervious. They have a high degree of resistance to atmospheric corrosion.

Plastics Plastic is a term usually applied to a material to describe its malleability and its ability to be modelled. Today more often it is the general heading for synthetic resins and other mouldable synthetic materials, and as many of these as possible will be dealt with in this book. They will include such plastics as perspex (*acrylic plastic*), expanded polystyrene, polyvinyl chloride and polyvinyl acetates.

Expanded polystyrene is a foamed plastic made by extruding molten polystyrene, which contains a blowing agent, methyl chloride. Heat causes molecular expansion of the agent, and the set material is of a volume 40 times greater than the starting material.

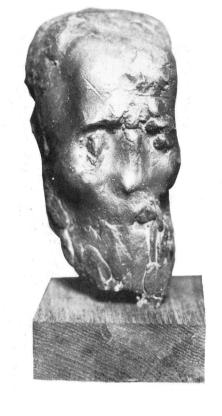

'Study of Buanarotti' by John W Mills. Modelled direct with wax for bronze casting

'Genghis Khan' in plastic and fibreglass by Phillip King
Rowan Gallery, London Photograph: John Webb

23

The studio

Every sculptor dreams of an ideal studio, that marvellous place which will be large enough in area, and sufficiently high to enable one to undertake all kinds of work. The ideal for one sculptor may be the very opposite for another, and to try to describe such a place would be ridiculous. I can, however, describe such requirements, facilities and equipment that I have found most important.

Firstly, I feel a studio needs to be simply a large ground floor room, well insulated, with running water, top and side light, preferably both north and south. North light on its own is too cold and flat and needs to be supplemented by a warm controlled south light, to give a useful and workable daylight. Side windows should be above 2 m (6 ft) to preserve good strong wall space. Artificial light I have found can be very well controlled by using a main fluorescent top light, supplemented with movable spot-lights. The colour of artificial light can be selected quite easily, according to the individual need and preference.

The floor of the studio must be strong, wood or concrete or composition. The floor will be expected to support considerable weight. This may be in the form of clay or large lumps of stone or wood. These materials, together with bankers, modelling stands, etc, can be extremely heavy, and require firm strong support. A dry place for storing hygroscopic materials such as plaster of paris and cements is necessary.

Large doors for moving sculpture and materials in and out are a prerequisite. Double doors are ideal, giving access for loading and unloading work on to transport. The studio needs to be fitted with a power electricity supply to run heavy duty electrical equipment, such as drill and grinders.

A work bench which is substantial and capable of carrying a heavy vice is essential. A free-standing engineer's vice may, in some cases, be preferable to a large work bench.

Shelves to store completed sculptures, and to store unfinished small works.

Tools and suitable accommodation for tools appertaining to the sculptor's particular need. Tool racks are useful so that tools are immediately to hand. The self-discipline of replacing tools as soon after use as possible is important, and a well-designed tool rack may encourage this.

Space outside the studio where work can be pushed on trolleys. To work in an open air environment is desirable, and if possible, outside working space under cover, both for working and storing completed works. Adequate storage space is the eternal problem for the sculptor, and the studio needs to be large enough to accommodate completed sculptures without infringing too much on the working space.

Beam A very useful feature in a well-designed studio is a substantial beam or beams, capable of bearing a load of at least one tonne (1 ton). Such a feature obviates the need for a heavy gantry or sheer legs, which take up valuable floor space in the studio, and which may be

too big for one's needs. Obviously if you are using large blocks of stone or wood, sheer legs or gantry are a useful means of suspending and moving a large weight.

Photographic equipment Every studio, ideally, should have some photographic equipment. A good camera at least, and an understanding of elementary photography, will prove an asset to sculptors. A sculptor is being constantly asked for photographs of his work, and it is often expedient not to ask for these back, it being better for them to be passed around among a fairly wide circle of people. Photographs when made by a commercial photographer are not always sympathetic to the sculptor or the sculpture, and more sympathetic records are obtained by taking your own. The cost in the long run is less, too. Processing your own film is time-consuming but, if possible, allowance should be made for doing this. I know many sculptors who take their own photographs and benefit greatly from this. They do not all process their own, but use a processing agency willing to produce special prints. The requirement of a sculptor from photography is more than a snapshot record of the sculpture. So I would say that the ideal studio should incorporate space in which to carry out at least part of this photographic need.

The maquette

What is a maquette? It is a statement in three-dimensional terms of the idea which may have been roughly realised, by drawing and thinking around the potential form of the idea. You may need to explore and experiment with the axial play of volume, and to further permutate actual three-dimensional forms, avoiding the illusion always present in the drawn line. Being more certain of the balance and curve, twist and weight, before commencing the projected work. Permutation of forms and their carvability may be exploited by carving the figure or idea simply from a block, similar in kind and dimension to that finally to be used, but smaller in scale. Similarly permutations of form, scale, gesture and formal quality can be realised quickly in small modelled maquettes, allowing freedom to explore the idea in relation to different media. Assemblage sculptures demand sketch models realised as far as possible in similar materials, so that an understanding of the structure and effects of assembly will be embodied in the working out.

Picasso in much of his work exploited the finite skills of craftsmen, managing to do this only by appreciating the skills involved and knowing the image he required to be made so well that he could direct the craftsman. His knowledge of the image came by continuously drawing, painting and modelling the idea and producing infinite variations of the theme to arrive at one that could be developed further. This was then presented to the craftsman, and in the case of a sculpture the craftsman was presented with a maquette to work from, to be developed jointly by the artist and the craftsman.

Carvers often make maquettes in materials that need to be carved, ie plaster of paris, expanded polystyrene or polyurethane, pre-cast aerated concrete building blocks, all of which can be cut to the dimensions proportional to the block finally to be carved, and the sketch quickly cut. In this way a unity is achieved throughout the work. Purists who admire technical virtuosity always carve maquettes, maintaining that modelling cannot be translated into carved form. This is an extreme view and of course disproved by such consummate carvers as Michelangelo and Donatello.

Welded sculpture is often made in maquette form by welding or brazing, which helps not only to design the work but also to realise the problems involved in the final execution. Curved flat or linear shapes are best exploited in materials that easily allow experiment directly related to the final work, such as thick paper, card, or either of these materials coated with wax.

Wax and clay plus the various proprietary synthetic clays are the most facile substances with which to model and can obviously be used to make maquettes with equal facility and speed. I have already mentioned that individuals should seek the means that best

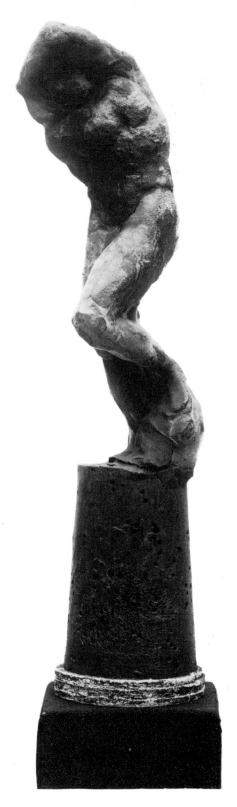

Wax study for a 'Slave' by Michelangelo
Victoria and Albert Museum Crown Copyright

Fragment of maquette for the 'Bearded Boboli Slave' by
Michelangelo *British Museum Photograph: John W Mills*

suits their needs, and this of course applies to the work at the sketch model stage as well in the final sculpture.

The maquette should be preferably of a useful working scale to the final sculpture, a proportion that requires simple calculation to be able to enlarge from, eg 10 cm to 30 cm (4 in. to 1 ft) making a simple multiplication of three times the dimensions of the maquette. Maquettes are always being asked for by clients, architects or other commissioning bodies, and are best made to a particular scale. Maquettes for commissioning bodies are always necessary to give an idea of the three-dimensional impact of the projected sculpture.

Enlarging from a maquette is an operation at once important and difficult. Inherent in any maquette are qualities which are there because of the freedom of scale and the minimum attention to detail. These qualities are easily missed when enlarging or too much attention is paid to them. Rodin was particularly aware of the accidental qualities inherent in a small sculpture, and tried to preserve them in large works. To exploit these qualities further, he often had the work scaled up and down; in this way making accidental forms work for him. He employed jobbing modellers for this work and the scaling was done by using a three-dimensional pantograph.

Michelangelo used a unique method of enlarging from a maquette. He always studied the block to be carved (or chose the block with the greatest care), and worked out his maquette directly in relation to the block, becoming as familiar as possible with the stone, the depth from the surface at which various points, planes, etc of the figure existed. The maquette was placed in a vessel similar in shape to the block and had a hole at the bottom with a plug. The vessel was then filled with a pale opaque liquid to cover the maquette. By removing the bung, the level of the liquid would recede revealing the maquette, and the exact section of that part to be carved. The level of the liquid would correspond with a predetermined measurement on the stone.

The diagrams on page 30 illustrate some aids to enlarging or reducing work. The scale for half-size reduction is particularly useful when working from the life model.

'Nu' in bronze by Pablo Picasso
The Hanover Gallery, London

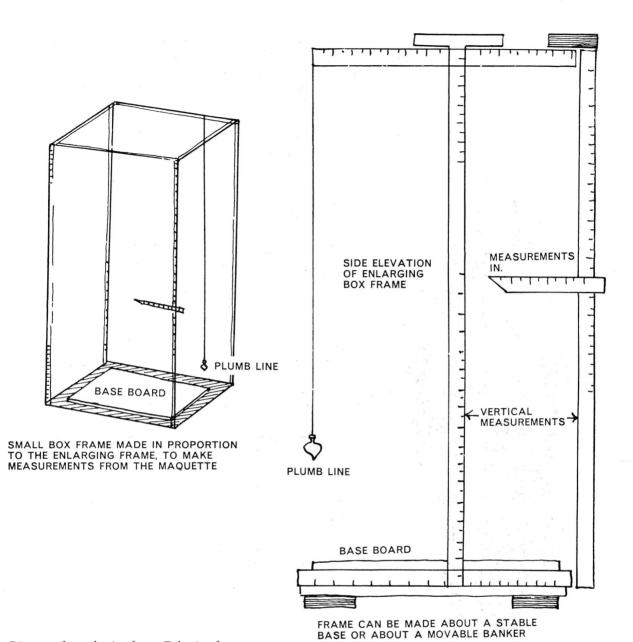

SIDE ELEVATION
OF ENLARGING
BOX FRAME

MEASUREMENTS
IN.

VERTICAL
MEASUREMENTS

PLUMB LINE

BASE BOARD

PLUMB LINE

SMALL BOX FRAME MADE IN PROPORTION
TO THE ENLARGING FRAME, TO MAKE
MEASUREMENTS FROM THE MAQUETTE

BASE BOARD

FRAME CAN BE MADE ABOUT A STABLE
BASE OR ABOUT A MOVABLE BANKER

*Diagram of an enlarging frame. Enlarging frames are
constructed around both the maquette and the material of
the enlargement. The two frames have constant vertical
and horizontal members, calibrated with proportional
measurements. The two frames should be made in
proportion to each other. Any measurement made on the
maquette can be made on the enlargement, at the required
height, etc. A plumb line is hung from the two frames to
be certain of the accuracy of vertical measurements, and to
enable any other lines of measurement to be seen in
relation to this. A calibrated pointer for measuring
distances towards the centre of the frame is essential*

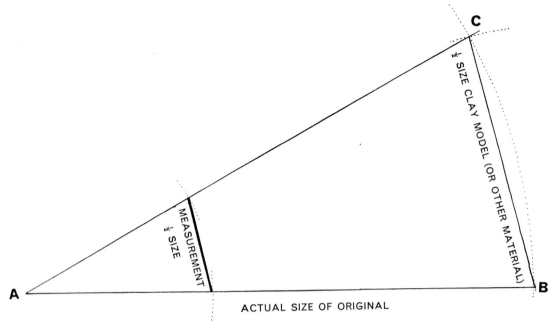

Draw a line A–B the actual length equal to the height of the original.

Describe an arc from point B, of a radius of half the length of A–B, at C. Describe an arc from point A, at a radius equal to the length of A–B, to cross the first arc to make point C, draw a line from A to C.

To use the scale take a measurement from the original. With a radius equal to that measurement draw an arc to cross both lines A–B and A–C. The measurement required is that distance between the two lines at which the arc crosses

Diagram of a drawn scale for making ½ size reduction from the original

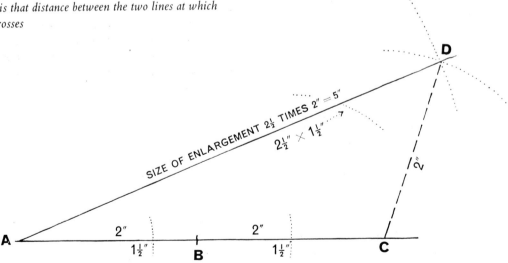

Diagram of a drawn scale for enlarging up to 2½ times the original

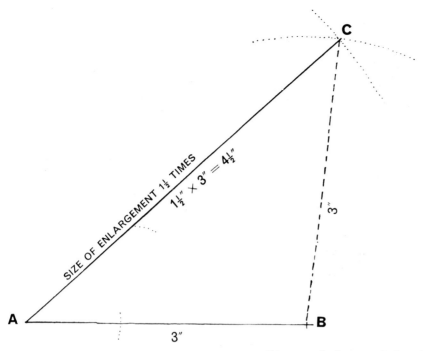

SIZE OF ENLARGEMENT 1½ TIMES

$1\frac{1}{2}'' \times 3'' = 4\frac{1}{2}''$

3"

3"

A

B

C

Diagram of a drawn scale for enlarging 1½ times

Draw a line A–B, the length to correspond to the height of the work to be enlarged. From B describe an arc at C, the radius equal to the length of A–B. Next describe an arc from point A, at radius 1½ times the length of A–B, to intersect the first arc at C. Draw a line A–C.

To use the scale make a measurement along A–B, then from this point describe an arc, the radius of which is the same as the measurement along A–B, to cross the line A–C. Measure the distance between the point along A–B and the point along A–C at which the arc crosses; this distance will be 1½ times the original measurement along A–B. Any measurement arrived at in this way will be 1½ times enlargement

◄ Draw a line A–B–C, the length equal to twice the height of the work to be enlarged (in the diagram this length is 6·3 cm (2½ in.)). Describe an arc from point C, of a radius of 5 cm (2 in.) at D. From point A describe an arc of a radius 2½ times 5 cm (2 in.) to cross the first arc to make point D. Draw a line A–D.

To use this scale, take measurement, mark it off twice along line A–B–C, then describe an arc from the second point to cross the line A–D. The distance between the point along A–B–C and the point at which the arc crosses the line A–D is the measurement required for the enlargement.

The example shown in the diagram finds the enlargement of a measurement of 3·8 cm (1½ in.)

Stone

Together with clay and wood, stone is the oldest material used by man, to send messages, to make images, inscriptions, tombs, homes and weapons, and because of its extreme hardness it is the most durable.

The stone most suited to carving is that which has been freshly quarried, having no hard outer skin, which exposure to the elements causes. Blocks of stone such as may be found on a beach or some such open place are often brittle and have a weathered outer skin, which makes it difficult if not impossible to carve. These may be abraded to a required form, but not carved with a mallet and chisel. Freshly quarried stone is the best. The block should be free from flaws, and set up and carved according to the bed from which it has come. The bed means the way in which the stone lay in the quarry, with its stratafication horizontal. A badly set up stone not lying on its bed will split and break off because weather can get in and exploit all the natural breaks between the layers of the growth of the stone.

There is a great deal of information written about stone, its geological structure and location, and I recommend that such information should be sought by those wishing to make sculpture from stone. To be forewarned is to be forearmed, and to be armed with knowledge appertaining to the material you intend to use is wisdom.

The way in which stone is carved and mounted is governed by the nature of the stone and such knowledge comes from experience, by cutting as much and as great a variety as possible. A great deal may be learned from studying the many ways in which stone has been used in the past, both architecturally and sculpturally. A proper study should be made of these applications, by those wishing to use stone to its known limits.

Basically, as far as working the stone is concerned, there are two principal ways in which the image or form trapped within the stone can be released. The most common method is that of carving with mallet and chisel.

Michelangelo, certainly one of the greatest carvers of marble, explained carving as 'knocking away the waste material to reveal the figure within the stone'. He did precisely this, he simply knocked away the waste stone, but first he determined the exact location of the figure within the block. With any kind of carving, one should first be as certain as possible of the block, the block according to the idea, and the place occupied within the block by the image to be carved. Intelligent study of the piece of stone or wood is always time well spent.

The act of carving, the actual knocking away of the waste stone, is done with a mallet of either wood or iron; hitting a hardened steel tool into the stone in such a way as to remove a pre-estimated amount of waste material, with control. The iron tools are:

The point used to make the roughing out. It is with this tool that the largest pieces of stone (*spawl*) are removed from the block. The point's

job is to burst away the stone. An experienced sculptor will carve to within 13 mm ($\frac{1}{2}$ in.) of the final surface with the point. It is used in various sizes, from the largest to the finest the stone will allow.

The claw is used to draw the figure more precisely in the stone. It is the intermediary tool, between the point and the chisel. One achieves a kind of cross-hatched drawing with the claw. It is used in varying size on the stone, according to the fineness required by the work at this point.

The chisel is the tool with which the final statement is made, establishing with clarity the form and the detail of and on that form. Chisels are used in diminishing size to achieve the smallest possible detail, and are followed by the use of abrasives.

The way in which these tools and the marks they make are used is according to the individual, to the desired image and surface. The order is constant: point, claw and chisel. The striking of the hammer is important, the angle of impact upon the end of the chisel, point or claw, and the rhythm of striking. The rhythm is important because to be able to carve for long periods (and it must be realised that the carving is not the quickest process), you must sustain your energy and use it in such a way that the stone does not dissipate this strength and quickly exhaust you. A steady rhythm also enables you to think in the speed of the material. The angle of impact is important, because the hammer should hit the tool squarely on the end, so that the impact is carried straight down the metal to its cutting edge, thus having a maximum effect and giving maximum control over the cut. The tools should always be kept sharp. Blunt tools waste energy and cause loss of control, and further they bruise the stone. A piece of gritstone should always be kept handy on which to sharpen the tools whenever they require it. The tools should be sharpened according to the stone that is being carved. A general guide is that marble requires tools with a longer point or tooth and a hard temper. Limestones need tools with a blunter point, a broader flatter tooth and a softer temper. Granite and very hard stones can only be carved with thick stumpy tools and hard temper and must be broader at the cutting edge than for any other stone. The claw is not a tool that can be used with any effect on granite, and so for this work another tool, a *granite axe*, is used. This is a double-bladed axe of hardened steel, on a slender hickory handle. The granite axe is used to great effect by bouncing the blades on the surface of the stone, bruising the stone so that it may be cut with the chisel. Granite axes may have one blade or be multi-bladed, having anything from two to six blades. Granite is bruised so the chisel can gain some purchase because closing the surface (that is, cutting with a fine tool giving no tooth for the chisel to make a proper cut) makes the job more difficult and tedious.

Alabaster can be cut with almost any sharp tool; those used for carving marble are useful. Some people, however, prefer to use old wood-carving chisels to carve this stone, believing that the cushioned

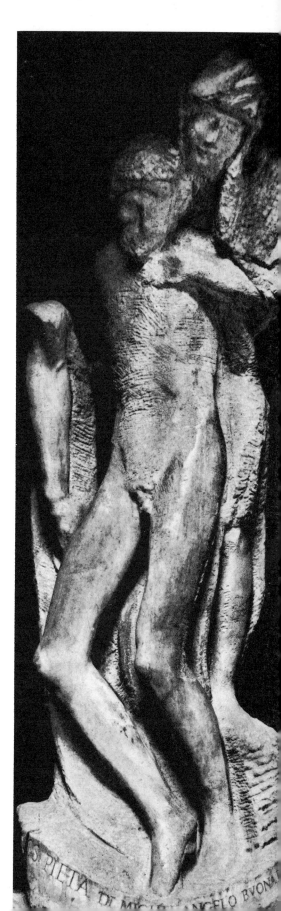

'Pieta Rondanini' by Michelangelo. The technique and use of the various tools can be seen clearly Collection of Castello Sforzesca, Milan

By courtesy of the Mansell Collection Photograph: Alinari

wooden handle make it less easy to bruise the stone; a bad fault, and something that should be avoided when carving alabaster, as it results in a white bruise mark that penetrates the stone's surface up to 13 mm ($\frac{1}{2}$ in.).

The most important factor regarding tools is that they should be kept in good working order; a well-cared-for tool always helps work to progress smoothly; and the well-used tool is the best cared for. You will soon get to know the tools which best suit you once work is started, when holding the tools, and the feel of the stone becomes familiar.

The second method used historically in making stone sculpture is *abrading* the waste stone away. This is a very long tedious method indeed, but it does produce a particular kind of form, a more tactile one. The form carved with a hammer and chisel is often edgy, the hard precise edge of the actual chisel cut is quite rightly always dominant. The kind of line achieved with the chisel is harder and crisper than the abraded line, and this is quite obvious. Examples of the extreme difference between the rubbed and the carved form are the abraded Egyptian sculptures, and the harder linear sculptures of the Gothic period in Europe.

Abraded forms are made by the consistent pounding of the stone, to break down the surface, so that it may be easily rubbed into shape, by using a strong abrasive such as carborundum. The forms are therefore almost caressed to finality, having the sensuality and individual character which makes a person want to touch the sculpture. This method may be used to some advantage on the softer stones, some sandstones and certainly on alabaster.

The methods of pounding and abrading have often been used together (see the Eskimo carving below). This combination was used by the Greeks, and since they were the source of the classical ideal, derivations of their particular techniques are used today. The

The late Barbara Hepworth working on large stone figures for The Festival of Britain 1951
Radio Times Hulton Picture Library

This charming carved stone sculpture is Eskimo, and illustrates the acute understanding of the material and the images contained within. The oars are of carved bone
Collection of Toronto Dominion, Toronto Photograph: John W Mills

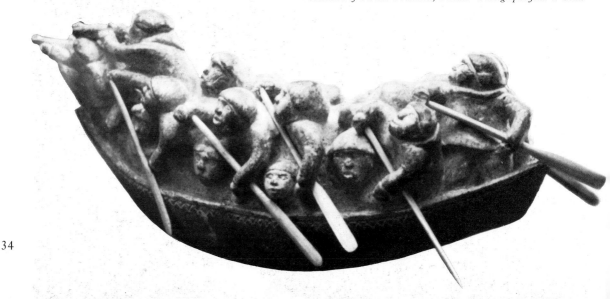

Greek method of pounding differed from that of the Egyptians, in
that it was done with an iron chisel and not with a dolomite pounder.
Of course they were using marble which is a much softer stone than
the Egyptian granite. The chisels were directed at right angles to the
surface of the stone, not cut across at the angle we use today with our
hardened steel tools. Their chisels were designed to bruise the stone
in the same way, and for the same reason as the Egyptians, and as
with granite still, that is to enable the chisel with a cutting edge to gain
some purchase. The modern equivalent of the Greek bruising chisel
is the *bouchard*; this is a hammer with rows of teeth at the end, which
when bounced on the surface keeps it open. The photograph of the
late Sir Jacob Epstein (below) shows him using a bouchard on the
sculpture *Ecce Homo*.

All the detailed information one may need about cutting stone and
using stone has been written, but what is often neglected is the
preamble to carving, the *maquette*. How do you begin on the stone?
How do you start to find what is in the block?

All these things depend upon your own needs and methods, and there
is no universal method which makes all things simple. You must
simply work a great deal, look a great deal and gradually evolve a
particular method suited to your own temperament and speed,
according to the stone and the idea. There are many methods for
transcribing an idea via a *maquette* or model to the stone block. All are
as good or as bad as the other, according to the artist, and some of the
simplest are illustrated on page 29. Some sculptors enlarge a precisely
worked out maquette, others may make a maquette simply to estab-
lish the idea three dimensionally, locating forms and planes and
directions roughly, then they abandon the maquette for the freedom
of cutting the stone. Yet another sculptor simply takes a block of
stone and carves directly into it without a maquette or preliminary
model of any kind.

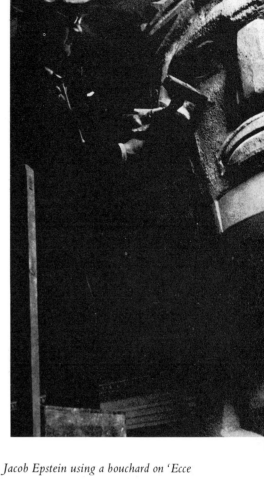

The late Sir Jacob Epstein carving his large alabaster
'Jacob and the Angel'. Note the marks of the point
Radio Times Hulton Picture Library

The late Sir Jacob Epstein using a bouchard on 'Ecce
Homo' Radio Times Hulton Picture Library

If a maquette is overworked there is very little point in enlarging it; it becomes just a task and gives very little satisfaction.

Michelangelo carved directly to the figure in the block. He did not often make a general roughing out of the stone, gradually reducing it to the final dimensions. This latter method has generally been practised in Europe for some time now, but it is a tedious method, making the process longer, and the idea becomes tired. Michelangelo carved with great speed and economy. By carving directly to the figure, by first being certain of the location of it in the block, and by being confident of his own ability, he retained as much stone as possible so that should he see a better alternative to his idea he could easily make an adjustment.

The position of the arm on one of the Boboli giants changed so much during the carving that, instead of being in the front of the figure as originally intended, it is now behind, and the shoulder has been changed accordingly. This can be done only if the maximum stone is retained during the carving. It is not possible when the figure is entirely roughed out to be carved many times to a final dimension. Maximum stone must be retained to accommodate an alternative. I am not saying that you should always think of possible changes, but to me carving once is infinitely better than carving many times. The so called Rondanini *Pietà* is an example of the freedom to be achieved with stone. The *Pietà* as it stands is in fact the second version of the idea, the extra arm and the faint traces of two former heads indicate the original design, before being re-carved, a further indication of a great sculptor's control over the medium.

To learn about the techniques of working marble one could do no better than study the work of Michelangelo.

Practical points

It was not simply the actual cutting or carving but the removing of large portions of stone that most puzzled and deterred me when first confronted with carving stone. How to split a piece of stone roughly where you wanted it to be split and how to lift the stone are questions to which you must know the answer, in order to be able to work in your own studio without always calling for assistance. To learn a great deal of this I recommend working, if possible, in a stonemason's yard. In this way you learn how those craftsmen, dependent upon carving as a living and therefore doing things in the quickest and most efficient way, tackle certain jobs. If it is not possible to work with them, try to watch them whenever you get the chance, and quarry men, too. Others to watch are the craftsmen who lay granite kerbings. A sculptor's life is necessarily taken up with a great deal of labouring and he must be prepared to handle great weights, bend thick irons and generally to be strong of arms and to have stamina. Close study of those who work in this way all day, every day, may save you time, energy and money in some of the things which you may have to do.

Lifting heavy weights, in this case blocks of stone, is done in many ways, but the equipment most common in a stone carver's studio is a strong load-bearing gantry, or a beam and pulley and tackle, an assortment of strong crowbars, boxes and random wood blocks. With this equipment the task of raising a stone to a position for carving is a simple lesson in applied mechanics, and when completed, the stone is ready for carving. The stone should preferably be set up on a *turntable* or *banker* so that one can work all round it. The underneath surface must be trued first if the sculpture is to stand well.

Pulleys are simple tackle, which can be easily made up, to move stone about the studio. The diagram indicates the principle by which pulleys and hoists work. The most simple hoist is a strong rope passed over a pulley. The load is attached to one end and is pulled from the other. The load will move at the same speed as the rope is hauled. To raise a greater load two pulleys are needed. The rope must be fixed at one end, passed around a pulley to which a hook is attached, then through another pulley. The free end is to haul upon. The load will rise at half the speed the rope is hauled, enabling twice the load to be raised. Three pulleys or four pulleys allow three and four times the load to be lifted at a third and a quarter of the speed.

Weston blocks are a system of three pulleys with a continuous chain to pull on. The two pulleys at the top, secured to a beam, gantry or sheer legs, are of different sizes. This allows the chain to be pulled quickly over the larger pulley and the load to be lifted slowly over the second. This tackle is the most common in sculptors' studios.

Small stone blocks can be handled and carved in a *sand box* (a box filled with sand) into which the stone may be wedged making it stable and steady and free to carve, the impact being taken up by the sand. This way also prevents damaging an already carved surface when working on the side or the reverse surface.

To fix a small stone upright for carving a vertical form a wooden frame can be made into which the block will stand on the turntable. Alternatively it may be fixed to a horizontal block with plaster of paris, making sure to wet the two stone surfaces thoroughly before applying the plaster.

Splitting stone is a comparatively simple operation, but one that requires practice and much care; small amounts of stone may be removed from a rectangular block by means of a steel tool, called a *pitcher*, which must always be used on a flat surface. Another way is to cut a deep groove all the way round the block and when ready hit the piece to be removed with a mallet. Remember that the stone will break at its weakest part, so one must make certain the groove is the weakest point. Large blocks of stone may be split by adopting the method used in quarrying, that is by means of *feathers* and *wedges*. This is done by drilling a series of holes in the stone, using a stone drill along the dividing line, then inserting the feathers and wedges and, having done this, hammering the wedges carefully in series, going up and down the line until the stone breaks in two. This, too, is the method for removing large pieces of waste stone from the figure in the block. The *stone drill* is a tool with many uses. When I first used

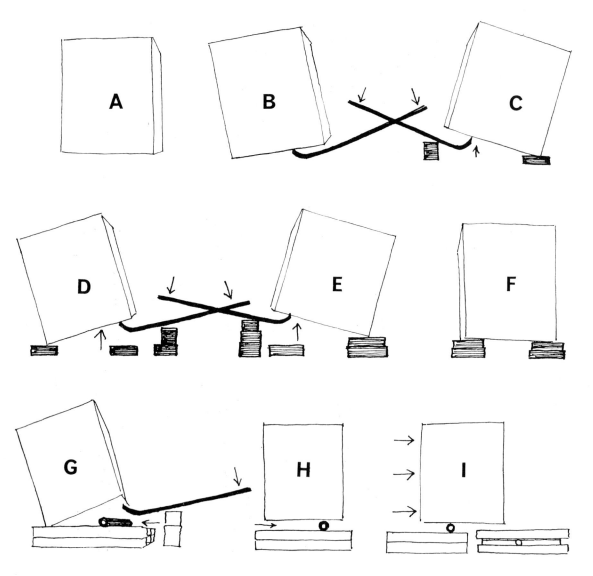

Illustration of placing a heavy block of stone, ready to carve on a banker, using a crowbar, random wood blocks and a metal roller: A The stone block. B The stone tilted with the crowbar to place the first wood block. C Tilted the opposite way to place the second wood block. Note the extra wood block placed under the crowbar to give a higher leverage. D, E and F The stone tilted again and again until sufficient blocks have been placed to bring the block up level with the top of the banker. G The stone tilted again to place the roller. H and I The stone is rolled on to the banker, which has been placed alongside. J The stone in position for carving. Wood blocks or battens have been placed underneath the stone to enable crowbars and rollers to be placed to remove the completed carving

one it opened up a whole range of forms that seemed hitherto to require just tedious and monotonous work. The problem of how eyes and deep hollows are carved, the folds of drapery, hair, etc is solved by the drill. By first opening the stone with the drill it may be carved into with great freedom. This, too, is part of the technique of pointing up and enlarging; by taking a measurement from the surface of the block into the figure, one simply drills down to a depth near the figure and removes stone to the bottom of the drill holes. The drill may be a hand operated bow drill, a brace or an electric drill.

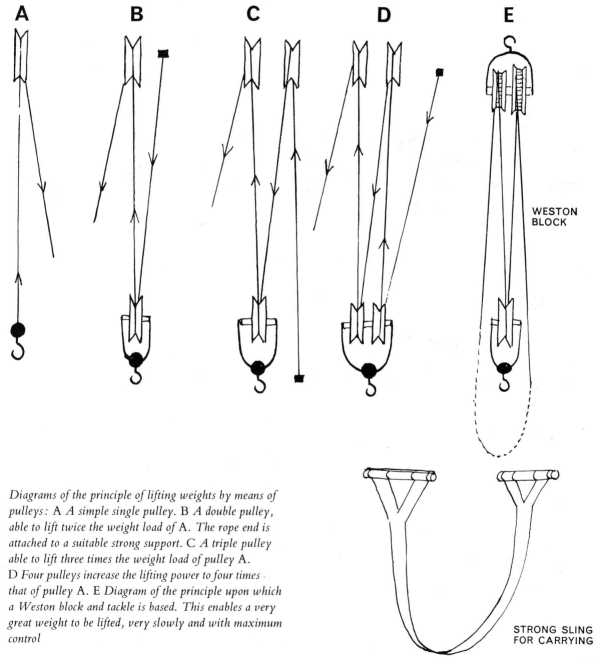

A **B** **C** **D** **E**

WESTON BLOCK

STRONG SLING FOR CARRYING

Diagrams of the principle of lifting weights by means of pulleys: A A simple single pulley. B A double pulley, able to lift twice the weight load of A. *The rope end is attached to a suitable strong support. C A triple pulley able to lift three times the weight load of pulley* A. *D Four pulleys increase the lifting power to four times that of pulley* A. *E Diagram of the principle upon which a Weston block and tackle is based. This enables a very great weight to be lifted, very slowly and with maximum control*

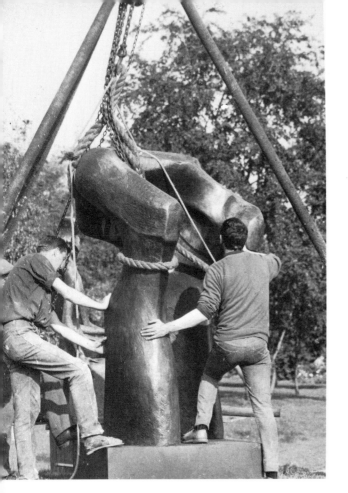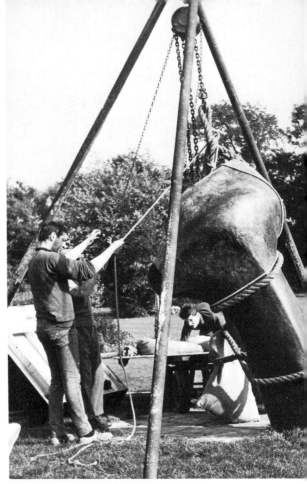

A series of photographs showing Henry Moore and some of his assistants moving large bronze sculptures. They are using sheer legs, block and tackle, and strong wooden levers Photographs: Lynton Money

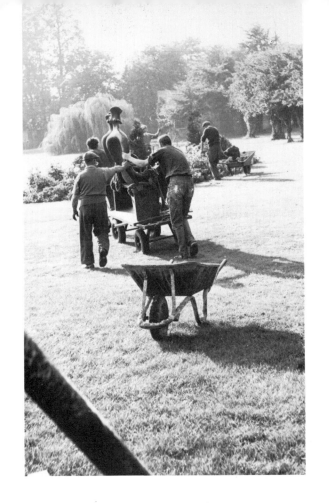
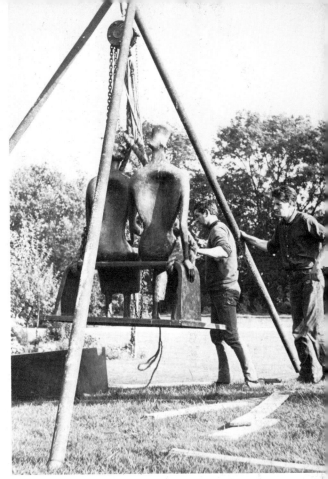
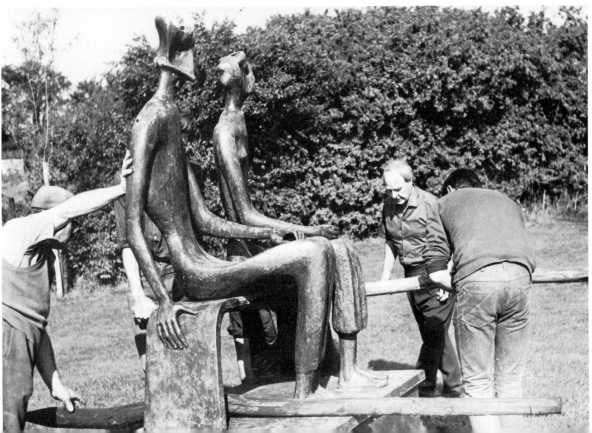

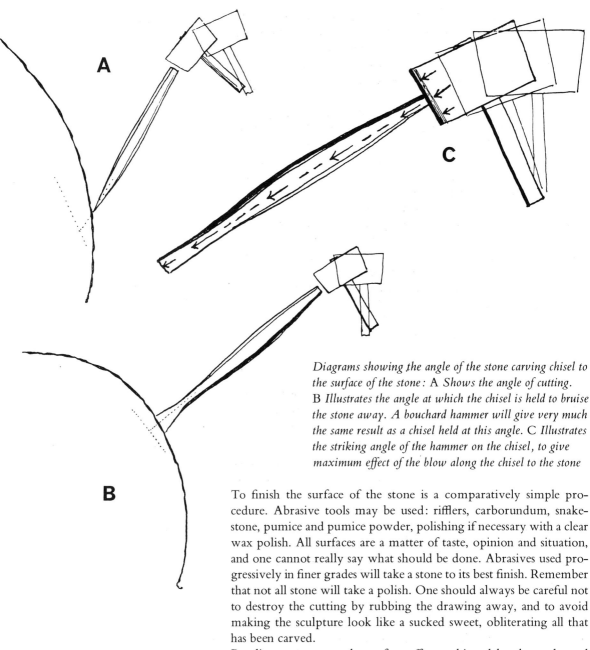

A

C

B

Diagrams showing the angle of the stone carving chisel to the surface of the stone: A Shows the angle of cutting. B Illustrates the angle at which the chisel is held to bruise the stone away. A bouchard hammer will give very much the same result as a chisel held at this angle. C Illustrates the striking angle of the hammer on the chisel, to give maximum effect of the blow along the chisel to the stone

To finish the surface of the stone is a comparatively simple procedure. Abrasive tools may be used: rifflers, carborundum, snakestone, pumice and pumice powder, polishing if necessary with a clear wax polish. All surfaces are a matter of taste, opinion and situation, and one cannot really say what should be done. Abrasives used progressively in finer grades will take a stone to its best finish. Remember that not all stone will take a polish. One should always be careful not to destroy the cutting by rubbing the drawing away, and to avoid making the sculpture look like a sucked sweet, obliterating all that has been carved.

Peculiar to stone are the surface effects achieved by the tools used upon it. Today stone sculpture is finished when the sculptor says so, when the image has been realised with maximum impact. In the past the client expected a smooth surface, mainly because of the supposed classical tradition and the kind of surface recognised as stone. Of course any surface made on stone must be of the nature of stone, but there are those which are good, revealing much of the fine quality inherent in the stone, and those which are less good, revealing none of its qualities. Michelangelo knew the quality of the stone and used the tools to maximum effect, not decoratively, but according to the

surface most suited to his ideas. Thus the mark of every tool used was often left because to eliminate it would have been wasted effort, and such effort could be better used upon the parts that required further refinement. Of course he, too, took many works to a fine final surface, but only because it was necessary to do so according to the image he wished to achieve.

An important point to remember when carving is not to open the stone or wood, that is to pierce it. Do not carve more than half round until the final size and proportion has been decided upon. Once the stone is open the forms around the hole can only become thinner and smaller as carving continues and the hole becomes larger, forcing the forms that surround it farther apart.

Stone may be obtained from mason's yards or stone merchants, and most towns have a masons' yard. If of course you live in an area where stone is quarried there is no problem of finding suitable stone. The demolition of old buildings often proves fruitful for obtaining fairly good blocks of stone, and should always be investigated.

Recognising stone, that is its nature and its quality, is an important factor for the sculptor and the geological structure should be studied and followed so that you become visually familiar, and thus are able to select the stone most suitable with certain knowledge of its nature and workability.

The basic groups of rock formation are:

Igneous rocks	Sedimentary rocks	Metamorphic rocks
Granite Galbro	Sandstone or gritstones	Marbles
Basalts	Limestone	Steatites
Diorite, obsidian	Magnesian limestones	Slates

Igneous rocks are those which are formed by the cooling of subterranean masses, and according to the depth and the consequent speed of cooling so the nature changes. Those cooling at great depth are usually coarser grained such as the granites, and those nearer the surface, cooling quicker, are finer grained such as basalt. Colour varies according to location, but there is a wide range, from light grey to dark grey, to black. Pink, brown-red and dark green granites are usually speckled and difficult to work with but are very durable.

Sedimentary rocks or stratified rocks are formed by deposits of sediment in successive layers. These deposits are intermingled with infinite varieties of organic skeletal remains, containing calcium carbonate, the main ingredient of limestone, and the majority of limestones used by sculptors are of this nature. Sandstones have a large content of silica, often as much as 98 per cent. The hardened steel nature of silica makes this stone as difficult to work as granite, though even more durable. York stone, a gritstone, was used before the advent of pre-cast stones as paving stones because of its durability. Limestone is probably the most widely used in the world because of its extreme workability. The denser limestones take a very fine eggshell polish.

Metamorphic rocks are igneous or sedimentary rocks that have undergone a change during their existence; the change being caused by

Diagrams of some of the carving tools for stone. The illustrations are similar to those published by suppliers of carving tools. A Mallet headed chisel, for use with a wooden mallet. B Mallet headed point. C Mallet headed claw. D Some of the shapes of chisels at their cutting edges. E The shape of claw tool for carving stone other than marble. F Shape at the cutting edge of Bull-nose chisels. G The cutting edge of straight chisels. H Cup headed chisel, for use with a steel or iron hammer. I Cup headed point. J Cup headed claw. K The shape of claw needed to carve marble; the tooth should be longer and have a harder temper than other claws. L Pitcher, used for quick roughing out, followed by a heavy point. M Round nosed heavy point. N Claw bit holder with chan claw bits. Also used in hammer form

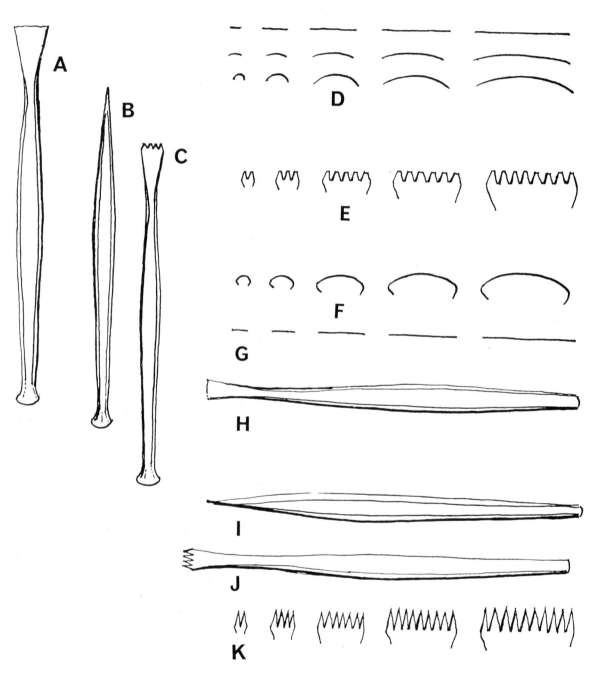

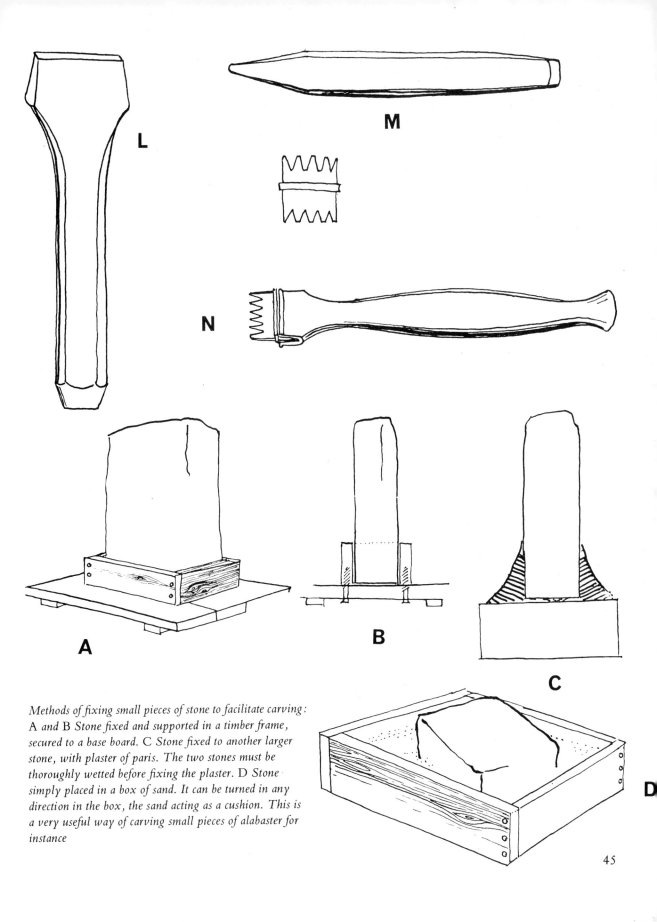

L

M

N

A

B

C

Methods of fixing small pieces of stone to facilitate carving:
A and B Stone fixed and supported in a timber frame,
secured to a base board. C Stone fixed to another larger
stone, with plaster of paris. The two stones must be
thoroughly wetted before fixing the plaster. D Stone
simply placed in a box of sand. It can be turned in any
direction in the box, the sand acting as a cushion. This is
a very useful way of carving small pieces of alabaster for
instance

D

45

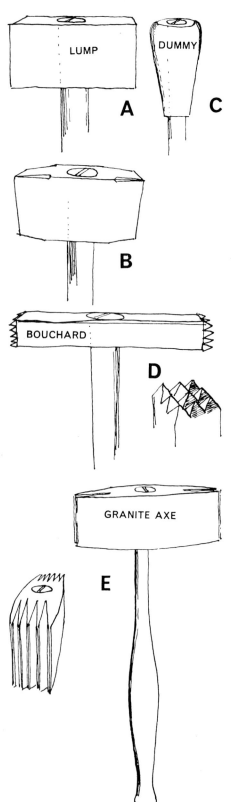

great heat and pressure and chemical reaction, usually during volcanic eruptions. The heat deep in the earth softens the stone, the pressure causes recrystallisation of the original formation. These rocks have been the most favoured by sculptors because of their beauty. They have a great colour range but the cream and white stones have a splendour unsurpassable. It is a pleasure to carve marble.

The tools most useful for stone carving include the following:

Drill, which may be hand driven or electric. It is used to make the necessary holes to place the feathers and wedges with which the stone may be split, thus removing large areas of waste material.

Electric drill, with attachments for drilling, grinding and polishing.

Pitcher, a tool used for roughing out, pitching from a flat surface.

Point, another tool used for more specific roughing out.

Punch, used in the same way as a point, but on softer stone.

Claw, used for drawing into the stone.

Chisel, used for drawing the image more precisely in the stone.

Lump hammer (iron).

Steel hammer.

Dummy hammer, used for cutting letters; it is a very light hammer, often with a lead alloy head.

Wooden mallets, made from beech or *lignum vitae*, used with mallet headed tools.

Rifflers and rasps and various abrasive tools.

Abrasives, including gritstone, for sharpening claws and chisels. Carborundum slip stones for finishing and polishing stone. Putty and pumice powders are the finest abrasives.

Letter-cutting chisels, for cutting inscriptions and fine detail.

Tungsten tipped chisels, for use on very hard stone, such as granite or irish limestone.

Calipers, proportional calipers, tee squares, and various measures for enlarging and assessing proportions.

Stone saw, for cutting stone.

Crowbars and *random wood blocks*.

Bankers, turntables and *sand boxes*.

Pulleys and *sheer legs*, or some method of lifting to facilitate carving large blocks of stone.

Plumber's bob and line.

Chalk for drawing on the outside of the block.

Some hammers used in stone carving: A An iron lump hammer. B Hardened steel hammer. C Dummy hammer, used for finishing and cutting letters. D Bouchard, the modern tool used to bruise stone away. E Granite axe and an alternative head with many blades

Wood

On the subject of wood carving much has already been written. The nature of carving, the taking away of waste material is the same no matter what the medium. Wood is generally less brittle than stone, being of a fibrous nature, therefore it requires sharper tools with greater tensile strength and harder temper. Because wood is fibrous, the kind of form one can carve is finer, and less massive than stone. The material has a tensile strength which enables the carving of more adventurous forms, with greater variety of weight disposition. As well as its tensile strength wood gives greater freedom and range to sculptural form because of the ease with which it can be attached to other blocks or pieces of wood. This makes it possible when carving to correct or adjust an erroneous part or a part about which you have had second thoughts, by simply replacing that part with a new piece of wood. Extending limbs or attaching one form to another give greater freedom to the sculptor.

The type of wood for carving is a matter of choice, opinion and suitability to the projected idea, image and situation. The wood, however, must be well seasoned no matter what kind it may be. To carve green wood—wood that has not been seasoned—is unwise because upon drying and maturing the carving will split, causing irreparable damage to the work.

Seasoning reduces the weight of the log by reducing its moisture content. The natural moisture 'cell water' content dries out and during this drying the wood shrinks, placing great strains across the grain and causing some cracking. An important aspect of seasoning is the acclimatisation of the wood to its environmental condition. Some sculptors buy and collect logs to store in the studio where it will be carved, thus giving the log time to season and to become acclimatised. Temperature and humidity change cause the wood to swell or shrink. Even after maturing, splits and cracks open and close with these environmental changes. Wood is always moving in this way. Special care should be taken to make certain of the temperature conditions and consistency of those conditions before selecting wood for a specific site.

Wood is best seasoned very gradually over several years. It must be allowed to stand in a constant dry temperature in such a way as to allow air to circulate freely around it. It should be kept out of direct sunlight and away from moisture. Large logs must be stood clear of the ground to allow air to circulate properly. Wood seasons in varying lengths of time of course, according to the log size; in natural air conditions it may take anything from eighteen months to six years to mature. Uneven drying results in deep cracks, spoiling the log for large works. Industrially, wood may be kiln dried, and this is an economical method, saving the very long periods required for natural seasoning and the necessity for storing the wood for that length of time. Kiln drying is, too, the most efficient method of reducing the moisture content of the wood.

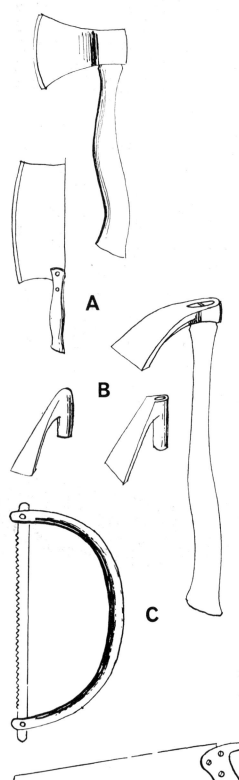

Splitting is the eternal problem of the wood carver and there really is no way around it. It is in the nature of wood to swell and contract with any change of temperature or humidity, and the best that can be done is to control as far as possible the temperature, etc. Well-seasoned wood will, of course, be less liable to split. Some equatorial woods split very little, if at all, because of the closeness and complexity of their grain. The close and complex grain is very dense, consequently the strain it is able to take during drying is very much greater than a less dense wood. The reason for splitting is the shrinkage of the wood as it dries; the wood usually shrinks around the centre or heart of the log, causing vertical cracks to appear on the outside surface of the log. To avoid this a hole can be drilled through the centre of the log, using an auger, removing the very centre of the log to give it room to contract. Many of the medieval wood carvings were carved three-quarters round only; the remaining quarter was cut away, penetrating the wood in a semi-circular form to allow the wood to shrink without cracking the surface and affecting the carved image. It is possible to carve green wood if an adequate allowance for shrinkage is made. If you design the form so that you cut through the heart wood, this will reduce the amount of cracking caused by the shrinking of the wood about the heart. This is all the more necessary now that well seasoned wood is difficult to obtain.

There are two grades of wood, hardwood and softwood. The category into which a particular wood falls is not determined necessarily by its actual hardness, but by whether it is deciduous or coniferous. Deciduous or broad-leaved trees are those which drop their leaves in winter in temperate climates. The conifers are evergreen and have narrow, spiny, needle-shaped leaves. Deciduous trees are the hardwoods, conifers are the softwoods. Generally the hardwoods are closer grained than the softwoods, more difficult to cut, but capable of taking finer forms and higher polishes. Hardwoods, too, are usually the most durable.

The proper study of wood carving is the study of sculptures made from wood, and indeed all forms of three-dimensional form and construction made with wood. Today, particularly, the use of wood in sculpture is not restricted to wood carving. Three-dimensional images may be made from an assembled collection of wood, manufactured items and natural logs.

The form that has evolved over the centuries in the manufacture of wooden artifacts, decoration and construction, is peculiar to that material. To make it look or appear to have been made with another is false. A particular medium is chosen because it is suitable to the planned image or idea, or vice versa. The idea fits the medium, consequently the evolved character of the material should be recog-

A collection of some of the items used in wood carving to clear some of the waste material in large areas quickly:
A Axes. B Adze, showing two alternative shaped heads.
C Bow saw, used mainly for cutting across large timbers.
D Rip saw

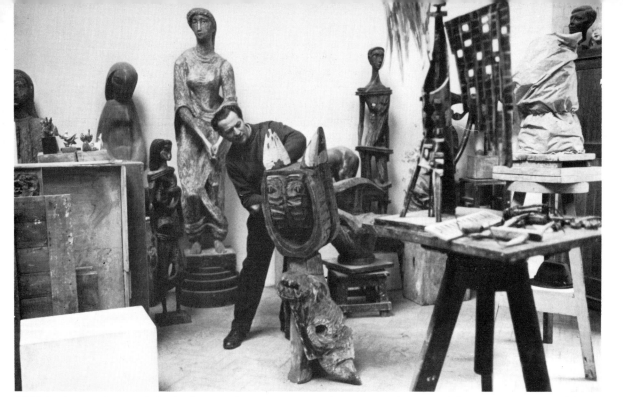

Willi Soukop carving wood. In the foreground is a modelling stand which is an essential item in the studio
Photograph: Crispin Eurich

Egyptian wooden spoon. This is an interesting and honest use of the material; and a beautiful figure. Approximately 20 cm (8 in.) long British Museum

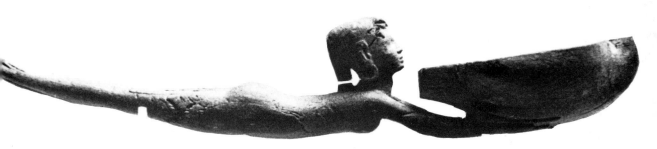

nised, used, and not abused. A proviso must be made, however, in that a successful end justifies the means; the way must always be clear for innovation. Too strong an adherence to tradition may stultify a new idea.

Wood carving involves a definite procedure. The tools used are chisels, flat and semicircular (gouges), saws, adze and axes, and they are best used in the following order:

The *saw* is used, of course, firstly to remove large areas of waste material, prior to actual carving. The *adze* and the *axe* may be used for very preliminary roughing out, it being easier to remove large chips with a large handled tool which requires a long swing, especially when carving very large works. The adze was used a great deal by

A

primitive carvers, used in diminishing sizes as skilfully as a mallet and chisel. Mallet and chisel are the tools most used in Europe, although today, of course, all tools that will aid the forming of wood are used by sculptors. Chisels range from semicircular in section (*gouges*) to flat (*chisels*), and they range in size from 50 mm (2 in.) or more in width (according to the sculptor and the wood), down through every size to 6 mm ($\frac{1}{4}$in.) and less. Mallets are preferably wooden, made from good pieces of beech or *lignum vitae*. These mallets will not split and will be fairly dense and weighty. Weight is important because it should be the mallet that does the work, the arm being merely the vehicle which swings the mallet up and down rhythmically. The weight of the impact comes from the mallet; the impact must be directed straight down the chisel to the cutting edge. The angle of impact is important, and the direction of the cut. Ideally, one should use the gouges necessary for the projected work, gradually reducing the size and the depth of gouge till the work is finished with the flattest, smallest chisel.

Of course the kind of surface required may range from the raw saw cut, to the adze or axe, to the deepest gouge or the smoothest polished surface. The choice and application must be left to the sculptor according to the idea.

Rasps and sandpaper are the abrasive tools which are used to take wood to a final smooth surface and the use of these is very obvious. The hazard, however, is in destroying any form that may have been carved by misusing either sandpaper or rasp, and care must be taken to retain the freshness of carving and the character of the material and the tools used in the production of the sculpture.

To carve the wood it must first be set up in a suitable way. Large logs, as with large blocks of stone, require sheer legs, wood blocks and crowbars, etc, to ease the difficulty in handling them. Their weight makes it obvious in which way they are set up to be carved. Make certain before starting that, if the figure or form is to stand well, the underneath surface of the log is made true. It is much easier to do this before commencing to carve than when the figure is complete.

Small logs can be made stable by first trimming the base, then screwing into the block underneath a bench bolt leaving the end projecting long enough to go through the bench top. The projecting length will accommodate a large wing nut which locks the block to the bench making it firm and stable for carving.

Choose the wood to fit the idea and vice versa. It is wise to have as little waste material as possible, but wood can be joined easily to add extremities, or build the basic form to be carved from many pieces of wood. Some useful joints are illustrated on page 52.

Rifflers and rasps: A Rifflers for use on marble, plaster or wood. A wire brush will be necessary to clean the teeth of the riffler of any deposits of damp material. These tools are also available in a wide variety of shapes and sizes

Treatment of wood

Because of the susceptibility of wood to the changing atmospheric temperature, it is, in the wrong atmospheric conditions, a very delicate material. Consequently, careful measures have to be taken to preserve the wood. In a cool, dry atmosphere, wood will last for ever. Witness to this are the Egyptian carvings now preserved in our museums, which have been protected by the dry constant temperature in the tombs where they have lain for centuries. Moisture and humidity influence decay as well as insects and various damaging plants, and fungus growths.

The treatment of wood involves filling cracks which may open when the carving is placed in its final site, and the sealing of the wood pores from attack by moisture, growths or insects.

Cracks may be filled with plastic wood, which can be bought in almost any handyman's store. Sawdust mixed with wax can be used as a filler. Wood shavings can be glued into the cracks, preferably wood shavings from the actual carving. A useful filler can be made by mixing sawdust from the same wood as the carving with polyester resin. In fact almost any clear glue or resin with sawdust can be used as a satisfactory filler.

Sealing the surface may be done with many traditional materials such as wax polish, oil, gilded with metallic (gold or silver) leaf. Today, resins of many kinds have been developed for the treatment of wood to seal against all kinds of attack. Stores in most towns carry stocks of sealers, stains and polishes, and these should be experimented with to find one suited to a particular job. Finding out, too, what new mediums are available is best done in this way, as it is impossible to try to cover in this book the hundreds of different preparations on the market. These materials are, however, usually clear, applied to seal the pores of the wood, and to enhance the grain and character of the wood. Wood grain and colour is enhanced by exploiting its full depth and range of tone within the natural colour.

Paints can be used if the natural quality of the wood is to be covered, but this must be done with great care. Opaque colours may simply destroy the character of the carved form or destroy optically the shape of the carving, or just make the wood look like any other material. Polychrome sculpture is a most difficult art form, requiring a complete marriage between the carved or modelled form and the effect and character of the colour. This needs great control and should be carefully considered and carried out with deliberation. Paints suitable for external use are the toughest, and again I can only advise experiment with what is available in your particular part of the world. Good paints for use internally can be made with a polyvinyl acetate base (PVA).

B *Plaster rasp. Designed specifically for use on plaster of paris. The rasp will remain free from clogging and thus enable one to work quickly on fresh plaster as easily as on old. The rasp is designed on the cheese grater principle. These too are available in a wide variety of sizes*

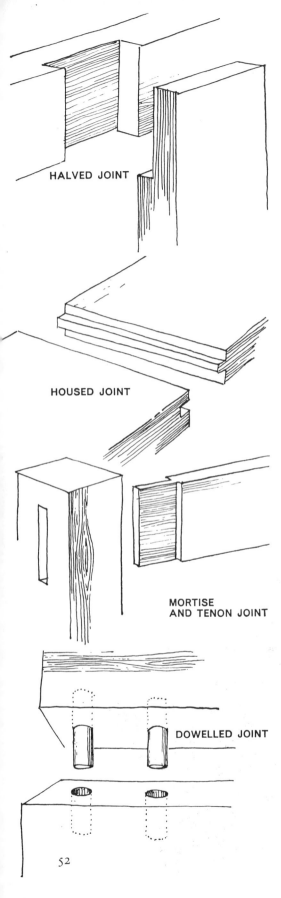

HALVED JOINT

HOUSED JOINT

MORTISE
AND TENON JOINT

DOWELLED JOINT

Some of the various hard- and softwoods are as follows:

Softwoods (coniferous)	*Hardwoods* (deciduous)
Larch	Ash
Spruce	Beech
Pine	Oak
Yew	Chestnut
Cedar	Elm
Cypress	Eucalyptus
Fir	Hickory
Hemlock	Mahogany
Juniper	Maple
Kauri	Satinwood
Podocard	Teak
Sequoia	Walnut
	Plane
	Sycamore
	Lime

Obviously one cannot advise for or against a specific wood; experience in some measure should be gained in as many varieties as possible.

The tools most useful for wood carving include:

Saws, for cutting wood in various conditions, and for removing large areas of waste.

Sawbench, for supporting the timber to be sawn.

Bankers and turntables.

Axes and *adze,* for roughing out.

Chisels and *gouges,* as wide a selection of these tools as possible, to actually carve the wood, down to the finest possible mark.

Mallets, made from beech or *lignum vitae* (well seasoned).

Bench screws, for securing wood to a bench or banker.

'G' cramps, for holding wood down on a bench, or for holding pieces of wood together to be glued and fixed.

Rifflers and *rasps.* Other abrasive tools to include grater-type rasps, eg Surform tools.

Sandpapers; a complete range of grades of sandpaper should always be kept in the studio, in a dry place.

Crowbars and various random wood blocks, with which to raise large works.

Lifting gear, for lifting large blocks bodily.

Various glues, varnishes, resins and wax polishes for treating finished carvings.

Auger, for drilling holes deep into the wood, for instance, down the centre of a log to ease the shrinkage.

Chalk, for drawing on the outside of the block.

Clay

Clay is probably the most available material in the world and no doubt everyone at some time or another has scooped up a handful of stiff mud and fashioned it into a shape. Clay is moist, stiff, tenacious earth of the same origin as the igneous stone which we carve. The clay is a by-product as it were of the stone, caused by decomposition due to weathering. The decomposed particles have been carried by the rain and river, and deposited where the flow of water slows. This, of course, has been happening since the beginning of time. In some parts the deposits are particularly dense and fine, and it is from these places that clay is dug, and exploited for brick making and pottery. This accounts for the particular location of these works, also for the nature of the architecture in the neighbouring area, brick as opposed to stone. Clays suitable for pottery are of very particular kinds, and the nature of these clays and pottery bodies have been dealt with in great detail by Dora Billington in her book *The Technique of Pottery*. Clay used by sculptors does not need to be so fine and pure as that for pottery except when used for terracotta, which is to be fired.

Any clay may be used to make the form which is to be cast in another material. Of course the quality of the clay may have an effect on its workability. Poor quality clay may be difficult to work, may be *short*, not plastic, with a tendency to break when modelled. Most clays in their natural state are too short in quality for modelling over an armature, and need to be mixed with finer clays to achieve a material suitable for modelling. One way of getting over cracking caused by shortness in clay is to add some fibrous material. A small quantity of jute scrim is ideal and helps to bind the clay. The clay will become less short as it is used over and over, being constantly broken down and reconstituted. Clay suitable for modelling can be bought from any

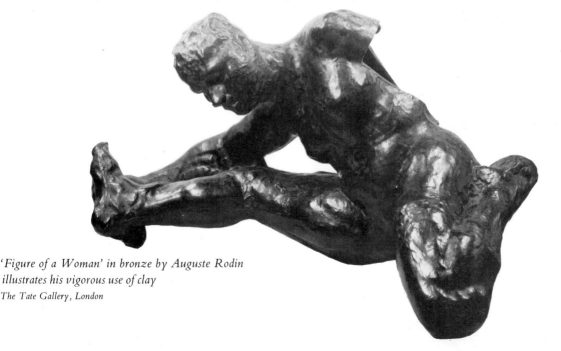

'Figure of a Woman' in bronze by Auguste Rodin
illustrates his vigorous use of clay
The Tate Gallery, London

53

pottery, and this is often the best solution, saving time and energy needed to refine it. The clay should be as fine as possible, free from sand, grog or any hard particles that would hinder casting. Clay with sand or grog in it will not stand the constant wetting that is necessary when modelling. The moisture penetrates too easily and weakens the adhesion to the armature. Clay may be on an armature for as long as a year, and there is nothing more disheartening than to arrive one morning to find the figure you have been working on, an amorphous heap at the foot of the armature, because the soaking given the night before has so weakened the adhesion that the clay has fallen away from the armature.

Clay to be modelled only does not need to be as pure and free from foreign bodies as that to be modelled and fired. Potters are often shocked by the clay in the bins of a sculptor's studio; they see the impurities, such as small pieces of plaster of paris perhaps, a result of making a mould from the modelled form, and think immediately of the disaster this would cause during the firing. Clay should be kept free from impurities, such as pieces of plaster, nails, etc, purely from the point of view of surface and fine modelling. Anything that interrupts the modelled surface is bad, and nails and pieces of scrim are obviously dangerous to one's own hands. Pieces of plaster which do get to the surface of the modelling must be removed, or else they will be picked up by the mould and when cast the final work will have a hole the size of the piece of plaster.

Rodin used to keep his clay in many varying states of hardness and softness. Further he would allow the modelling to dry at varying rates, so that the quality he wanted to model was done with the right kind of resistance from the clay. For instance, a hard bony form would be realised by using a literally harder clay, or when the clay had hardened slightly on the modelling it would be burnished to the required hardness. Softer forms would be dealt with using softer clay. The figure *Susannah* by Manzu (page 20) is just such a sculpture, realised fairly quickly in soft clay, handled in such a way as to evoke the sensuous flesh of the subject.

Clay, which is so malleable as to be almost characterless, can often result in sculpture which similarly has little character. Resistance from the material often affords the opportunity of forcing a particular form or surface from that material. By varying the state of the clay a greater variety of tactile quality may be achieved. The sculpture should be a result of handling clay with the qualities peculiar to that technique. The study of Rodin sculptures is of great value, and will aid the further understanding of these qualities.

The figure *L'homme qui marche* is an extraordinary sculpture in many ways. It demonstrates the freedom Rodin enjoyed, because of his

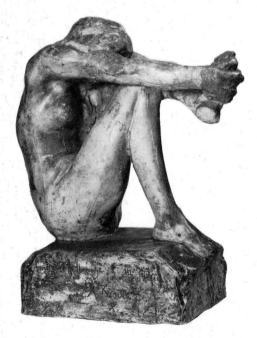

'Figure of a Woman'. Plaster maquette by Auguste Rodin
The Tate Gallery, London

'L'homme qui marche' by Auguste Rodin. This fine sculpture illustrates clearly the superb handling of clay for the bronze of which Rodin was master
Musée Rodin, Paris SPADEM, Paris 1965

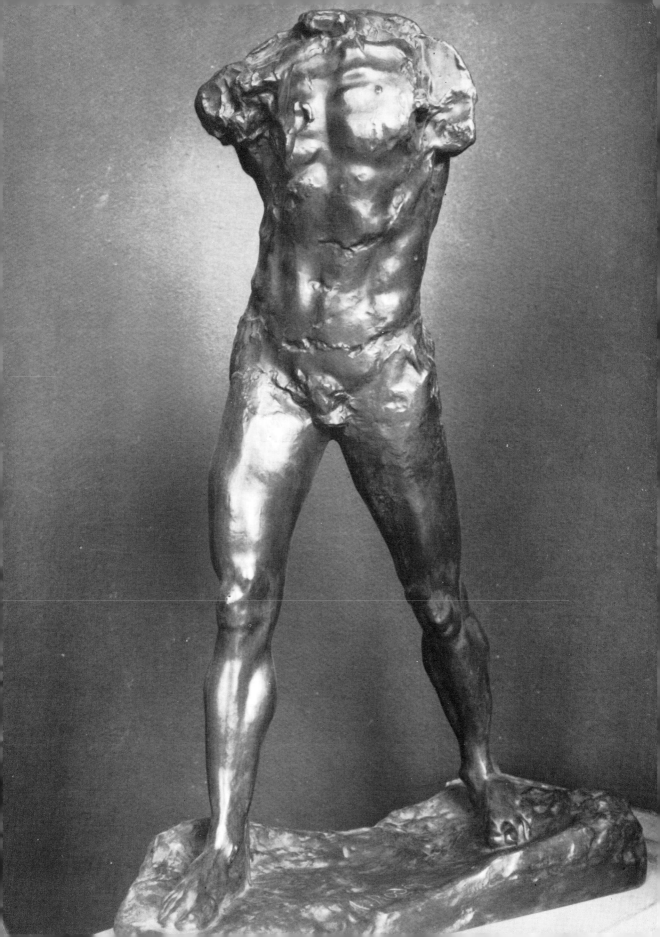

skill, making this in fact the first fragment sculpture. That is a sculpture whose surface is commensurate with the fact that the figure is incomplete, having neither arms nor head, thereby freeing the sculptor from the traditional surface finish, and permitting modelling that is free and energetic in relation to the fragmentary image. The maquette *Figure of a Woman* and the bronze *Figure of a Woman* illustrate further Rodin's masterful handling of clay, as do the details from the *Burghers of Calais*.

Storing clay is important; it should be stored when moist in sealed rust-proof bins. Galvanised dustbins will keep the clay in good condition but they are usually not strong enough to hold very large amounts. A galvanised storage bin or bunker is more satisfactory. Anything that is liable to rust should be kept out of the clay when it is stored. The reason for making sure no nails or screws remain in the clay after dismantling the armature is because rust affects the clay,

Details from fountain group in bronze by Giacomo Manzu
Crouching male figure *Reclining female figure*
Wayne State University, Detroit Photographs: John W Mills

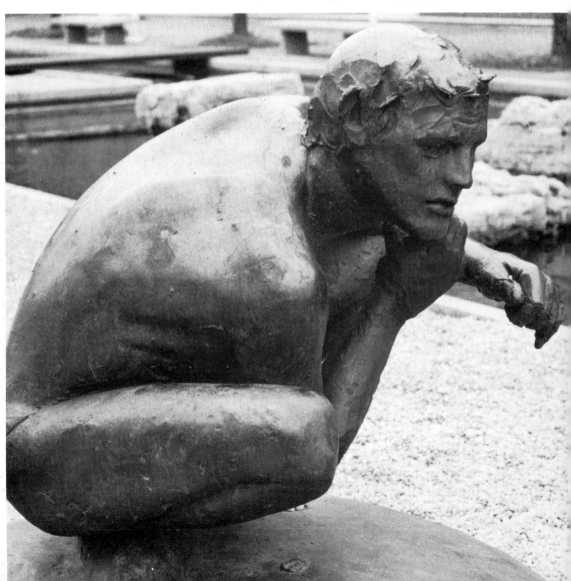

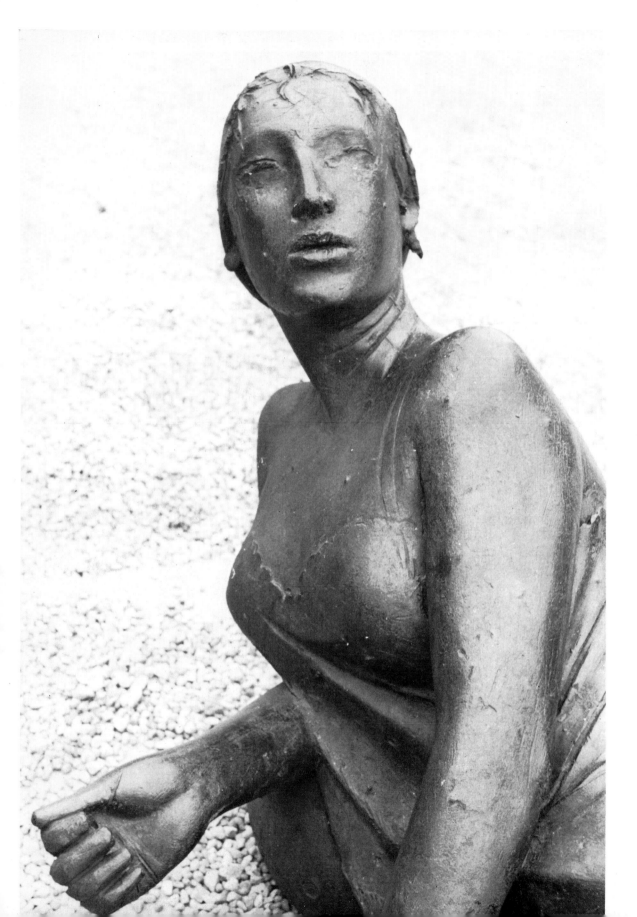

Detail of hands from the 'Burghers of Calais' illustrating the consummate skill and the tactile handling of clay for bronze so typical of Rodin Photographs: John W Mills

making it brittle and crumbly. Dry clay should be stored in a dry atmosphere and sealed from contamination. It can be easily reconstituted by breaking it down and immersing it in water until the required consistency is achieved.

Clay has very little tensile strength and will not retain a stretched shape without support. It has compressive strength only. When built up layer upon layer it can be modelled into large bulky forms. Its own strength can best be realised by constructing hollow forms, as in pottery. Consequently when the image to be made is complex and the form varies in size and direction, an armature must be made around which the clay can be modelled. Armatures are described on page 135–139.

The actual modelling, applying the clay to build the form, can only be learned by experience. Our fingers are natural modelling tools and we should endeavour to become as proficient as possible with just the fingers, modelling the finest forms without using a wooden spatula (modelling tool). The sculpture is more sensual and tactile, as a result of pushing, prodding, squeezing and easing the clay. Tools should be regarded and used only as extensions to the fingers.

There are literally hundreds of modelling tools for clay, and any supplier will confront you with a selection that may leave you speechless. The best are made from boxwood in an infinite permutation of shapes and sizes, and are often very beautiful. You are well advised not to buy any until the need arises for a particular shape. Make do until then with a piece of ordinary wood. If you wish to make your own tools, hardwood should be used. Old boxwood rules are of ideal

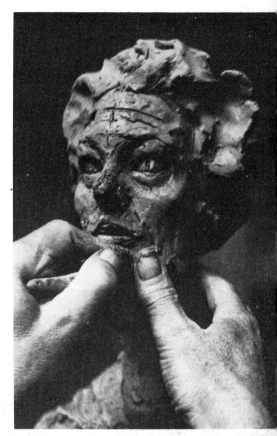

Two clay heads in progress by Alberto Giacometti Conzett and Huber, Zürich Photographs: Franco Cianetti

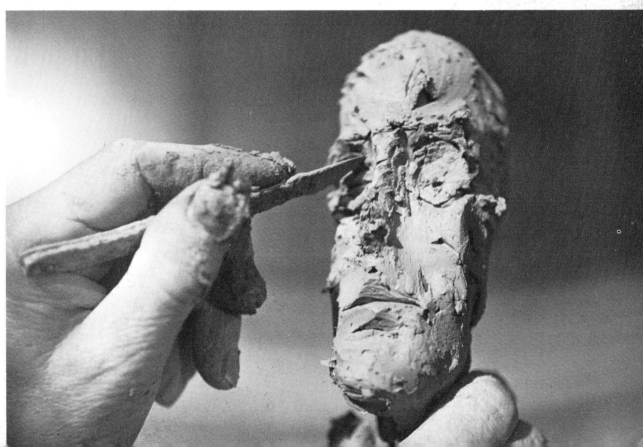

METAL SPATULAS

WOODEN SPATULAS

Metal and wooden modelling tools. Some shapes of steel spatulas and wooden modelling tools. The variety of shape and size of these tools is infinite, designed to suit every need and hand

wood from which to make them. Modelling tools should be kept free of clay when not in use for a long period and should be oiled. Do not leave them in water, because they will crack and deteriorate.

Modelling is an additive process. When building up the clay form it is advisable to keep the form a little smaller than that which is finally required, leaving room always to add more. Cutting the clay away, to achieve the form, should be avoided unless this quality is particularly needed. If it is realised that a form is too large, better to cut it right back so that you may build out to the correct form again. There are no rules. There are accepted practices for the purists but the successful end always justifies the means, no matter what rules are broken.

The clay may be added in pellets of uniform or random size. It may be pushed with the finger tips, the palm of the hand or the edge of the palm; mallets may be used with patterned ends to break up the light across the form. Steel spatulas may be used, but wooden tools are most common. An incision or line made in the clay with a knife or steel spatula has a very different quality to an incision or line drawn with a wooden tool. Very wet clay may be used to model a surface. When the clay is almost leather hard it can be burnished to a final surface. A combination of both very wet and leather hard clay surfaces can be used. Experiment is the key to finding out. Do not be satisfied with only one limiting technique; find out as much as you can about the nature of clay and what you can do with it, and use the method which most suits you.

The beginner should seek the nature of the clay for himself and not wait to be told what to do. By simply taking a lump of clay from the bin and by pushing or pinching it into some shape or other is the best way of starting. Do not start too soon to make a definite figure, but experiment so that when eventually something definite is attempted, some confidence of control may be had over the clay. Pushing, slapping, prodding and pinching can be done with no other material, and full use of this should be made. Clay should be added only as the attempted form demands. Experiment with the marks that various objects make on the clay, and learn to understand the range and quality of marks that can be made, experiencing a range extending from hands and fingers to tools of all kinds, and thus achieving as much variety as possible.

Some tools essential for modelling clay, apart from the hands and fingers, are as follows:

Wooden modelling tools, in a fairly wide range of size and shape.

Wire loop tools, used mainly for scooping out clay; these can have serrated edges with which to apply a texture to the clay surface.

Calipers and *Proportional calipers*, for measuring forms and distances.

Large syringe, for spraying the clay with water, to keep it moist and in a fit state to work on.

Textured wooden mallets, to consolidate clay masses, etc.

Fine copper wire, for cutting off large areas of clay.

Plastic sheeting and *wet cloths*, to cover clay to keep it moist, when left for long periods.

Bankers and *modelling stands*, as many of these as can be fitted into the studio is ideal.

Materials for *armatures* of various kinds, as described in the chapter on armatures.

This equipment is also used for making terracotta sculpture, but for this material all the tools must be spotlessly clean.

American sculptor John Mason carrying out a relief 'Blue Wall' to be fired. The clay is bedded on silver sand to stop it sticking and cracking as the clay hardens and shrinks

Terracotta

Terracotta is in fact 'baked clay', and it is under this general heading all fired clay bodies are grouped by sculptors. Baked clay, and images made of this material, is as old as man and, if cared for, long lasting. Witness the Chinese prehistoric terracotta *Mounted Warrior*. A more recent example of terracotta is the head of *Rembrandt* by the author. When clay is baked or fired, the resulting states of the material are of several kinds, but that mostly used by sculptors is *earthenware*. This is a porous, soft and opaque body fired in temperatures of up to 1100°C. *Stoneware* is a very hard and dense non-porous body fired at temperatures of up to 1300°C. Other kinds are porcelain and bone china, but these are not often used by sculptors. All clay can be fired providing it is clean and free from any foreign bodies that will react unfavourably during the firing to the clay and its natural components. The most common foreign bodies that somehow creep into terracotta in a sculptor's studio are pieces of plaster of paris, and these, when deeply embedded, cause the fired clay to split and small holes on the surface will appear both during the firing and after. Iron pyrites also cause blow-outs during firing, and any unknown clay should be tested before use. Always be certain to keep clay for firing clean. This means that the clay normally used for modelling should not be used for terracotta, and it is wise to store the two clays quite separately. The kinds of clay that are suitable for making sculpture to be fired are those which are used by potters, and again I would refer the reader to Dora Billington's *The Technique of Pottery* and her descriptions of clay bodies. Suitable terracotta bodies may be bought from a pottery or clay suppliers, and from brickfields. The kinds of clay most readily available are white and red clay, and to these may be added one or more of a number of additives which enhance the quality of the clay to strengthen it or to help make it more workable, according to the sculpture to be made. Some such additives are as follows:

Sand, when of good quality, is almost a fine silica which makes the clay more refractory, or able to stand the higher temperature of stoneware bodies. It also may enhance the texture of the clay. When fired at earthenware temperatures the surface may be rather granular and open. If such a surface is required, a large proportion of sand will give this. An application of sand to the surface whilst modelling gives a coarse open surface which can be more controlled. Builders' sands, and sands used in foundry work, which vary in colour and texture, can produce an interesting result. These often contain iron which gives an attractive rust colour, usually in spots of colour, impossible to control, but when used at a judicious place on a suitable work this may prove to be very pleasing. Of course, experiments with any proposed additives should first be made to see what may result.

Flint when added to clay helps give whiteness, density and a higher

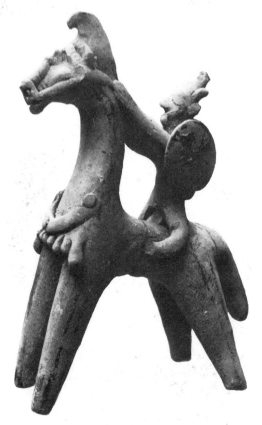

'Mounted Warrior' in terracotta. Chinese
British Museum Photograph: John W Mills

firing temperature. Flint, china clay or quartz may be added to a clay to increase its rigidity or tensile strength.

Grog, ground fired clay, usually refractory, may be added to give a coarser texture and reduce the shrinkage and warping of the body.

Feldspar may be mixed into clays, too, because it acts as a flux; it also increases the density and durability of the completed work.

These additives are those most generally used by sculptors for terracotta, and are but a few of those used by potters. If you are interested in exploring the possibilities of fired clays I recommend you to seek the advice of a potter who is willing to communicate some formulae; then carry out experiments to particular needs. The formulae for clay bodies which are unusual are often jealously guarded. They are a source of constant interest, with a potential danger of ensnaring one into simply making interesting clay bodies.

Fashioning these clays into sculpture requires skill and patience, but as with any sculpture, a large helping of common sense is never amiss. It is possible to fire terracottas which are solid; if this is done slowly enough, if the clay body is strong enough, and if the clay has been compacted enough so as to be free from air pockets and impurities. For the best result the forms should be made hollow, with the thickness of the clay varying from a quarter of an inch to an inch, according to the size of the sculpture. The hollow form must have a hole or holes to release air which expands during the firing; each enclosed hollow will require such a breather hole. The Haniwa head illustrates this point admirably, with holes at the mouth and eyes. If this important factor is overlooked the sculpture will explode during the firing, the size of the explosion being relevant to the thickness of the clay wall— the thicker the wall the greater the explosion, and the greater the damage done in the kiln.

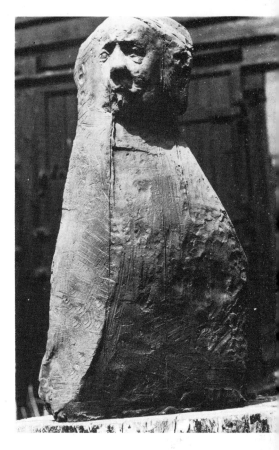

Hollow forms can be made in several ways:

1 By building the forms solid and, when near leather hard, these solid forms are hollowed out by cutting them with a fine wire and removing the centre clay to gain the thickness required. The cut halves are then squeezed together with *slip* made from clay dissolved in water; the same clay as the sculpture. These solid forms may be made around an armature which can be removed during the hollowing. The armature should be constructed bearing in mind this removal.

2 The form may be coiled. This is done by rolling the clay on a clean dry board or table top, into long sausages. These are then laid one upon the other to make the hollow form. The rolls should be the thickness required for the size of sculpture you are making, and each layer should be moistened to make the best adhesion between the layers.

'Rembrandt' head in terracotta by John W Mills. Made
by coiling and slab building directly with coarse clay
Photograph: John W Mills

Terracotta head from the Han Dynasty
British Museum Photograph: John W Mills

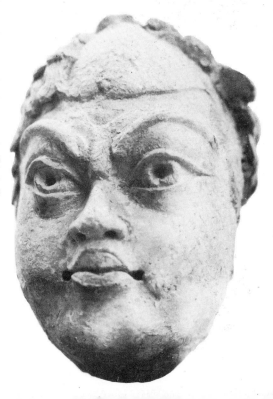

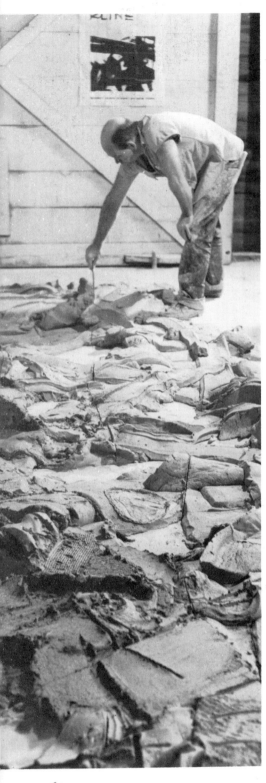

3 The form may be built up from slabs of clay to the required thickness, previously prepared, and assembled to make the shape. Again it is always advisable to wet surfaces which are put together to make them adhere.

4 Hollow forms may be made by pressing clay, or pouring clay, in a liquid state, into a plaster of paris mould, prepared from a shape modelled solid, then moulded. Piece moulding, the type of mould most suitable for this, is described on page 75. Hollow forms made in this way may be complete images, heads or figures, or basic shapes which can be assembled to make the image.

5 If you are proficient at throwing shapes on a potter's wheel, basic forms may be made in this way and assembled.

Hollowed clay forms may have a tendency to sag, even when made in clay which is fairly rigid, so to avoid this struts must be put in, or supports of clay, giving strength to the wall, which is liable to sag. These should be placed in a way similar to buttresses on old walls, and for the same reason. There can be no rule for this, except that the wider the span or expanse of a wall the more liable it is to sag and need supporting. Common sense and experience are again the best teachers. It is interesting and very worthwhile to look closely at terracotta sculptures which have been made by past cultures. Sculptures in baked clay have been made by almost every culture and civilisation known to man. Consequently the range of treatments that have so far been used is very extensive, and to be able to recognise a form or image, not only idiomatically but by its manufacture, is an essential part of the sculptor's knowledge. Terracotta sculptures range in scale and treatment from the very small and crudely fashioned of primitive man to the very large and sophisticated sculptures of civilised societies. Our museums are veritable treasure houses of information for the visual artist, and too great an emphasis cannot be placed upon the advantages gained from close study of the many examples of every kind of art form to be found in them. Terracotta sculptures in their wide idiomatic and historical range are there, and should be found and studied as much as those of today. Particular note should be made of the quality of modelling for terracotta. It is more direct and retains much more of the nature of the fingers and tools used than forms modelled to be cast into another material. For instance, a tiny roll of clay may be applied directly to another, retaining its very rolled and pressed form; this is easily fired and made permanent on a terracotta sculpture. It would most likely be knocked off or damaged during any casting process, losing its particular character. So although there is a distinct difference between the form modelled with clay and, say, that which is carved, there is too the difference between that form which is modelled and cast and that which is modelled and fired. Apart from being fired clay, the use of that fired clay is entirely a matter for the sculptor. Combinations of any of the methods

John Mason working on a clay relief to be fired. This demonstrates an exciting use of the clay

described are as good as any single one, and vice versa. Misguided purists have again influenced thoughts regarding terracotta, and the result has been the many poor sculptures which, although made from fired clay, have been singularly dull examples of what an exciting and lively material can be.

Before beginning to model a work with clay to be fired, the clay must be prepared. Take the clay to be used and knead it until it is free from air, well consolidated, and even in texture throughout. This is called *wedging* and is a most important preparation which should not be skimped.

Once the clay image has been made and hollowed, not forgetting the hole to allow for expansion of air, it must be left in a dry atmosphere, and allowed to dry out slowly. This is best done on an open slatted shelf, or by standing the sculpture on pieces of wood 25 mm (1 in.) square, to allow the air to circulate around it. The drying may be controlled by covering the sculpture with newspaper or fine dry cloth, so that the outside surface dries at a similar rate to the inside. This also stops fine forms from shrinking and breaking away from the main bulk of the sculpture. If a sculpture has to be dried on a flat board it is best to cut it free—if it is not already free—and place fine silver-sand underneath it to stop it sticking to the board, causing it to crack open when the clay dries and contracts. Shrinkage of clay is an important point to remember when making a terracotta, and tests should be made to find out the exact shrinkage of the clay you intend to use. Generally, terracotta clay shrinks about 1 in. to every foot during firing. If a work is being made as a commission or to fit into a specific site, shrinkage must be taken into account. When the clay form has thoroughly dried it is ready to be placed in the kiln to be fired.

Two of John Mason's fired clay sculptures in which the quality of the material is used to great effect
Ford Foundation Purchase: Collection of Chicago Art Institute

Casting: moulding techniques

The principle of moulding is similar in all kinds of moulds, that is the making of a negative (female) mould from which the original can be removed, and into which the casting media may be introduced to make the positive cast (male). The making of moulds from which casts may be taken, a negative form out of which a positive is taken, is older than the Bronze Age. Man, the hunter, carried with him a mould of an arrow-head from which he made new castings whenever he ran out or when the old ones became too worn to use. Moulding forms, and the economy of mass producing shapes by moulding was a common practise, used by all clay cultures, who quickly reconciled the tedium of repetitious modelling, with the efficiency of making a negative form, hard and porous enough to enable soft clay to be pressed into it to make a positive, that would be the final image.

The sculptor should aim to be as proficient as possible at making the many various kinds of moulds. Types of moulding and casting are as follows:

Waste mould This mould, usually of plaster of paris, is taken from a soft clay form. The clay is removed from the mould then replaced by whatever the final cast is to be made from. When this has been done and the filling has hardened, the mould is chipped off carefully, becoming waste. Hence the name.

Piece mould This can be made from any hard setting moulding media, but most commonly of plaster of paris. It may be taken from a hard or soft material. The principle is that every undercut form must have a separate piece of mould. The pieces when complete fit into a jacket which holds them in the correct position for filling. More than one cast may be taken from his kind of mould, according to the strength and durability of the moulding media, and the casting media. Piece moulds are generally taken from completed works of a hard material.

Gelatine mould This is a mould made from gelatine, a flexible material held in shape by a plaster jacket. Gelatine moulding superseded piece moulding in art bronze casting, because of its flexibility, and its ability to reproduce faithfully the finest detail and the deepest undercut. It is chiefly used to make wax reproductions from the original or master cast, for casting into bronze via the lost-wax process. It is used also to make plaster reproductions.

Vina mould This is a polyvinyl chloride which when cool is flexible and very durable. It is used in much the same way as gelatine, which it has superseded in many studios, because of its strength and resistance to a much wider range of casting media. Plaster of paris, cement, wax, resins of various kinds, may be cast from vina moulds. Its storing value is a great advantage, as it does not deteriorate as does gelatine.

Plaster piece mould showing clearly the pieces and the keys registering one cap to another

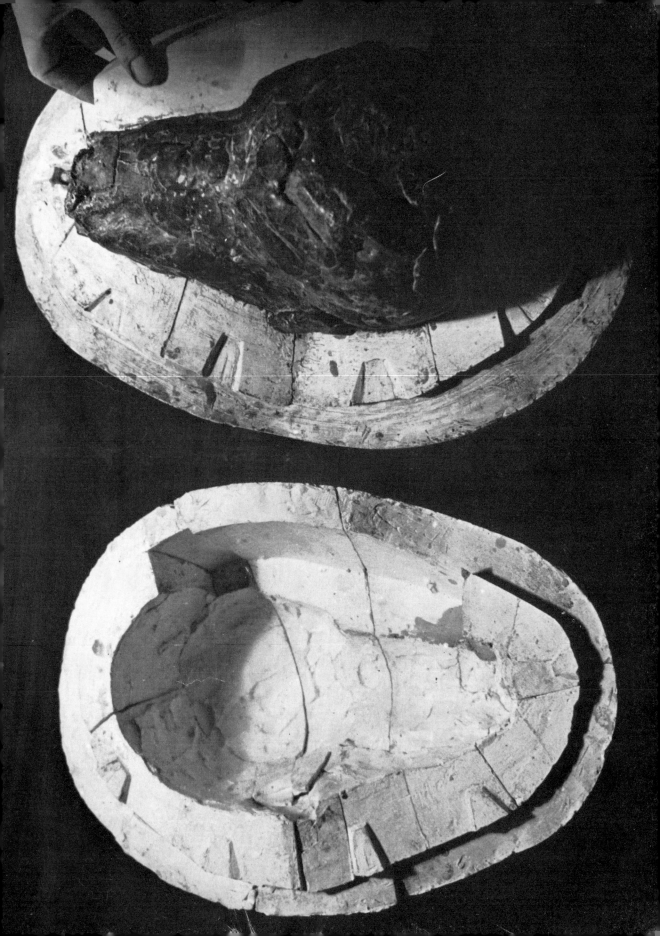

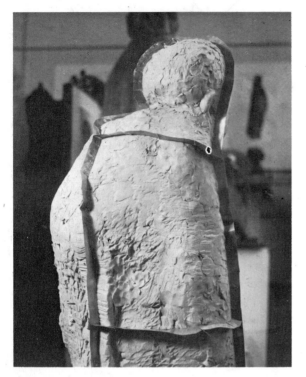

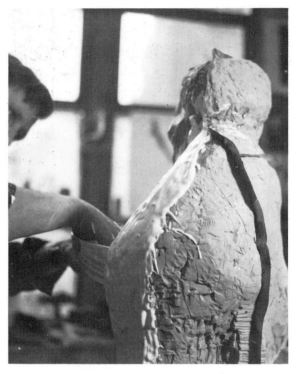

1 *Brass shims placed to make the division of the caps and the main mould*

2 *Applying the first coat of plaster of paris*

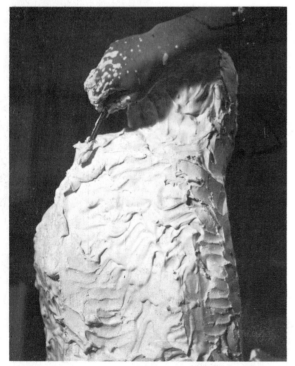

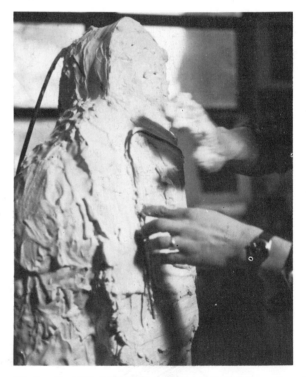

3 *Revealing the brass shim after every application*

4 *Placing the mild steel reinforcing*

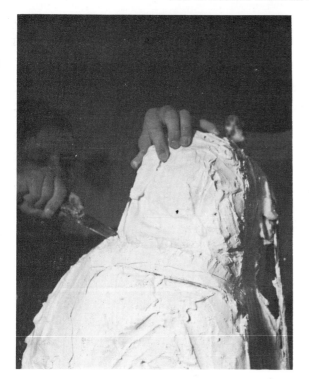

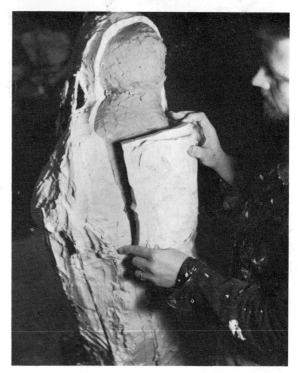

5 *Inserting a knife to lever the cap from the main mould.*
Suction broken between the clay and plaster with water

6 *Removing the caps*

7 *Examining the caps for flaws and removing the burr made*
by the shim

8 *Removing the clay*

Photographs: Lynton Money

Vinagel This is a useful polyvinyl plastic which may be used to make permanent flexible moulds, and its application varies considerably. It is basically a modelling compound, and requires a low even heat to cure.

Cold rubber compounds Cold curing rubber compounds enable moulds to be made from wax modelling or any other delicate material which may be affected adversely by heat or excessive handling. They have a certain tensile strength when used with an additive, but may be reinforced by a plaster jacket.

Waste moulds are made from the clay form by composing a clay or shim (*brass fencing*) wall around the model to divide it into the number of parts necessary to remove the clay and armature, and to introduce the casting material. The number of pieces may vary from a simple two-piece mould to an infinitely complex mould with many pieces. The principle, however, is the same no matter how many pieces are made. The mould is divided in such a way as to create a main section, containing the bulk of the sculpture, and pieces which fit into this main mould are called *caps*. The caps are designed to make it possible to remove the clay or armature, clean and treat the surface of the mould with a parting agent, and fill the mould with the casting material and the necessary reinforcing material. If the mould is made to enable these procedures to be carried out with maximum ease, the entire process can be worked smoothly.

The material most commonly used for dividing the plaster mould is brass fencing (*shim*) 0·127 mm (5000th in.) gauge. This is best handled by cutting it into strips approximately 5–7·6 cm (2–3 in.) long, and 6 mm ($\frac{1}{4}$ in.) wider than the thickness of the mould. This thickness varies according to the size of the job from about 13–25 mm ($\frac{1}{2}$–1 in.). One would estimate a maximum thickness of 25 mm (1 in.) for a life-size figure. Sculptures larger must of course be thicker, but properly reinforced no mould need be thicker than 2·6 cm ($1\frac{1}{2}$ in.)

To make a mould with brass fencing

Draw the dividing lines carefully in the clay with a sharp knife blade. Then place the shim along this line to form the seam, overlapping each piece slightly. The object is to make a brass wall continuous along the drawn line and at no point thicker than the gauge of the metal, apart from the slight overlaps. The shims must be placed evenly along the line with an even top edge. Any sharp corner which sticks out should be trimmed, as such corners, if left, are liable to cut your hands when building up the plaster to an even thickness.

The thickness of the seams (the flash) in the finished work depends largely on the care with which the shims are placed. The thinner the seams the more accurate the cast form will be.

Plaster master cast, and the plaster jacket for gelatine mould made from the master cast

A

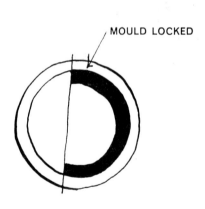

MOULD LOCKED

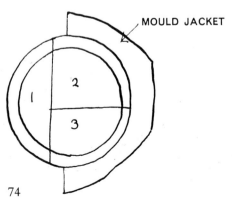

MOULD JACKET

The clay model, with the brass fencing, has now to be covered with plaster of paris. The first coat of this is coloured by adding a powder colour to the water. This coloured layer is a warning layer only; it is to aid chipping out, giving warning to the sculptor that the cast surface is near and that care is needed. The mould is then built up to the required thickness, uncoloured. Mild steel reinforcement should be placed on top of the coloured layer, so as to strengthen integrally the plaster thickness of the mould. The mild steel should be placed so as to give tensile strength to the plaster which naturally is brittle and liable to break. Particular attention should be paid to the seam edges; these need to be very strong to allow for prising the seams open. The metal shim should be exposed after each application of plaster by scraping over the seam. Upon completion the metal shim should be exposed, with an even flat area of plaster to each side of it. When the mould is complete, being of fairly even thickness and suitably strengthened and the shim exposed, it should stand for at least an hour to harden. After hardening the mould is ready to be opened, ie caps removed from the main mould to allow removal of the clay and armature.

Clay wall seams Making the seams with a clay wall is done in the following way. Flatten some clay and make strips of approx 13 mm (½ in.) thickness. Place the strips of clay to make a continuous wall along the drawn line on the clay original. Support this wall from one side with small buttresses of clay. The side opposite the supports must be as smooth and as even as possible, touching the original all along its lower edge. Against this smooth side the plaster mould is made. Place the warning coloured layer, then build the mould thickness, with the necessary mild steel reinforcement to give a strong mould. One can make only one side of a cap or mould at a time because the clay wall has to be removed to make a fine seam. When the first side of the mould has been made, the clay wall is removed; the resulting side of plaster seam has to be coated with a parting agent and keys made into it (small indentations with which to locate its neighbouring cap). If the mould is a simple two-piece one, you can go ahead and make the second cap to complete the mould. If there is more than one cap the edge of the second cap where it meets the third has to be made by placing a clay wall for this. Then the second cap can be completed; warning coat, plaster thickness and mild steel reinforcement. This process is continued until the whole sculpture is moulded. The completed mould is then left to harden for at least an hour.

A mould is opened by pouring water on to it, then by inserting a plaster knife into the seam, gently levering the cap off. The water seeping in through the seam breaks the suction between the plaster and the clay (caused by the plaster hardening), and makes it possible to remove the cap.

Caps once removed should not be left lying flat, but stood on edge against a support to avoid warping.

Once the caps are off, both the clay and the armature should be carefully removed and the surface of the mould cleaned and checked for air bubbles.

After cleaning, any air bubbles or cracks or breaks in the mould should be repaired, and the caps tried to make sure they fit.

The surface of the mould must then be prepared with a release agent. Soft soap is the best parting agent for plaster from plaster. This is brushed on to the mould to make a lather and left on for about 10–15 minutes. The oil from the soap seals the pores of the plaster, thus preventing a bond with fresh plaster. Surplus soap should be removed with a brush and the mould surface painted with the merest trace of oil, enough to make only a spot in the palm of the hand. Too much oil causes pin-holes on the surface of the cast.

Piece moulding is the name of the method used to make mould pieces, from a hard original, and usually to produce more than one production. Although it is possible to make a piece mould from clay it is not as precise as that taken from a hard surface, which allows each piece to be tested for draw as it is made. Piece moulding is used in bronze foundries for making wax positives, when the original is too big for rubber moulding, or will not withstand the heat of rubber moulding. The process is basically simple, similar to clay wall moulding, in that one piece is made at a time. Each piece must be tested to make sure it can be removed easily from the original, and consequently from the cast, and that it does not lock on to the undercut. Each undercut requires a separate piece of mould. Then the next piece is made in the same way, according to that piece, and tested to make sure it will come away easily from the original and the first piece. This procedure is repeated until a negative mould is made of the entire sculpture, plus a case or template, which will hold the pieces together to be filled.

The hard original must be painted with a release agent such as oil. A useful mix, often used by plaster-mould makers, is meat dripping melted, to which a little oil is added. This makes a parting agent which is easily applied, and which does not sink into the cast surface. It is usually available in good quantity.

When the caps are removed during testing, the surface of the original and the cap must be dusted free of any particle of plaster or clay; the smallest particle will cause a bad joint. The procedure or technique for making a simple piece mould is as follows:

Place and prop the original on a flat board, larger in area than the sculpture, first marking on the sculpture the seam line which will eventually divide the mould and case. Paint with release agent. Now

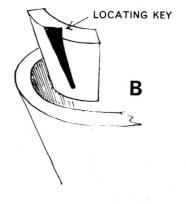

Diagrams illustrating the principles of piece moulding:
A Design the caps to eliminate any possibility of locking the mould to original. It is best always to make two caps to be certain of a mould which will draw off the original. One piece may lock if it just goes further than the half round. B Illustrates the shape of the locating key which should be cut into each piece. C Shows the method of making the pieces around a form. Note that the jacket can be used to pick up the surface of the original which contains no undercut

build up a bed of hardish clay around the sculpture about 2·5–7·6 cm (1–3 in.) thick according to the size of the sculpture, to within 6 mm (¼ in.) below the drawn line. Next build a ribbon of plaster of paris on top of the clay up to just below the drawn line. Leave a space of about 6–13 mm (¼–½ in.) all round between the sculpture and the bed of clay and plaster. Scrape the plaster ribbon when it is hard to as smooth a surface as possible all the way round. Then fill the space between the ribbon and the sculpture with clay, and smooth this to make as clean a joint as possible on the sculpture. The fineness of the seam around the figure will depend on this. Next paint the ribbon with release agent and make sure that the original is clean and oiled. The first piece (cap) can now be designed and made.

Mark the cap on the original and build up to this mark with plaster. A clay wall may help to make the piece, serving to keep the plaster from running all over the cast, but this is up to the sculptor. When the plaster has hardened, trim the cap to the shape required and remove it to make sure it will pull away without damage to the cast. Trim the cap further, making sure it tapers from the seam edge. This will allow the case to be drawn off the pieces. Replace the cap, oil it, make sure nothing gets in between it and the original, and make the next cap fit against it. When this has hardened trim it to shape, remove it, trim it further for taper and replace it. Repeat this until the whole of the original is covered, testing each piece as it is made, being sure to oil each piece and clean it, and check for taper (draw). When this is all done put keys into each piece (a simple V groove will do), and paint it substantially with the parting agent.

Now build up on top of the plaster ribbon a clay thickness of about 2·5 cm (1 in.) outside the completed caps. Cover all the pieces with plaster of paris to make the case, reinforcing it with iron if necessary. The thickness needs to be 2·5–7·6 cm (1–3 in.) according to the size of the sculpture. Allow the case to harden. When this has hardened remove the clay from the top of the plaster ribbon; this will give room for the fingers to get under the rim of the case. Lift this off to make sure it will draw, replace it, being again careful to avoid particles getting between it and the caps.

Turn the whole thing over—case, caps and sculpture—and make the caps for the back in the same way.

Try to design the mould so that most of the undercuts are accommodated in the front case and pieces as in a main mould, leaving only simple one- or two-piece caps to make at the back.

The caps should be numbered, and their corresponding place in the case numbered, to make it easier to assemble the mould, also to determine the order in which they are removed from the casting. Highest numbers are usually removed from the casting first.

It is impossible to give illustrations and details for making particular piece moulds, but a general principle is given on page 68, which may be applied to moulding an undercut at any size.

Plaster bandage moulding from life

Plaster bandage mould from life

It has become a relatively common practice to make moulds from a living person, often in lieu of modelling skill, in order to duplicate the human figure. I know of no example of sculpture made using this method that can be regarded as a fine work of sculpture, but it is a practice that is useful in respect of study or to achieve the kind of image known as *photo realism*. The most facile material for making this kind of mould is proprietary plaster bandage, the same as that used in hospitals to make plaster cases around injured limbs. This is a bandage impregnated with plaster of paris, so that when dipped in water the plaster is activated and sets quickly (approximately 2 to 3 minutes). To make a cast from life:

First catch your model. Mark the planned divisions of the mould on the subject using a water soluble marker, when this is dry cover the skin with petroleum jelly (*Vaseline*). Hair should be shaved, or tied back or well lubricated, according to where it is situated. The first section of mould can then be made.

Cut the bandage into manageable strips, about 30 cm (12 in.) long, then dip them one at a time in warm water, and apply the strips to the surface. Fold the bandage back at the drawn line, and make this as neat as possible. Build up a thickness of about 3 mm ($\frac{3}{16}$ in.) and reinforce the build up with ribs of plaster bandage where it requires strength. This cap can then be left to harden.

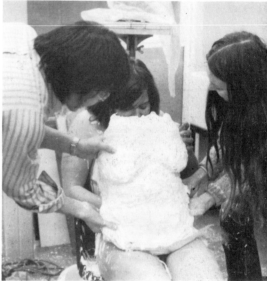

The folded seam edge is next treated with a release agent, clay wash or petroleum jelly, and the next section of mould made with careful attention being given to the meeting of the caps to form a good seam. The build up is made in the same way as for the first section, and all subsequent pieces of mould are made in this way. Large areas will require strengthening to prevent warping, but it should be remembered that this is not a comfortable situation for the model and so the mould should be planned carefully before starting. Once the mould is complete, the surface needs only to be treated according to the filling it is to receive and the cast made.

Warning When making a cast from a living head, seal the ears with lubricated cotton wool, and do not cover the nostrils. Use straws or small plastic tubes as vents to allow the subject to breath, and remember that as the plaster expands on setting the discomfort of the model is increased, and the form can also be distorted.

Flexible moulds using gelatine or vina mould (polyvinyl rubber)

The principle and method is the same for both materials, but as polyvinyl rubber has superseded gelatine in most applications, I will describe the method most practicable using that material, and later give the information relevant to gelatine.

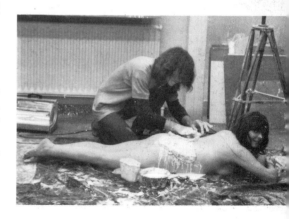

The original may be in any material which will stand the heat of the molten rubber, between 120°C and 170°C. With clay it is advisable to allow this to become leather hard, to assist the making of the case. Porous materials must be sealed with a sealer manufactured for this

purpose, or with shellac and very little oil. If sealing is not possible, soak the porous original in warm water before pouring the rubber; this will ensure against poor results due to porosity of the original.

The following process is applicable to a simple form. More complex forms or figures are an extension and adaptation of this. Place and prop the sculpture upon a flat surface, with about 15 cm (6 in.) space all round. Then build up a rough clay bed 5–7.6 cm (2–3 in.) wide, to a predetermined height line around the sculpture, leaving a small space between the bed and the original. The bed determines only the parting line between the sections of the case. Prepare the surface of the original by painting it with an oil separator or by covering it with dry newspaper. Surfaces of metal, cement or plaster should be oiled only, clay or *plasticine* should be covered with damp paper. This separator is necessary to avoid clay or dirt sticking to the original during the manufacture of the case, and so blurring the cast. Clay is placed over the sculpture in an even layer, which will eventually determine the thickness of the flexible material. This may be built up in rolls of even thickness or rolled out as a pancake of even thickness and placed on the original. Undercut forms should be well covered, and the shape of the thickness of clay built to taper from the clay bed, to draw from the case. Smooth this clay covering. A rim or lip must be made all round this thickness to hold the rubber open in the case. A press-stud device is useful to keep the rubber from falling out of the case when it is held up, as in diagram C. Cones of clay should be placed at all high points on this clay thickness to make sure the rubber runs properly, allowing air to escape. The cones must taper up and be as high as the eventual thickness of the case. Cover the clay layer, cones, rim and studs with a plaster of paris case of at least 25 mm (1 in.) thickness. Reinforce this if necessary with mild steel. Shape the case as in diagram E, with a rim to allow clamps to be placed round the case to hold it together later. When this side of the case has been completed as shown on page 79, turn the whole thing over and remove the clay bed. Trim off the seams of the case, make location keys in this seam edge, apply a parting agent, oil or clay wash. Repeat the process on the second side, separator, clay thickness, rim, studs, cones, and make

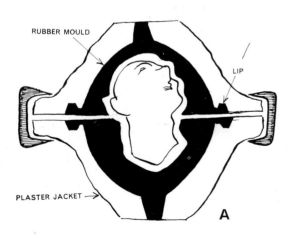

RUBBER MOULD

LIP

PLASTER JACKET →

A

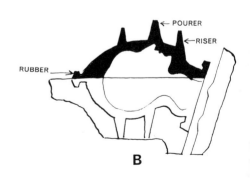

← POURER

← RISER

RUBBER

B

the plaster case. Make an end plate after the case pieces; this plate locates the figure and the case sections, and is necessary for this when pouring the rubber only. The plate does not need a clay thickness, and is left off when the rubber mould is being used to make a casting.

The clay thickness has now to be removed and replaced with the flexible mould.

Take off one section of the mould case, remove the clay, clean the case, trim the inside edges to make sure it will draw; trim the cone holes, enlarging the highest to be a pouring hole. Remove the clay thickness from the original and clean the surface of the sculpture. Next make a clean fine seam at the dividing line by filling the space between the case and sculpture with clay, right up to the sculpture as precisely as possible. Make locating keys in the clay seam. The locating key can be made by cutting with a wire loop tool, a channel 3–6 mm ($\frac{1}{8}$–$\frac{1}{4}$ in.) wide all round the sculpture, or by making conical impressions at key points.

Replace carefully the section of case and clamp this tightly into position. The best clamp for this purpose is a *joiner's dog clamp*, which by the very nature of its shape as it is tapped into position, closes the sections and tightens them together. Next make a pouring cup not less than 15 cm (6 in.) in length and fix this over the pouring hole in the case. Make also clay caps which will be used as plugs on the re-

C

Diagrams of some of the important factors and stages in the manufacture of flexible moulds from polyvinyl rubber or gelatine: A Section through both jacket and mould showing the taper to allow the jacket to draw off the mould easily, the lip of rubber which helps to keep the mould properly open and located on the jacket edges, and the best method of clamping. B Illustrates the conical rising and pouring funnels. The pourer is always situated at the highest point. C A press stud of rubber which helps to secure a very flexible mould. This can be achieved also by tapping small panel pins through the mould into the plaster jacket. D Illustrates the locating or registration keys, which enable the mould halves to fit properly one to the other

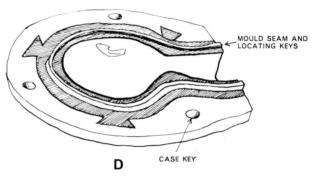

MOULD SEAM AND LOCATING KEYS

D

CASE KEY

CLAY POURING CUP

RISERS

WOOD BLOCK

E

maining rising holes of the case. Some sculptors put clay funnels over rising holes, too, to ensure escape of all trapped air.

The vina mould should be prepared by melting in an air-cushioned aluminium pot. This may be bought from manufacturers of poly-vinyl rubber or can be made by the sculptor. The melting point of the material is higher than that of water, so the pot which should be of aluminium must be cushioned to withstand such high temperatures. An air bath is the best melting arrangement—the same principle as a glue pot or porringer without filling the outer pan—as boiling water is not hot enough to melt the compound. Such a melting pot can be easily made from two tins, one larger than the other. A hole cut into the larger tin to house the smaller makes a pot suitable for amounts up to 4·53 kg (10 lb). The materials must be cut into small pieces and stirred all the time during melting to stop the material from burning. Larger amounts than 4·53 kg (10 lb) require an electrically heated, thermostatically controlled melting pot.

When the rubber is molten and free from lumps, pour it into the sections of the mould case prepared, via the pouring cup. Pour it evenly in a steady flow and not too fast. When it rises to overflow from the air vents, plug them with small discs of wet clay, called *clay lugs*. Fill the funnel to the top. Allow this to cool; the time will vary from $\frac{1}{2}$ hour to 3 hours according to the size and pouring temperature. When it is cooled repeat the whole process for each section. No separating agent is required between vina mould and vina mould. It will not adhere unless the temperature of a second pouring has been higher than the first.

It is possible to make simple vinyl rubber moulds by placing the original in a surround of clay or lino, sealing any openings through which material may escape, and filling the vessel thus made with molten rubber to cover the sculpture completely. When the rubber has hardened, remove the clay or other material and cut a seam into the rubber to release the original and to make access for the casting medium. Plaster cases may be placed on the outside of such a mould to hold the flexible rubber in shape. Small forms can be cast easily this way, also reliefs may be quickly moulded in this manner. It is not a very precise way of casting, but often an expedient one.

Points to watch for are (1) the draw of the plaster case; (2) porosity, seal the original in some way, such as brushing with very diluted shellac and methylated spirit solution; the unfilled pores will cause the vinyl to be aerated and cellular in appearance. A heating cabinet which can pre-heat a model between approximately 50°C and 60°C will help to stop porosity of the mould; (3) precise seams and location keys; (4) steady, even pouring of the material.

Blemishes on the mould surface may be repaired with a hot knife or metal tool, and dirty moulds can be cleaned with soapy water or detergent.

A

B

Illustrations of melting pots for polyvinyl rubber, hot melt compounds: A Saucepan air-cushioned in a larger vessel. This is sufficient to melt up to 4·53 kg (10 lb) of material. B Thermostatically controlled electric melting pot. Can be made to take any quantity of material

Gelatine The process is exactly the same as for vinyl rubber, with the exception of melting the actual material and treatment of the plaster case. Gelatine requires a very fine oil separating agent between layers of gelatine and between it and the original and the plaster case.

Preparing gelatine is done first by soaking the material in water for at least 24 hours to make it soft and pliable. It should be cut into small pieces and dried for storing. It is in small sheets when bought new. When it has been soaked, it must be placed in a clean bucket or pan, within another larger bucket or pan, cushioned with water and placed over a heater to become liquid. When it is liquid allow the gelatine to cool to blood heat (the temperature at which it can be easily handled), and then pour it steadily into the case. It is best to ask another person to plug the rising vents for you so as to maintain the steady pour. Gelatine, because of its low melting point, will quickly chill and crawl if a steady flow is not maintained.

Each section of the mould case must be painted with shellac and dusted with french chalk to prevent the gelatine from sticking.

The gelatine mould surface should be hardened by painting it with formalin or a strong solution of alum in water. If plaster of paris is to be used as a casting medium, the surface must be painted with fine cellulose to prevent the water dissolving the gelatine, and a fine film of oil applied as a separator.

Only plaster and wax can be taken from gelatine without difficulty. Materials which produce heat during setting are not suitable for casting from a gelatine mould. Good definitions, too, will last for not more than four castings before becoming blurred. Without a hardening agent painted on to the gelatine surface, the number will be approximately two only, without blurring.

Various cold curing rubber compounds

There are on the market today various cold curing rubbers, which have proved to be very useful for many different kinds of moulding, such as from a wax original, or from an original which may be damaged by either the rugged treatment of moulding with plaster or the heat of gelatine or vinyl rubber.

The principle for use in all the cold curing compounds is the same. No release agent is really required, although the finest possible film of oil can do nothing but good. Always test release agents on a small sample. The rubber compounds are liquid or pastes and are painted or poured on to the surface of the original. When dry the liquid becomes a

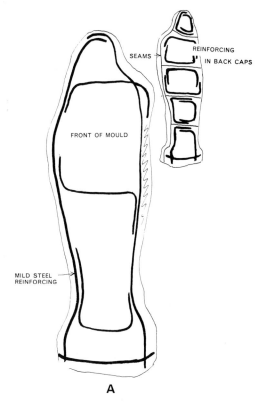

Mould reinforcement: A Illustrates the method of placing irons (mild steel) to reinforce the mould. The irons are placed just inside the periphery of each cap and main mould, to afford the maximum strength at the edges of the mould where it is most vulnerable. B Wooden frame or cradle fixed to the front of the main mould with scrim and plaster of paris to facilitate handling, and to give added strength to the greater part of the mould. The mould can be easily raised and lowered or carried by means of this frame or cradle

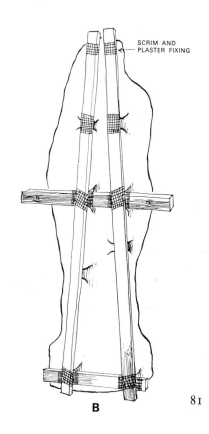

81

flexible film. This film may be added to by thickening the material with an additive. In the case of latex rubber, it may be thickened by adding fine sawdust until the required consistency is reached. Silicone rubbers are made in liquid and paste form, and the paste is used for thickening the mould on top of the painted skin.

The mould can be made by covering the object completely, building up the necessary thickness of mould, then cutting the mould to release the original and to introduce the casting medium. The mould may need no plaster case, but to achieve a greater degree of rigidity ordinary bandage soaked in the medium and included in the thickness will give added rigidity and strength. The same kind of mould can be made simply by dipping the sculpture into the rubber compound, until a sufficient layer has been built up to make a substantial mould. This can then be cut, and peeled off the original and then prepared for the casting medium.

Moulds may be constructed in sections by building clay walls around the area first to be dealt with, and then building each section to make a fine joint with its neighbour, making sure that the locating keys are made to give perfect register.

These rubber compounds are expensive and so suitable mainly for small work. They cannot be reconstituted. When the mould is stored it should be dusted with french chalk to avoid deterioration.

Wax moulds

Wax is used as a moulding medium, to reproduce fine forms or to make a mould from hard clay. The form can be dipped in wax, or the wax can be painted on to the form. The wax mould is opened simply by cutting it, to remove the clay. The wax mould can be reinforced with bandage dipped in wax, and further support can be achieved by fixing wood laths to the mould with wax and bandage. When the mould has been filled, it can be removed easily by warming it and peeling it off. Concrete, plaster of paris or polyester resin casts can be taken from wax moulds.

Additional tools required:

Plastic bowls and *buckets*, in which to mix plaster of paris.

Galvanised metal buckets, in which to prepare gelatine.

Various metal spatulas, for modelling plaster.

Various plaster cutting tools, knives, rifflers, rasps, graters, etc.

Jute scrim, with which to reinforce plaster of paris.

Brass fencing (shim).

Oil, grease and soft soap (parting agents).

Mild steel, to reinforce moulds, and mould jackets.

Melting pot, for preparing polyvinyl rubber.

Melting pot, for preparing wax.

Powder colour (yellow ochre), for colouring the warning coat of a waste mould.

Various brushes, for applying plaster and wax.

Brunswick black paint, or a mixture of resin and wax to paint metal reinforcement against corrosion in plaster.

Plus the various raw materials from which the moulds are made.

Casting : filling methods and materials

Moulds must be good and suitable for the material which is to be cast from them. Access to the entire surface of the mould must be available to the sculptor. The size and position of the caps must be designed to give maximum access to gain the greatest control of the casting medium. For instance, a mould for making a hollow cast must allow the caps to be fixed, and filled securely from the inside. The fixing may be simple in degree as with plaster of paris, or complex and tricky as with polyester resin, or it may be half-way between the two as with cements of various kinds. The moulds from which hollow casts are to be made differ from those which are simply turned upside down and filled with the liquid casting medium, with a gentle vibration to release any air which may be trapped.

Most large castings are hollow, because a hollow cast is stronger and more durable. It is also more easily transported, being considerably lighter in weight, and consequently the mould must be designed to assist the filling technique.

With all materials, cap and main moulds are best filled separately and allowed to harden. The most important factor in this technique is to make sure that the filled caps fit snugly to the main mould, and allow room for a good filling across the seams inside the case to form as strong a bond as possible. One cannot over-emphasise this point. A snug fit gives the thinnest seam, the thinnest seam indicates the greater casting skill, and the best reproduction of the true volume of the modelled form. Strong filling across the seams is an obvious advantage, creating consistent strength throughout the cast thickness. Casting materials divide into two main categories: the first, those which can be poured in liquid form to fill a mould, the second, those which are packed, painted, or applied to the mould surface to form hollow castings. I will describe the character and use of the materials, and in so doing, the kind of mould will be clearly indicated. The sculptor or student should then determine which kind of mould is most suited to his purpose in relation to the casting medium.

Plaster of paris

Into the prepared mould reinforcing irons can now be shaped for strengthening any weakness anticipated in the cast. In a standing figure, for instance, legs, arms and neck require strengthening, always being vulnerable to breaking, both during chipping out and there-after. The cast must first be able to withstand the shock of being chipped out, and be strong enough afterwards to stand up to normal wear and tear. The reinforcement, bent to shape to fit in the centre of the form, is now to be fixed into the mould. But first the mould has to be soaked so as not to take moisture from the fresh plaster. When

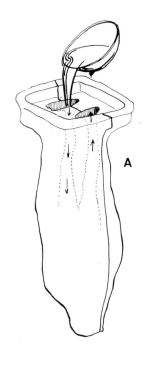

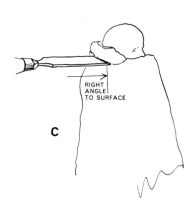

RIGHT ANGLE TO SURFACE

it is soaked, fix the irons with small blobs of plaster. They should be fixed in such a way as not to block the entry of the plaster to be poured in.

When the irons are fixed the caps, which also have been soaked, should be replaced and the seam sealed with scrim and plaster.

Now the mould is ready for filling. This is done by turning it upside down, so that it presents a large opening, into which freshly mixed plaster may be poured until the mould is filled. The pouring must be done gently, steadily and at one pace. As the plaster is being poured, the mould should be tapped or vibrated gently to release any air which may otherwise be trapped in the mould. Steady pouring in one place allows the air to escape. Avoid pouring the plaster too quickly, and never pour into two different openings at the same time.

When pouring the plaster into the mould it is advisable to have a helper standing by armed with lumps of clay, ready to plug any leak which may occur.

When the mould is full, trim off any excess and leave it to set. When the plaster has set turn the whole thing the right way up to harden.

These instructions are given as for a solid plaster cast which can be poured, but it is not wise to fill solid life-size figures or heads, or any large volume. Hollow casts can be made by applying to the prepared mould surface a layer of plaster. This can be done with a brush. A second layer can be applied with jute scrim to strengthen the cast, placing any reinforcing iron on top of the second layer and fixing them with scrim and plaster. A thickness of not more than 13 mm ($\frac{1}{2}$ in.) is all that is necessary. The caps are treated in the same way. The seams must be kept as clean as possible to ensure a close fit. Caps which do not allow access to the inside of the mould may be fixed to the main mould by 'squeezing', that is by placing fresh plaster to overlap the filling between the caps and main mould, then gently tapping the caps into place with a wooden mallet, squeezing out surplus plaster. Other caps which have an opening can be fixed securely to the main mould with plaster and scrim, and then the seam filled from the inside with plaster and scrim. The thickness of material need be no more than 13 mm ($\frac{1}{2}$ in.); it must be as even as possible, strengthened throughout with scrim, and reinforced with iron where necessary. At the reinforced points, thicknesses of 25 mm (1 in.) or more may occur, including the iron, but the filling need be no more than 13 mm ($\frac{1}{2}$ in.).

Chipping out Taking the waste mould from the cast is done carefully by chipping away, hence the name waste mould. The chipping is done using a wooden mallet and a blunt joiner's chisel. The wood of the mallet and chisel handle muffles the blow sufficiently so as not to damage the plaster cast. This chisel should be blunt because the object is to break the mould from the cast, not to cut it off. Held at right

Filling and chipping out: A Illustrates filling by introducing the liquid material pouring steadily down one opening, allowing air in the mould to escape up the other or others. The mould must be gently vibrated to ensure the release of any air bubbles. B Levelling the cast base

by drawing a straight edge across it, when the plaster is about to go off. This ensures that the cast is at least as level as the original. C Chipping off the waste mould. The chisel must be held at right angles to the surface, chipping into the mass of the mould and cast

angles to the surface of the cast, the blunt chisel will fracture the mould which will lift from the cast freely, because of the parting agent. Do not try to take too large a piece at a time, chip away carefully and methodically and do not prise the mould from the cast. Always chip into the mass of the mould and cast and not across it. This will avoid breaking extremities such as arms, legs, ears and noses. Start whenever possible by revealing a high point through the mould, and gradually peel back the waste. Final cleaning up and picking out small particles of mould is best done with a slender pointed tool such as a dental probe. The flash at the seam may be worked off or be left according to the taste of the sculptor. Work done on the cast should be kept to a minimum because any riffler used on the surface destroys the density of that cast surface, which it is impossible to replace. Tool marks, however, can be eliminated by burnishing carefully with a small wooden modelling tool. Allow the cast to dry out thoroughly before painting, or applying any other material.

Roman joints Joints are made to enable work to be easily transported, or to provide the necessary pieces for the foundry, to mould and cast and assemble.

The principle of jointing is fairly simple. Of course the actual simplicity or complexity of a particular joint depends entirely upon the form. Basically a roman joint is a female or negative shape, into which a positive or male form fits, locking into position, locating the two pieces into exactly the right place.

Ideally the joint is made during the filling of the mould, using the mould itself as a template. To do this, before beginning the mould, a line must be drawn into the clay which determines the joint. Then in the mould this line is proud and clearly marks the joint and facilitates making the female half of the joint. The male half can then be cast into the female, which has been properly shaped to draw and locate accurately. Texture and modelling are continuous on the surface across the joint, because this is cast from the mould.

Building work directly in plaster enables you to make a joint first, before modelling a definite form. Providing the joint is kept liberally coated with a release agent, it will remain perfectly operable.

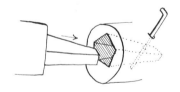

A completed form can be cut and jointed by first making a simple piece-mould or clay pressing of the area around the proposed joint. Remove the mould and saw through the form. Make the female joint and grease it, chip away sufficient plaster on the male half of the joint. Replace the two halves into the piece or clay mould. Then pour in plaster to cast the male half of the joint. Remove the mould when the casting has hardened and separate the joint.

Roman joints can be made in any material. The points to watch for are the draw or taper which enables one half to be taken from the other, registration of the joint, liberal application of release agent, oil or clay wash, whichever is suited to the particular media, cleanliness of the joint, and the precision and neatness of the edges to make as fine a line as possible. A butting surface should be as smooth and trim as possible, with registration points cut into it.

Diagrams of some roman joints

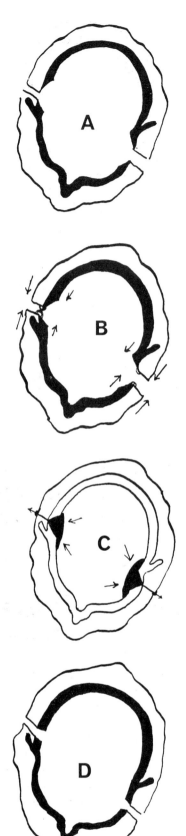

Cements

Cements are the basic binding agents for concrete which harden with the proper addition of clean water. When mixed with aggregates they form mortar or concrete, according to the size of the aggregate. *Mortar:* sand and cement. *Concrete:* sand, larger aggregate and cement. These terms, however, are more applicable to the building industry and not to sculpture. There are two basic types of cement, calcium aluminium silicate, which makes the portland cement types, and alumina, which is the raw material for aluminous cements. Cements have a setting speed, a hardening speed and a curing speed, and these are an important factor when selecting that most suitable to the work. Generally the portland type cements are cheaper than the aluminous cements and, if a portland cement is suitable for the production of the work in hand, then economically this may be an important deciding factor.

The following table gives the relevant setting, hardening, and curing times of cements. (There are proprietary additives for all types of cement, which can alter these times. Advice about these should be sought from your local dealer.)

	Setting	*Hardening*	*Curing*
Portland	10 hrs	3 days	21 days
Portland rapid hardening	10 hrs	24 hrs	7 days
Aluminous	3 hrs	7 hrs	24 hrs

Both groups of cements can be coloured by adding colouring compounds recommended by the manufacturers. Portland cement is a pale grey colour in its natural state, and aluminous cement is almost black in colour in its natural state. Interesting colour and range of texture may be achieved by using interesting aggregates. The size of the aggregate may range from a powder as fine almost as the cement itself, up to 6 mm ($\frac{1}{4}$ in.) or more. The coarser the aggregate the greater the compressive strength of the mixture, hence the reason for large stone aggregates in building foundations for instance.

The cement being merely the binder when mixed with an aggregate, is therefore mixed in ratio to the surface area of the aggregate. The smaller the aggregate size the greater the surface area, that is the surfaces to be covered and stuck together by the cement. The greater the size of the aggregate the smaller the surface area. The shape of the aggregate should be as granular as possible, made up of facets which may be fixed together more easily. Proportions are important to the strength of the final material, and to the workability of the mixture. The coarser aggregates, because of their small surface area, may be mixed in the ratios of 1 part cement to 6 parts larger aggregate (concrete). A normal mix with sharp sand is 1 to 3 (mortar). The coarse aggregates naturally are more rugged in appearance and should be selected for use according to this character. Sand as an aggregate allows a fairly fine result and may be used in conjunction with finer grade materials or preceded by a layer of neat cement, if very fine detail is required. The very fine aggregates, more generally used now

for work up to life size, allow for the finest reproduction of detail; a fingerprint can easily be reproduced. The fine aggregates, such as brick dust or fine pumice, are mixed preferably in equal portions because of the greater surface area of the aggregate. It is unwise to increase the proportion of aggregate when it is almost as fine as the cement itself. These fine cements do offer faithful reproductions but, because of the size of the aggregate, it is wise to include fibreglass in the thickness, to give tensile strength. The addition of fibreglass enables one to make a strong cement cast, light in weight and very durable.

I describe two methods of casting with concrete. These methods, however, have to be adapted by the sculptor or student according to the job in hand. The student is well advised to make several tests before actually casting a sculpture. Make simple tests by casting simple forms: a sphere, a cylinder and a cube for instance, in order to practise the various ways of using the material, avoiding the chance of spoiling a particular sculpture through inexperience.

Make moulds not less than 25·4 cm (10 in.) in the longest dimension of some basic forms. I suggest a closed sphere, a sphere with an open end, a cylinder closed and a cylinder open, a cube closed and a cube with an open end. The moulds of the closed forms should have caps which vary in size and shape upon that form, so that the possibilities may be covered of squeezing caps on and filling caps from an open end, and combinations of the two.

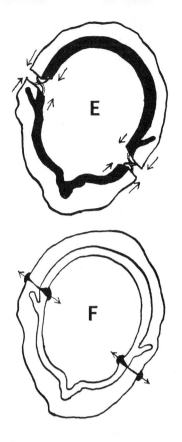

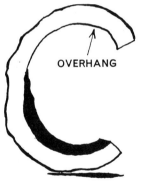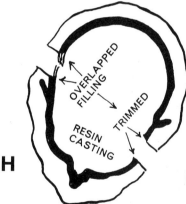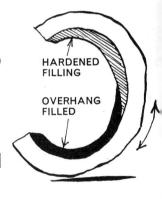

Diagrams of filling and treatment of seam edges: A The angle at seam edges which can be packed into after the caps have been fitted. B Neat cement or cement and fine aggregate, placed at the seam edges prior to fitting the caps. C Packing placed after the caps have been fitted. Note the overlap of the packing at the seams on the inside of the casting; this ensures a strong seam. D The angle at seam edges to be squeezed. E Neat cement or cement and fine aggregate placed on the seam edges ready for squeezing. F Indicates the action of the cement during the squeeze. The filling should squeeze out all round the mould to show a satisfactory filling. This mixture must not be too liquid and run down into the casting leaving nothing at the join. G Seam edges avoided during packing to keep them clean and ensure a good fit. Seams will be filled later by pouring and rolling the material around the seam. H and I Illustrate the treatment of overhanging surfaces. I Shows the filling and trimming at seam edges, for resin and fibreglass. The trimming at the seam edges is done with a sharp knife or with fine hack saws

Make the closed form mould. Open it and remove the clay, but do not wash the very fine clay film from the mould surface. This film is the most efficient separator, and will not blur the modelling because it is very fine. Remove large pieces of clay from the surface by dabbing with a lump of fresh soft clay. This will pick up these larger pieces. Release agents for piece moulds and moulds which have to be washed and consequently require an applied release agent are noted in the list of release agents on page 100.

Soak the mould well. A mould is soaked sufficiently when the moisture stays on the surface of the mould when removed from the water, and does not soak in. Prepare the concrete mix. Try to gain experience in the use of a number of different mixes so that the texture and allied techniques become familiar.

Mix a concrete with a large aggregate up to 3 mm ($\frac{1}{8}$ in.) mesh. The aggregate must be clean and free from foreign matter which may stop the cement setting. The material must be mixed until it is an even colour, with no pockets of unmixed aggregate. The object of the mixing is to cover the surface of the aggregate with cement binder. Next add water gradually until a moist mix is achieved which when patted by hand shines wet on the surface. The concrete must be evenly moist and well mixed to an even colour. This mixing is best done in a mixing box, illustrated on the facing page.

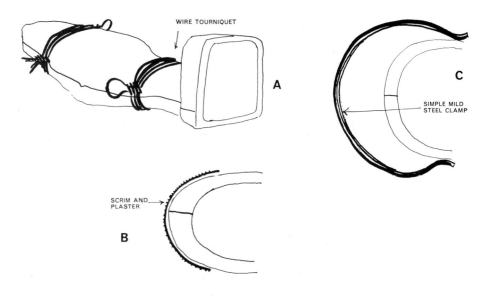

Fixing caps together. Illustrated are some simple methods of securing caps to facilitate filling efficiently: A Wire tourniquet, very good for squeezing small castings. Pressure increases as the tourniquet is tightened. B Simple fixing with scrim and plaster of paris. C Simple mild steel clamp to hold cap in position for filling. D Joiner's dog clamp. This is useful too for squeezing caps. Pressure increases as the clamp is tapped on to the mould

Pack a layer of this mix into the prepared mould. Tamp it firmly on to the surface so as to form a well-consolidated concrete. It will be found that vertical surfaces are difficult to cover, and overhanging surfaces impossible. To deal with these you must tip and turn the mould to gain access to the difficult surface. Wait for the initial setting to take place. This is important, as there is a danger of the surfaces already filled dropping away when the mould is turned. Fill up to the seams as shown on page 87, and allow the filling in the main mould and cap to set and harden. Portland cement filling should be covered with damp cloths which are allowed to dry out slowly as the concrete sets and hardens. Aluminous cements must not be allowed to dehydrate, and so need to be covered with wet cloths and plaster, to keep them wet for at least 24 hours.

When the filling has set and hardened, try the cap to the main mould to make sure it fits well. Adjust to fit by trimming off any superfluous lumps with a sharp stone carving chisel. Soak the caps and main mould. Place around the seams, overlapping both filling and mould, a substantial thickness of neat cement and water, then squeeze the cap to the main mould, gently tapping the cap to get as close a fit as possible. Excess cement will squeeze out, and it should squeeze out evenly all round the cap. Fix the caps with joiner's dogs or scrim and plaster. Fine slender forms may be squeezed by placing a wire tourniquet around the main mould and cap, then gradually and evenly tighten the tourniquet, to squeeze the cap home. When the cap is open, either because the form is open-ended or because another cap is to fit up to it, be certain to fill the seam well on the inside. If possible force a liberal filling of mixed cement and aggregate, using a spatula if possible. When the caps are secure and the seams filled as well as possible, leave the cast and mould to mature, covering with just damp cloths for a portland filling, and wet cloths and plaster for an aluminous filling. When the filling has cured chip off the waste mould or remove the piece mould.

This kind of concrete mix can be taken from a vinyl rubber mould, which must be of the hard, high melting point quality, to allow for tamping.

The method described is for filling with a coarse concrete, with an aggregate up to 3 mm ($\frac{1}{8}$ in.), and the surface will have very little finesse. This kind of concrete casting is best exploited for its aggregate quality, which may be of coloured marble or granite or plastic granules, whatever may suit the job. The final form, and quality of the material, is arrived at by abrading the surface to expose the aggregate. This concrete is ideally suited to carving upon a predetermined cast form with traditional stone carving tools, thus widening the scope of fine carved forms, by exploiting the quality and texture possible with this concrete.

Concrete made with a large aggregate may be ideally suited to a specific site or form, which needs the compressive strength of the large aggregate, and yet reproduces fine modelling from the surface of the mould. This fine reproducing can be achieved by painting the surface with a stiffish mix of neat cement, prior to packing the con-

INSIDE LINED
WITH POLYESTER RESIN

2'

3' 6"

Diagram of a concrete mixing box made from wood, the inside surfaces painted with polyester resin to make it waterproof. The box is an ideal vessel for mixing concrete; both wet and dry mixes

crete into the mould. This neat cement will pick up the modelling and give a dense hard surface, supported by the strength of the large aggregate. Even stronger concrete casts may be made by using a fine cement to reproduce the detail in the second method of casting with concrete, reinforcing the fine cement with fibreglass, backing up this mixture with a large aggregate mix, to give both compressive and tensile strength.

The second method of filling applies to cements neat, or mixed with fine aggregates and reinforced with fibreglass.

The treatment of the mould is the same as in the first method. Leave the clay film or treat the mould with a listed release agent, then soak the mould. Dry mix the aggregate in the required proportion, to an even colour. Add water to the mix until a very thick cream is made. Paint this cream with a brush to the surface of the prepared mould, making the painted thickness as thick as possible, at least 3 mm ($\frac{1}{8}$ in.). Then on to this painted layer pat a layer of chopped strand mat fibreglass. The fibreglass mat should be divided, so that the layer is finer than the bought thickness. This original thickness is to be built up in laminated layers throughout the filling. Having patted the fibreglass on to the cement, stipple more cement on to the fibreglass with the brush well charged with cement. This stippling ensures that tiny forms on the surface, such as high points of modelling, have strands of fibreglass to strengthen the casting. After stippling, build

Fountain made of concrete by John McCarthy, built on site by the contractor to the maquette provided by the artist. The concrete was poured into a carefully prepared shuttering Photographs: John McCarthy

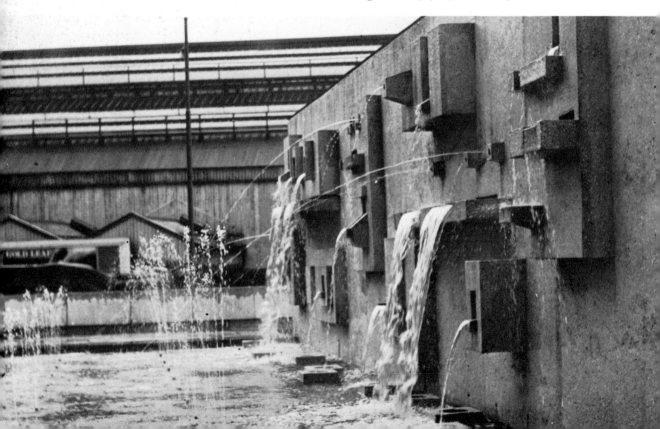

up another layer of cement and pat in another layer of glass, until the total thickness of fibreglass is equal at least to the original mat thickness. Build a final layer of cement to give a total thickness of between 6 and 13 mm ($\frac{1}{4}$ and $\frac{1}{2}$ in.) throughout. Trowel the final layer to as smooth a surface as possible, creating a double tension on the inside and outside surfaces of the thickness of cement.

Treat the seams in the same way as for a coarse concrete mix, squeezing caps into place, this time with the same fine cement mix (not neat unless neat cement is used for the casting). Pack finer mix into the seams where possible. The fine cement mixes can be mixed, with less water, to make a thicker consistency to pack into seams, and to build up a thickness. It is possible to mix a doughy consistency like clay, which eases filling seams and building up. When the seams are fitted and filled, cover the mould with damp or wet cloths according to the type of cement, and leave it to cure before chipping out or taking the mould off.

It will be found that vertical surfaces can be filled at the same time as those that offer no resistance, and even overhanging surfaces can be filled, with care. The fibreglass helps to retain the filling against the mould surfaces. These mixes allow a more controlled even thickness of material throughout the cast. Even thickness is an important factor, because all materials which undergo a chemical change either expand or contract, and naturally an even gauge makes any expansion or contraction equal. If it were not even, different rates of expansion or contraction would cause cracking or crazing. Contraction and expansion may be caused by changes of temperature, affecting uneven thickness, causing cracking or crazing.

Fountain by Keith Godwin for ATV House, Elstree.
Cast in ciment fondu. The plumbing cast into each piece.
Marble tesserae placed in the clay and retained in the
mould, then rubbed down in the final cast Photograph: Keith Godwin

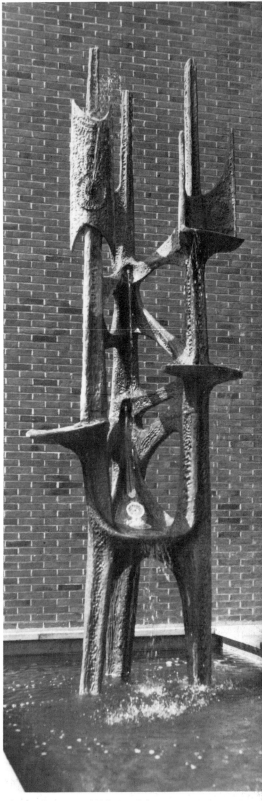

Photograph: Associated Television Ltd

91

Keep the thickness as even as possible throughout. In a standing figure or vertical form do not be tempted to make any part thicker, if it can be avoided. Legs should be cast hollow, suitably reinforced. Mild steel rod no greater in gauge than 5 mm ($\frac{3}{16}$ in.) is ideal for reinforcing a cast. Make gaiters of thin iron within the cast thickness, rather than one thick heavy gauge iron. The tube, remember, is a stronger structure than the solid rod.

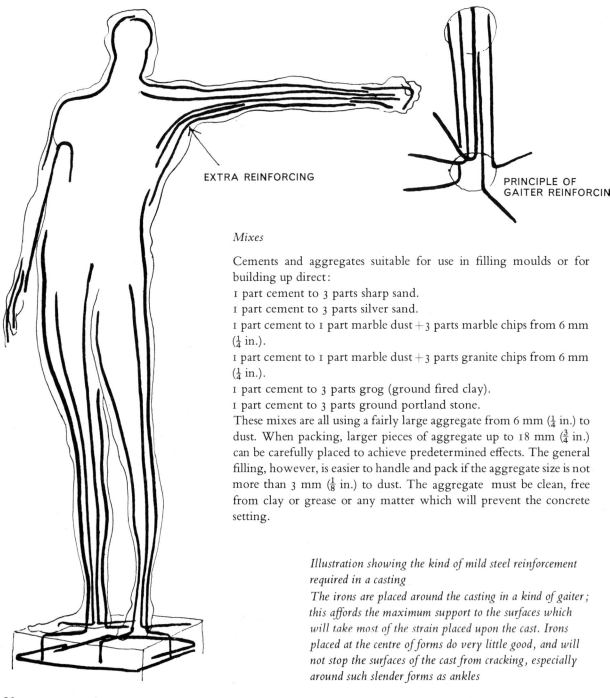

EXTRA REINFORCING

PRINCIPLE OF
GAITER REINFORCIN

Mixes

Cements and aggregates suitable for use in filling moulds or for building up direct:
1 part cement to 3 parts sharp sand.
1 part cement to 3 parts silver sand.
1 part cement to 1 part marble dust + 3 parts marble chips from 6 mm ($\frac{1}{4}$ in.).
1 part cement to 1 part marble dust + 3 parts granite chips from 6 mm ($\frac{1}{4}$ in.).
1 part cement to 3 parts grog (ground fired clay).
1 part cement to 3 parts ground portland stone.
These mixes are all using a fairly large aggregate from 6 mm ($\frac{1}{4}$ in.) to dust. When packing, larger pieces of aggregate up to 18 mm ($\frac{3}{4}$ in.) can be carefully placed to achieve predetermined effects. The general filling, however, is easier to handle and pack if the aggregate size is not more than 3 mm ($\frac{1}{8}$ in.) to dust. The aggregate must be clean, free from clay or grease or any matter which will prevent the concrete setting.

Illustration showing the kind of mild steel reinforcement required in a casting
The irons are placed around the casting in a kind of gaiter; this affords the maximum support to the surfaces which will take most of the strain placed upon the cast. Irons placed at the centre of forms do very little good, and will not stop the surfaces of the cast from cracking, especially around such slender forms as ankles

Mixes using finer aggregates are as follows:

2 parts cement to 2 parts water-ground flint + 1 part pulverised fuel ash.

1 part cement to 1 part pumice powder.

1 part cement to 1 part brick dust.

1 part cement to 1 part mixed brick dust and marble dust.

Notice that the mixtures using finer aggregates are mostly of equal portions.

Polyester resins

The mould which is to be filled with polyester resin must give clear access to all surfaces for the best results. The mould can be plaster, vinyl rubber or of cold curing rubber. Reliefs may be cast from moulds of any of these materials, and even from clay moulds, first allowing the clay to get leather hard.

The plaster mould should be as dry as possible and prepared with a release agent. The most effective treatment of the mould is described on page 100. Polyvinyl rubber moulds require no release agent at all, and for this reason it is one of the best mould materials. Cold curing rubber compounds require the application of a polyvinyl acetate release agent, whereas clay needs none.

The principles for casting with polyester resins are similar to those with other materials, allowing for the raw state of the medium, in this case a very sticky material, which must be painted on to the mould surface. I will give the simple explanation first and describe more fully each component later. It is important that the order and simplicity be understood before discussing chemical properties in detail.

Basically there are three component liquids: (1) the *resin* to which the chosen filler may be added; (2) the *promoter* or *accelerator*. The curing speed of the basic resin can be controlled (by adding accelerator); (3) the *catalyst*, which when added to the resin-accelerator, causes a chemical change and the resin hardens. The resins, accelerators and catalysts are sold under these names and resin suppliers will know what to sell you if you ask for a specific resin, with the necessary accelerator and catalyst.

It is important to remember the order of mixing:

(1) filler into resin; (2) accelerator into resin; (3) catalyst as and when required to harden the resin. Never mix accelerator and catalyst together, such a mixture may react violently and even explosively.

It is advisable to mix the resin and filler in sufficient quantity to make the whole casting; this is economically sound and saves time and energy which would be spent mixing consistent small quantities. The accelerator may be added to the mixer filler and resin to ensure that the basic setting time is consistent throughout. The addition of more accelerator to small mixes to help overcome a specific problem by speeding the hardening can be readily assessed from the hardening time of the whole mixed resin. Catalyst is added as required to cause the resin to harden. The proportions of the various components are important and should be obtained at the time of purchasing the resin from the manufacturer. A generalisation of these proportions will be found later.

The fine detail reproduction required from a casting medium is achieved by painting to the surface of the mould a layer of resin, the 'gel coat', whose job it is to make the faithful reproduction. Gel coat resin hardens against the mould surface but has a slightly tacky inner surface which aids adhesion of the next application of resin to build the laminate.

It is important that the 'gel coat' is applied with care and is even. The filler must be well mixed and as dense as possible in the 'gel coat'. Uneven thickness of this layer may cause patchy uneven colour on the surface of the final casting.

Because resin when hardened is fairly brittle, it requires a strengthening reinforcement. Laminates of resin and glass fibre are built up to the required thickness, and give very great tensile strength. The mat of glass fibre is stippled on to the 'gel coat' thickness, making sure the fibre is completely impregnated with resin. This is called 'laying up'. It is important that every fibre is bonded with resin to ensure a dense consistent thickness. The stippling helps drive the glass fibres into fine forms, making sure they are reinforced. Tools of various and curious shapes can be made to assist the reinforcing, by getting the fibre into difficult forms, and help an even 'lay-up'.

Iron reinforcement may be placed on top of the glass laminates. In fact reinforcement of any kind which gives the required rigidity may be fixed, such as nylon rope, metal of almost any kind, wood, in fact anything. It must be covered with resin and glass fibre, to make it strong and secure and protected from any corrosive attack.

Seam edges are as important as with any other material, and should be trimmed and cleaned to ensure close fit of the caps to the main mould. The caps can be fitted and sealed by squeezing if necessary, but should, where possible, be filled with a brush from the inside and reinforced with glass fibre to make the best and strongest fixing. You can leave the seam edges free when filling and making the lay-up. These can then be poured to fill when the caps are secured, if there is access enough for this.

When the resin has hardened and cured, the mould can be removed according to its type. Waste moulds chipped away, piece moulds carefully prised off, and flexible moulds peeled back from the casts. Repairs can be made easily to any blemish on the surface and, made with the same mixture, are indistinguishable.

An explanation of what polyester resins and auxiliaries are is necessary here in order to understand what in fact is happening to the material and why.

Polyester resin, unsaturated polyester resins, are thermosetting. They become hard and inflexible by the heat generated during the chemical change brought about by adding a catalyst. The chemistry of polyester resins is very complex indeed, and as it is very unlikely that anyone should want to manufacture their own, a brief outline of its

'William Blake' in fibreglass and reinforced polyester resin by John W Mills
Photograph: Graham McCarter

origin is all that may be required. For those who wish to know more, most resin manufacturers will give the necessary information.

The term 'polyester' is derived from *polymerised esters*. This is the reaction of dibasic acids and glycols forming polyesters, by polymerisation (the compound formed by simple chemical addition from a number of identical molecules with an identical number of units). The polyesters resulting from reacting dibasis acids with glycols are dissolved in reactive monomers (styrene). The cure of a resin is brought about by an activator or catalyst. The catalyst causes a further polymerisation, resulting in the gelation and cure of the resin to an inflexible and insoluble material.

Some of the raw materials most commonly used for the manufacture of polyester resin are as follows:

Dibasic acids	*Glycols*	*Monomers*
Maleic	Ethylene glycol	Styrene
Fumaric	Diethylene glycol	Methyl methacrylate
	Triethylene glycol	
	Glycerol	

The resin made from these raw materials requires the addition of a suitable catalyst for the quickest and most satisfactory hardening. The catalysts commonly used are organic peroxides, eg benzol peroxide. The catalyst causes the polyester to cross-link with the monomer and form a three-dimensional molecular structure, thus making an inflexible, insoluble solid.

The accelerator or promoter is another additive which may be mixed only with the resin. Its job is merely to promote curing which otherwise may take days, according to ambient temperatures. Cobalt naphthelate is the most widely used promoter.

This explanation is of necessity very basic and generalised, and is meant only to give some idea of what, in fact, is going on inside the mould and the medium, when a casting is being made. There are, of course, things that can go very wrong indeed, and any idea of what should be happening is useful to help avoid or overcome difficulties. For instance, a large contributory factor to efficient curing of resin is heat, and resins are made generally to harden and cure at temperatures from about 50°C to 150°C. If your working temperature is expected to be lower than 50°C, a resin designed to cure at low temperature must be used. This usually means that the organic peroxide catalyst required is less stable than benzol peroxide, eg methyl ethyl ketone peroxide, which will enable the resin to cure at 20°C. If a resin of the higher curing temperature range is used in a low temperature environment, the styrene monomer will evaporate, leaving an uncured

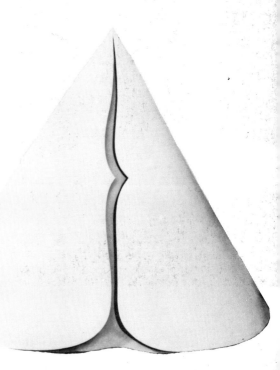

'Colorado' in epoxy resin by Frank Gallo
Courtesy Graham Gallery, New York

'Rosebud' in plastic by Phillip King
Rowan Gallery, London

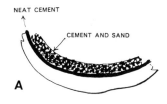

NEAT CEMENT

CEMENT AND SAND

A

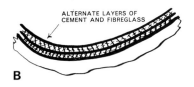

ALTERNATE LAYERS OF
CEMENT AND FIBREGLASS

B

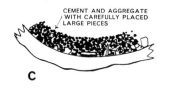

CEMENT AND AGGREGATE
WITH CAREFULLY PLACED
LARGE PIECES

C

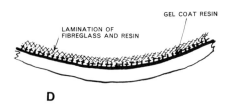

GEL COAT RESIN

LAMINATION OF
FIBREGLASS AND RESIN

D

sticky polyester jam. Be certain of the temperature environment **and** buy the necessary resin accordingly.

Exotherm, heat developed during polymerisation, is another hazard which often befalls the sculptor who is used to pouring liquids to fill a mould. The larger or thicker the casting the greater the exothermic temperature. For instance, if a general purpose resin is poured into a cubic container at about 25°C and allowed to gel and harden, the temperature may increase to about 160°C. During this heating great expansion and contraction takes place and large cracks will occur in the resulting solid. To avoid this, laminations of resin and fibreglass increase the surface area, so that exothermic temperature does not rise to a dangerous level.

The percentage of accelerator should not exceed 4 per cent, otherwise it may act, according to the resin, as a retarder, slowing the rate of polymerisation. Catalyst, too, should not exceed 3 per cent, because after that it does not increase the speed of cure, and is therefore a waste.

Fillers Polyester resins are of pale transparent colours, which are very beautiful, but they can be easily loaded with inert fillers to produce a specific density of colour or quality. Experiment will produce the result required and you should experiment as much as possible before undertaking an important casting. The use of a filler may assist a difficult lay-up by making the mixture thixotropic, making it less easily drained from a vertical surface. The limitation of the amount of fillers is the ease with which the mixture can be used. Fillers frequently used are:

Alumina	Calcined clays	Metal powders	Slate powder
Asbestos	China clays	Mica powder	Whitening

These fillers are introduced as dry powder, and they must be well and evenly mixed. They may affect the curing rate of the resin by diluting the resin and reducing the exotherm, thus retarding the setting, or by increasing exotherm, accelerating gelation and cure. Before making large quantities of mixed filler and resin, test the reaction.

Polyester resins may be coloured to any shade or colour by adding selected pigments, and most pigment manufacturers make pigment pastes especially for polyester resins. The addition of pigment pastes may again affect the curing rate of the resin, and careful tests should be made before mixing a casting quantity.

Resins may be sawn or cut, filed and abraded, and work can easily be done on finished castings and upon seam edges during casting, with fine hack saws, files and emery abrasives. Wet and dry emery papers can be used to polish hardened polyester resins.

Diagrams of various fillings: A *Section through a concrete casting showing the first layer of neat cement (or cement and a fine aggregate) then the thickness of coarser mixture, cement with sand or a larger aggregate.*
B *Shows the laminations of neat cement (or cement with a fine aggregate) and fibreglass, chopped strand mat.*
C *Illustrates a filling of concrete with large aggregate and the placing of larger selected pieces of aggregate, to be exposed and polished.* D *Shows the laminations of resin and fibreglass, beginning with the all-important gel coat*

Waxes

I intend to ignore wax formulae which have hitherto been used for waxes both for modelling and casting for lost wax. Waxes, used by sculptors, are mainly used as transitory vehicles—simply one stage in producing a final metal casting. One of the products of oil refining, micro-crystalline wax, has usurped most other waxes in fine art practice. It can be supplied fine and made of varying hardness according to the preference of the sculptor. The wax is simply melted in a suitable vessel, ie, saucepan or bucket, a pigment or dye is added to make a dense colour if required, and then the wax is used. Hard micro-crystalline waxes can be made soft by adding a fairly heavy oil or petroleum jelly to the hot molten wax, about 20 per cent. Wax manufacturers will supply these waxes and information regarding colouring agents. Oil refiners, too, are usually willing to help with supplying micro-crystalline waxes.

Casting with wax from suitable moulds is a delicate operation and requires some care. The thickness of wax is often to be the thickness of the metal finally, and so care to obtain an even thickness is important.

The moulds most suitable for the material are plaster-piece moulds and flexible moulds. The release agent from plaster of paris moulds is simply water. Wax will not stick to a moist surface or a dusty surface. French chalk is a fine release agent from rubber moulds, but the oil in polyvinyl rubber makes its own release.

When the mould is ready and the wax is molten, take a soft camel hair brush, large enough to cover the mould surface quickly, but small enough to get into any small detail. Charge this brush with wax and apply the wax to the mould. Make a mark with the wax only, do not paint with the brush. Immediately charge the brush again and place another mark against the first. This should ensure that there are no air bubbles between the wax marks. The object is to get a fine dense surface, free from air bubbles. Cover the surface of the mould in this way, then make a second layer. This second layer does not have to be quite so carefully applied as the first. Next trim the seam edges, and reinforce with wax any high points inside the mould (these will be hollows on the sculpture). Thicken these high points by rolling wax between the fingers, and placing a third thickness on to the two painted layers. Fit and secure the caps to the main mould, using metal clamps for this, both for piece moulds and for flexible mould cases. Then take the pot of wax from the heat and allow it to cool, until a fine cloudy film just appears on the surface. At this point fill the enclosed mould to the brim with wax, hold it for a minute or so then pour back into the pot the remaining molten wax. This pouring and waiting gives the wax time enough for a further thickness to chill to the mould. The longer the wait the thicker will be the wax casting. The wax, however, must only be poured when·this cloudy film appears, and high points must be reinforced by hand. If these two factors are overlooked, high points would disappear during the pouring and become holes and not hollows on the positive cast.

When the wax cools in the pot and is in a semi-molten state it can be modelled easily with the fingers to reinforce high points.

If the mould cannot be sealed and poured, the required thickness of wax can be built up with the brush or by modelling the final layer by hand. Seams must be trimmed to fit well and the seam filled with a brush or by rolling molten wax around the seam to seal and fill it.

Completely enclosed forms must have a hole made into the mould through which the wax can be poured. The lump which will be left on the form can be trimmed and modelled over when the mould is removed. Hot metal spatulas can be used for trimming and modelling the wax. I have found that small electric soldering irons with a spatula type head made and fitted over the bit make an admirable tool for modelling wax. It has the advantage of a constant heat. The alternative is to make a lamp by filling a jar with methylated spirit, puncturing the lid to the jar, and through this push a wick to feed from the methylated spirit, which can be lit to provide a heat source for heating the metal tools.

Modelling directly can be more easily done with micro-crystalline wax, and for some sculptures really helps to lessen the cost of bronze casting which is so expensive today.

Bronze casting and other non-ferrous metals are dealt with on pages 122 and 123, but as wax is so much a part of the tradition of bronze casting and the preparation of the wax original for investment, I think a description of the use of this material to produce the original form direct for casting into bronze should be dealt with in one go.

By making a form directly in wax to be cast in bronze, it is possible to by-pass the necessity in the first instance for making a plaster cast from which a mould is made and from that mould a wax positive. Reproduction from the bronze casting can be done at a later date if this is required. It should be remembered always that the wax is an intermediary medium to be replaced finally with a metal, consequently the form should be made hollow, unless it is very fine or very small. The thickness of the wax determines that of the metal and should be made according to the final metal. Usually the thickness of 5 mm ($\frac{3}{16}$ in.) is suitable for most metals, but lead, for instance, needs to be a little thicker to be stronger and less likely to dent. Small sculptures which are made solid should not vary too much in thickness throughout their form. The pouring gate described on pages 103–105 illustrates the special care necessary to make solid metal castings.

To make the original wax form it is important to experiment with the material to find that method which is most suited to your temperament and ideas.

Wax sheets can be made which can be cut and built up into a form. Sheets are made by pouring hot molten wax on to a wet plaster or stone slab. The wax chills upon contact with the slab to the required thickness, and will lift off the wet slab quite easily. Molten wax can be poured into clay or wet plaster moulds to make components which may be assembled to build an image. Hollow forms can be made by making a rough shape in clay, then dipping the clay into molten hard wax, or by building the hard wax up on the clay with a

brush to near the required thickness. When the wax has chilled, cut it with a sharp knife or with a hot needle and remove the clay. Wash out thoroughly any clay and make sure no small particles remain, then seal together the cut wax form with a hot iron or hot wax. Then model on to this form with a softer wax to make the final statement. Hot iron tools, as described, may assist in making the final surface.

Reg Butler making a wax original in preparation for the foundry Radio Times Hulton Picture Library

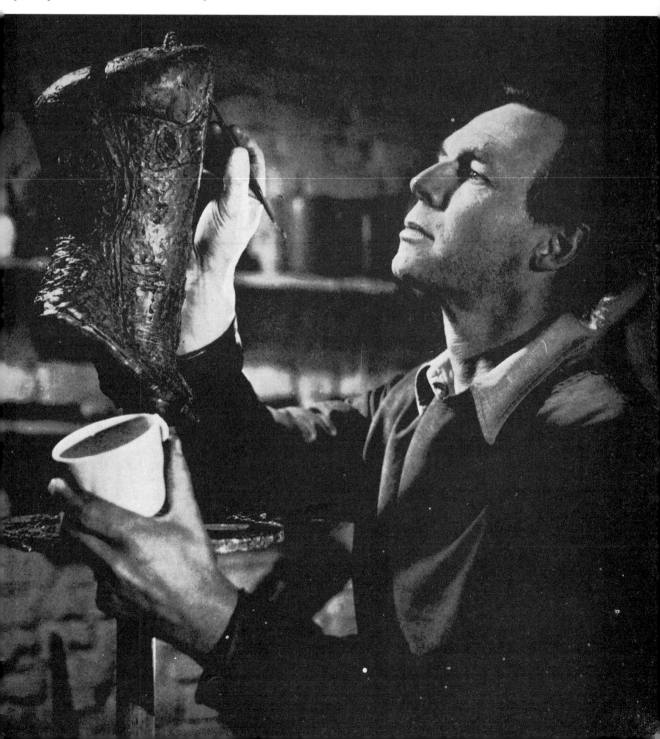

If instead of a rough clay form a rough form is made from grog—3 parts to 1 part plaster of paris—this may be retained in the wax to form what is called a *predetermined* core. This core in fact will remain in the sculpture throughout the metal casting process. The predetermined core principle has been used for centuries and by all cultures. Two major eras of predetermined core bronze sculptures are the Renaissance and the Benin tribe of West Africa.

Standing forms can be made from wax very successfully, by making what constitutes the armature of the work from hard wax, using heated metal tools. Additional modelling being carried out with the softened wax-oil mixture.

Again I must advocate proper experiment to produce individual techniques and results.

Parting agents

A brief list of the materials used as parting agents or release agents is as follows:

Soft soap diluted with warm water is the most efficient release agent for plaster from plaster. The soap is applied with a brush and made to later, and then left for 10 to 20 minutes. The lather is then removed with a brush. The mould is now ready for soaking and filling. Some sculptors apply a minute amount of thin oil to a soaped mould to ensure release.

Clay Clay film left in the mould is the most efficient release agent for cement or concrete, from plaster moulds. The clay film is retained by cleaning the mould with a dabber of soft clay. This picks up any large particles leaving an almost invisible clay film. This film is very fine indeed and will not seriously blur any modelling.

A mixture of clay and soft soap can be applied as a release agent for concrete from plaster if the mould has been cleaned thoroughly, such as with a piece mould. Brush to a lather, then remove excess lather and scum with a wet brush and water, making sure of an even deposit of soap, oil and clay film on the surface of the mould. Then soak and fill the mould.

Shellac and wax This method of sealing a mould surface is most efficient, and can be used for concrete casts where a minimum amount of surface bloom is required, and for polyester resin castings.

Simply apply shellac diluted with methylated spirit—two or three coats to seal the surface. Do not apply an undiluted shellac mixture or this will blur any fine detail. When the surface has been sealed in this way, apply a coating of liquid wax. The mould is then ready for filling. A polyvinyl parting agent must be applied over the wax for casting polyester resins.

Wax When used as a moulding material this requires no parting agent. To remove the wax from the cast simply immerse the casting in hot water, when the wax can then be peeled from the surface. Plaster and concrete can be cast easily from wax moulds as described, polyester and epoxy resins require the addition of a suitable PVA release agent.

Polyvinyl release agents These are manufactured for the plastics

industry and are suitable for releasing resins from plaster, wood, metal or resin moulds, and are always best used when applied over a first layer of liquid wax.

French chalk This is a good parting agent for gelatine and should be dusted on to a plaster case which is to contain gelatine. It is also the most efficient release agent for making successful clay pressings. It should be dusted on to a piece mould from which a clay press is to be taken, and on to any surface from which clay pressings are to be made. Be certain, however, that no chalk gets between the layers of clay, because it will stop the clay from adhering to itself.

Graphite When applied to a grog and plaster mould surface, eases the pouring and reproduction of the modelled surface in a lead casting.

Clay wash This is the simplest parting agent and is used for separating seams on mould cases or on clay wall moulds to separate the caps at the seam. It can also be used on wood.

Oil This, too, is a simple but effective release agent and can be used efficiently in the same way as a clay wash. It helps to release plaster from plaster or wood, and concrete from plaster or wood.

Equipment and material both for filling moulds and for working directly in any media will include that already listed for mould making, plus the following:

Small axes and *sharp-ended hammers* for working hard plaster of paris.
Large syringe for wetting down the plaster.
Glue size for retarding the plaster setting.
Polyfilla to add to plaster to make it adhere to a dried plaster surface.
Sandpapers to supplement the various rifflers and rasps.
Cement mixing box for dry mixing and for wet mixing cements.
Trowels.
Stone carving tools for use on a finished casting.
Fibreglass, to add to cement, and to use in casts made with polyester resin.
The raw materials for casting into concrete, cements, aggregates, etc.
The raw materials for casting into polyester resin, resin, accelerators and catalysts.
Brushes to apply the resins and to apply layers of cement.
Detergents to clean brushes, tools and hands before resins or cements set hard.
Sharp knives and *fine files* and *hack saws*, to trim seam edges, etc.
Various electric tools, including drills, grinding and sanding tools.
Metal tools to be heated for use on wax modelling.
Pencil soldering irons, for use on wax also.

Rollers made from washers, used to roll fibreglass and resin well into the mould. These can be made in many variations of size and shape, to fit particular needs. Before the resin sets hard, they must be cleaned with warm water and detergent. If resin is unavoidably allowed to harden on the roller a wire brush attachment on an electric drill will help to remove it

WASHERS

Casting: foundry methods

There are several ways of preparing and presenting work for the foundry to reproduce in metal: a master cast of plaster, cement or resin (in fact of any hard material), a hollow wax original, or a wax with a predetermined core as described on page 100. Before taking either of the latter to be cast, make sure that the foundry will take on a wax not made by their own moulders, and if a core is inside the wax, be certain to tell them what the core is made from. In fact, you should give the foundryman all the information possible concerning your original and the casting to be made. Treat him as a specialist just as you would a doctor; the more confidence the foundryman has in you, and you in him, the better the result.

The original in any hard material can be taken to the foundry, and a good moulder and founder will be able to reproduce from any master cast. When presenting the master cast be sure to discuss any cutting of the original with the moulder. Good moulders cut the master as little as possible, if at all. The necessity for cutting varies from foundry to foundry; one reason is the size of the biggest crucible available. It is useless to make a mould larger in volume than the biggest crucible's capacity of molten metal. Another reason for cutting is the manageability of the invested mould. If it is too large and heavy to handle it can be very easily damaged when in its brittle state after baking. If a master cast has to be cut at all, it is best done in the sculptor's studio during the making of the master when proper roman joints can be checked by the artist. Good foundrymen will come to the studio and discuss this with the artist, and such discussion and advice should be sought, especially when a large sculpture is involved.

The master casts described are principally for casting by the lost-wax, *cire perdue* method. They are, however, suitable for sand casting, the other commonly used metal casting technique, which is more economic than the lost-wax process. Roman jointed patterns mentioned above can be suitable for both lost wax and sand moulding. I will describe a bronze casting in both methods, giving in doing so some idea of the difference both in the casting process and in the result. It must be realised, however, that there may be many more formulae for sands and investments, riser and runners. Though formulae and actual technique may vary, the principle is always the same.

Traditionally metal castings are hollow, made either by the lost-wax or sand-moulding process. The reasons for making hollow castings are:

(a) economy: less metal will be used making a hollow casting;

(b) weight is not so great as with a solid casting;

(c) the hollow structure is stronger;

(d) solid castings shrink a great deal upon cooling, and may cause cracking where forms are of unequal size. Overall shrinkage is very great, but this, however, varies from metal to metal, and any consequent distortion may be very undesirable.

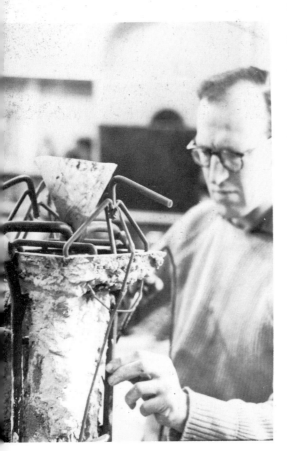

Of course you can make hollow castings when any of the above factors have some importance, but very small castings can be made solid quite easily. The amount of bronze saved in making a small hollow cast would be negligible, and the effort involved to make it hollow could be better used in making shrinkage more even, avoiding fractures, which can be done by using care in the size and placing of runners. The runners that allow the molten metal to feed into the cavity can be adjusted to even up proportions so that shrinkage can be spread over the casting.

If a thickness proves to be too great, solid castings can be made by including an armature, of similar alloy to that being used, at the centre of the thick form. This acts as a chill bar, causing the larger amount of molten metal to cool at a similar rate to other parts, thus reducing the possibility of fracture due to uneven shrinkage.

The principle of casting by the lost-wax, *cire perdue* method is as follows:

The wax original is prepared, either by direct modelling with wax, or by moulding from the master cast to produce a wax reproduction which will be cast into metal. If the wax is made at a foundry the sculptor must be certain to check the wax before it is invested. Any touching up, cleaning off seam flashes, signature, edition numbers, etc, can be done at this point. Bronze sculptures today are often produced in small editions, usually of six in number, with each bronze having its sequence number; thus reducing the total cost, by spreading it over the whole series.

The hollow wax is filled with the core material of 1 part plaster to 3 parts grog. Before filling the core weigh the wax to determine the amount of metal to be used. The ratio of 0·453 kg (1 lb) wax to 4·53 kg (10 lb) of bronze is normal, plus the estimated weight of the 'risers' and 'runners'. The core substance completely fills the volume of space inside the wax cast and must be poured in before the casting can be continued. If a piece mould or flexible mould is used, it is convenient to pour the core whilst the wax is still held in the mould so that no damage ensues when the mould is gently vibrated to release air bubbles to get a well-consolidated core. The method of the pre-determined core is described on page 100.

Iron pins are tacked into the core through the wax, with sufficient projection outside the wax to be gripped by the investment. This ensures that the core and investment stay in the same relative position when the wax is melted out. It is obvious that if there were no pins the core would be loose in the investment once the wax was gone, and could block the flow of the metal giving a faulty casting.

Next the pouring gate has to be designed and fixed to the cored wax. The pouring gate is the name given to the system of channels through

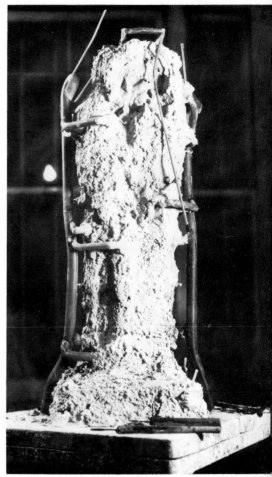

Michael Gillespie completing the pouring gate. The photograph shows the runners and risers and the funnel

Completed pouring gate, and the first layers of investment mould

This diagram shows an Italian runner which is used effectively to make a solid bronze casting. The runner is at least of a thickness equal to the volume of the thickest part of the sculpture. The ball is another reservoir of molten metal that prevents undue shrinkage and damage caused if the metal chills too quickly

Diagram showing the two methods of quick investment.
A A flask of thin metal is made and sealed, then filled
with the investment mix. The wax complete with
pouring gate is then dipped and held in suspension till
the mould is set. B The wax is attached to a base board,
and the flask made around this and sealed. The investment
is then poured into the flask to cover the wax

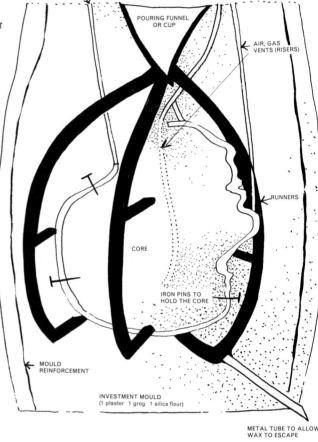

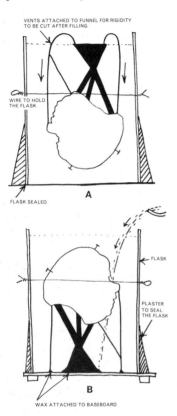

A *Represents the traditional runner system in which the*
metal runs first down the gate and is fed up into the mould
cavity. B *Shows the direct flow of metal into the mould*
cavity used for silicon bronze

Diagram of a pouring gate, within an investment mould,
indicating the risers and runners, the core, the core pins,
and the pouring funnel. See pages 103 and 106 for further
explanation of the pouring gate, and method of investing

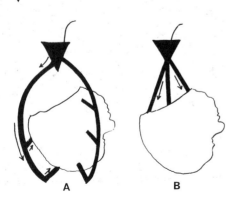

which the molten metal flows, and air or gases escape. The metal
flows down 'runners' and gases and air escape up 'risers'. The runners
are taken directly from a pouring cup or funnel to carefully chosen
points on the sculpture, to ensure the quickest and smoothest flow of
metal. Several gates are usually necessary to provide the quickest flow
and prevent the metal chilling too soon. The risers are taken from any
point on the sculpture which would trap air and prevent the flow of
metal up to the top outside surface of the investment. These airtraps
will normally be the highest points on the sculpture when the work is
in position for pouring the metal. The runners and risers are made
from wax rods and are fixed to the wax casting by simply applying a
hot metal tool between the rod and the cast, thus melting and welding

them together. Runners are thick rods, the diameter varying according to the size of the sculpture, from 6–13 mm ($\frac{1}{4}$–$\frac{1}{2}$ in.)—the greater thickness on large castings. Wax rods can be readily made by using two-piece plaster moulds of wooden dowelling or by filling a metal tube with wax and allowing it to harden. By gently warming the tube the cast wax rod can be pushed out. These rods are suitable for runners. Risers are thinner and can be made by dipping string into wax. They only need to be thick enough to allow gas or air freedom to escape. Large cores also need to be vented to allow gases to escape. The risers should be placed on the highest points when the work is in the casting position.

The next stage is the placing of the negative mould or investment around the wax sculpture which has been cored, pinned and fitted with a pouring gate. The investment can be made from a refractory plaster, or from plaster of Paris mixed with grog and silica flour in equal portions. To achieve reproduction of the finest detail, the investment is carefully painted on to the wax surface, all over the sculpture and pouring gate, making sure to leave a well-keyed surface to make the best adhesion to successive layers of investment. This first coat has to be fine and the finest grog sieve mesh should be used. The mould is then built up to make a thick mould, thick enough to be quite strong after baking. Heavier mesh grog should be used to build up the bulk of the mould, and in a large mould reinforcement with chicken wire is ideal for giving the required strength.

Poured investments are simple, a little wasteful, but this disadvantage is outweighed by the speed with which an investment can be made. The method is simply to make a flask using either thin sheet metal, linoleum, plastic sheeting, cardboard or empty tins. Mix the investment equal parts of plaster of paris, silica flour and grog, fill the flask and dip the prepared wax into the mixture. Agitating the wax will help remove air bubbles that will become beads on the cast surface; these can also be removed by quickly brushing the wax surface with investment before dipping. Hold the wax in position and allow the investment to harden. This method is illustrated on page 104 and shows an alternative method of pouring the investment around the prepared wax.

When the investment is complete and the mould strengthened, the whole thing has to be baked. Baking melts out the wax and dries the mould thoroughly ready for pouring. The mould can be cooked over a coke–solid-fuel fire or a gas-fired burner. Small moulds can be baked by binding a resistance wire around the mould, and with a transformer control the necessary slow heat is built up. Over open baking systems such as solid-fuel, gas or oil, the mould can be simply turned upside down and placed on stilts (see page 107) to bake and the wax will run out. With electrical cooking, however, the wired mould must be packed in an insulation substance, such as *Kieselguhr*, and

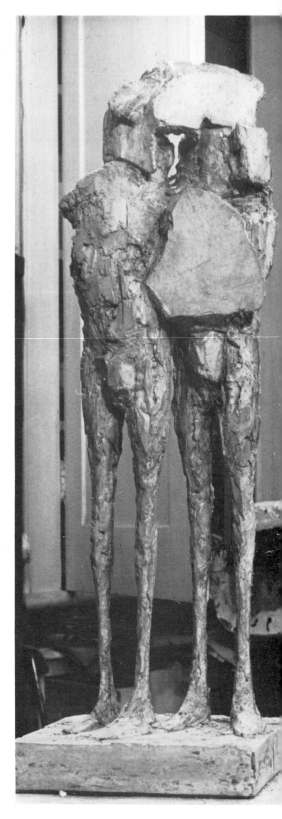

One of a series of bronze sculptures 'Assassins', by
Elizabeth Frink. In the foundry being cast into bronze.
Plaster master cast photographed in the foundry

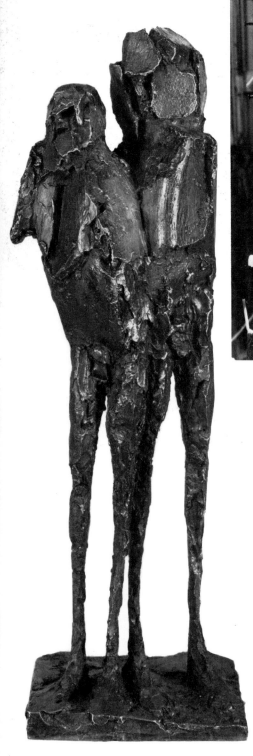

The prepared wax to which the risers and runners are being fixed. The iron pins to support the core are clearly visible

The bronze casting fresh out of the mould, showing the pouring gate. The casting now has to be cleared off and chased

A completed bronze sculpture. Another in the 'Assassins' series by Elizabeth Frink

cannot be turned upside down, so an allowance for the escape of the melted wax should be made. A satisfactory method is the fixing of a small metal tube on to a runner at the bottom of the mould in its baking position. This tube will stick through the mould and insulation material, allowing the melted wax to run free. This must be plugged before pouring the metal, of course. The mould is baked and ready when it has reached red heat all over, approximately 600°C, and has been maintained at this heat long enough to burn out any trace of wax or carbon from the investment. This is important, as although the main body of wax flows freely away, small amounts may be absorbed into the porous plaster and must also be burned out. If the funnel can be seen, it will be quite clean and free from any carbon deposit when the wax is completely gone, and baking should continue till this

occurs. Flaming at the funnel indicates that carbon is still burning in the mould, so baking must continue until this is complete and the funnel opening clean. Kilns fitted with pyrometers can be used as follows: pack the completed investment moulds into the kiln chamber making sure you can see the funnel openings (see page 102). Turn on the kiln and set it to reach 200°C and maintain this temperature for about 8 to 12 hours to dry the moulds thoroughly and begin to melt the wax out; then turn up the temperature setting to reach 600°C quickly. When temperature is reached the moulds should have completed their baking, so if there are no flames the kiln can be turned off and allowed to cool.

Electric kilns fitted with carbon rod elements and not wires, are ideal for baking moulds, if gas is not available and solid fuel not practical. In all cases however, if the kiln is housed in the studio an efficient ventilating system must be installed.

After baking the mould must be packed into a casting box or pit. A sandpit is preferable because the fragile baked moulds can be securely packed with damp sand to withstand the pressure of the metal when it is poured into the mould. The sand used ideally is foundry sand, but clean sharp sand will do. The moulds must be packed to the top, and the funnel and vent openings covered to prevent foreign matter entering the mould and affecting the quality of the casting. A vacuum cleaner can be used to suck out small particles and any carbon residue, but should be used with care. When the metal has been poured, and has cooled, the filled moulds are dug out, and the investment broken away. The resulting metal casting is then ready for chasing and finishing.

Charging the crucible in the furnace. More bronze is pre-heated on the furnace before being placed in the pot. Note the clean foundry area, and the protective clothing

▲

The fired moulds in the kiln prior to being placed in the pit to pour. Note that the moulds are upside down to allow the wax to run freely

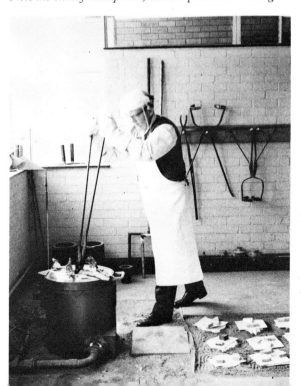

Preparing the bronze in the furnace ; skimming the molten metal

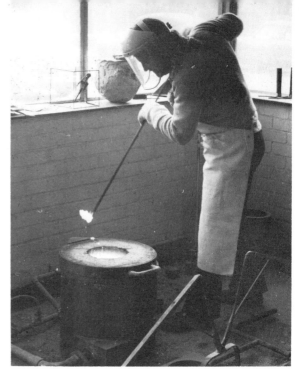

Lifting the molten metal in the crucible ready to pour

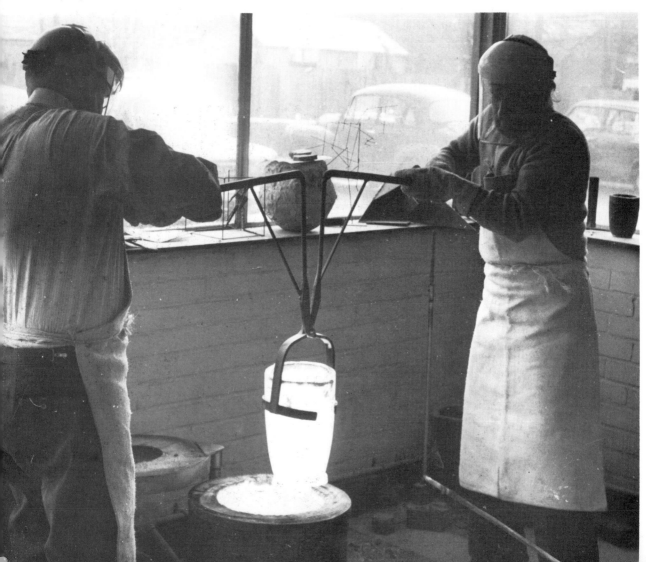

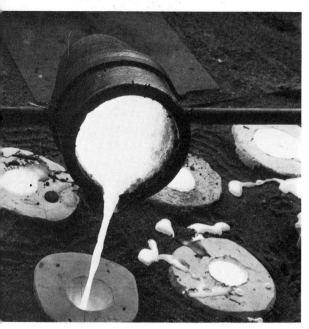

Pouring the metal. The pour is directly into the cup or funnel. Moulds show metal filled and risen up the vents

This illustrated two stages in the pour: moulds that have already been filled and moulds in the pit from the kiln ready to be poured

Pouring surplus bronze into warmed ingot moulds. The two-man shank and ring is being used. A wise step in art school foundry work

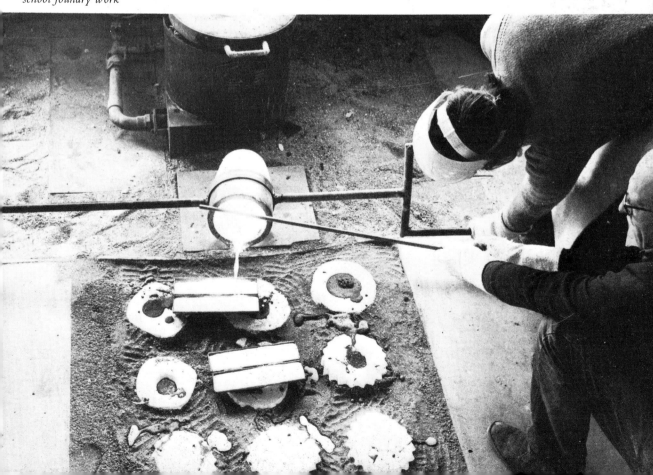

Some of the tongs, shanks and ring necessary to lift the crucible and place it to be poured. These items are vital to a smooth operation

Sand moulding

Sand moulding is yet another very old technique employed by the ancient civilisations, particularly the Ancient Greeks. The principle is as follows:

The master cast, which may be complete or in sections according to the plan for casting, is placed on to a bed of fine foundry sand (*mansfield sand*), within a sand box (*flask*). This box or flask is simply an adjustable rectangle of metal. The master cast is pressed firmly into this, and the sand around the form is tamped down to form a firm sand bed. The form and the bed are then dusted with a parting agent such as french chalk or silica. A piece mould of sand is then made, making the necessary allowances for any undercuts. Each piece needs to be trimmed carefully to fit properly one against the other, and tapered to draw. Only undercut forms need have caps made. They must draw well from the main sand case which can be made to pick up much of the form. The case is made by placing and clamping a second box on top of the first and placing sand on to both the master cast and pieces

which have been dusted with parting powder. This sand is tamped down to form a well-consolidated case. The sand is trimmed to be level across the flask. Tamping is done with rubber hammers. The consolidated sand is held in place by its own pressure outwards on the metal box sides.

When one side of the form has been completed in this way the two flasks are inverted and both the original sand bed and the first flask removed. The second flask is carefully laid down revealing the other unmoulded side of the master cast. This has to be dusted and the necessary pieces and case made in the same way as on the first side. When both sides have been completed, the two boxes are parted and the pieces of sand mould carefully removed from the master cast. These pieces are pinned into the sand case, long needle-like pins penetrating through them, thus fixing them into the sand case. The master cast is removed and set aside. Pieces are fitted and fixed into place on the oher side of the mould. A pouring gate is cut into the sand and at the seam edges of the two cases, and a system of runners and risers is made by cutting channels into the sand.

The core for a sand moulding can be made in several ways, all of them rather tedious. Solid castings, however, are not always desirable. The core for a sand casting has to be built up to the same dimensions as the original, and the final metal thickness pared down from that form. This can be done, if possible, by casting the core from the mould from which the original master cast was made. It can be made by modelling with the sand a core to fit the form, constantly trying the core against the original to make a good fit. A core can be made from the sand mould by using a softer sand and carefully casting this into the sand mould, then making the metal thickness by paring down the cast core. When the core is made it is held in place by iron rods resting on the flask edge. Core vents are made to allow core gases to escape. The core is fixed, the flasks clamped together and the seams sealed. The completed mould is then ready for the oven to be dried and to harden further by heating; then when dry and hard, the mould is ready to receive the molten metal.

The two methods described are both normal practice to art bronze foundries. In recent years the cost of castings made in these foundries has been exorbitant, verging on the ridiculous. In this craft, the voo-doo of tradition has resulted in unbearable costs making it impossible for young, not yet established sculptors to afford metal castings. The direct practical result of these inflationary costs has been that a number of sculptors now make their own bronze castings, or prepare waxes in their own studios. Others have turned to adapting industrial casting techniques.

In the USA many sculptors make their own metal castings, alu-minium and bronze, and in 1970–71 I worked in Michigan with two sculptors John Pappas and Jay Yager who taught me much about bronze casting as practised in America, where some of the traditional techniques have been shaken up and rejuvenated by using new alloys and simplifying investment materials. This book now contains those lessons, with my gratitude.

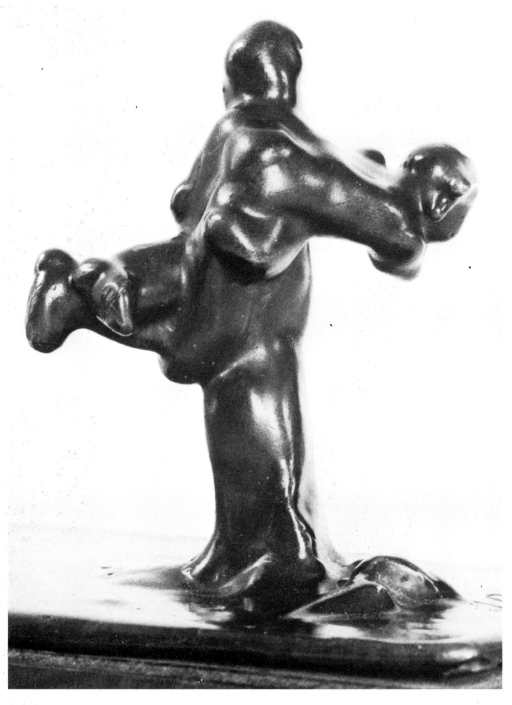

'Man and Woman'. Silicon bronze maquette by John
Pappas Photograph: Tom Jones

'Jube' in silicon bronze by Jay Yager
Photograph: Agar, Minnesota

Right
'Short Loop' in silicon bronze by Jay Yager
Photograph: Agar, Minnesota

Above right
'Man's Head' relief in polished silicon bronze by John
Pappas

A modified lost wax process useful to sculptors is that developed for industry to give high fidelity casting, known as the *ceramic shell process*. This entails the use of a ceramic investment material manufactured commercially. The prepared wax, complete with sprues (pouring gate), which for this process can be simplified (see page 104), is painted with a wetting agent, and then dipped into a bath of liquid investment and then into powdered silica. These applications bind together and are then allowed to harden, and the dipping repeated until a mould thickness of approximately 6 mm ($\frac{1}{4}$ in.) (up to 13 mm ($\frac{1}{2}$ in.) on larger items) is achieved. Complex forms may require reinforcing in the investment, which can be afforded by including stainless steel wires in the mould build up. The mould when dry is ready for the wax to be melted out, which needs to be done quickly and evenly preferably in an autoclave, but failing that with infra-red heaters or

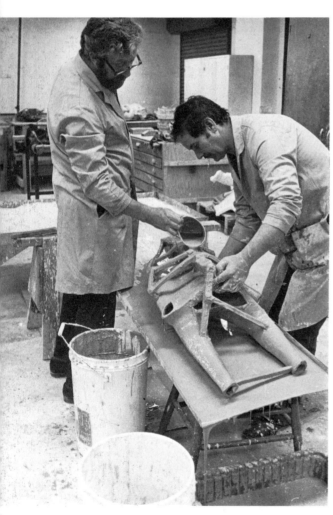

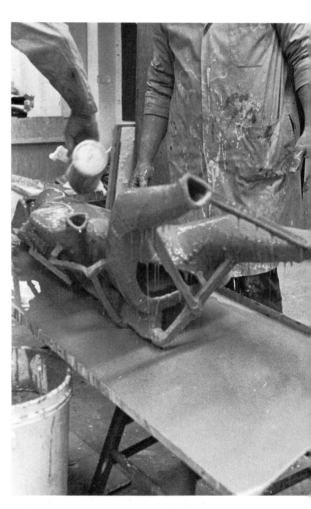

Illustrations of the ceramic shell process as practised by messrs Lee and Townsend at the Ontario College of Art and Design

The silicate is then applied to the resin surface to make the investment mould. The layers of resin and silicate are built up to the required thickness, determined by the size of the piece and the metal to be poured

oxy-acetylene. The object being to remove the wax without causing expansion to break the mould. The ceramic shell can withstand considerable thermal shock and can be heated to de-wax, by whatever means available up to 537°C. After the removal of the wax the mould is placed in a burn out kiln heated up to 920°C to remove any carbon residue. This burn out can take as little time as thirty minutes or at the most two to three hours. The molten metal can be poured directly into this fired investment and does not need packing in sand, although the wise will always take sensible precautions, and pack in dry sand. John Pappas actually slush moulded a form in stainless steel, using a ceramic shell mould.

The cost of lost wax and elaborately cored sand moulded non-ferrous casting is exorbitant, and may mean the loss of a commission and the satisfaction of seeing a work to a conclusion, that is in the metal for

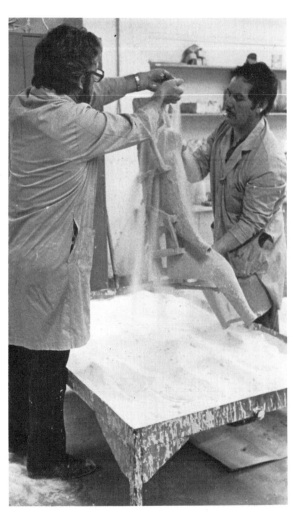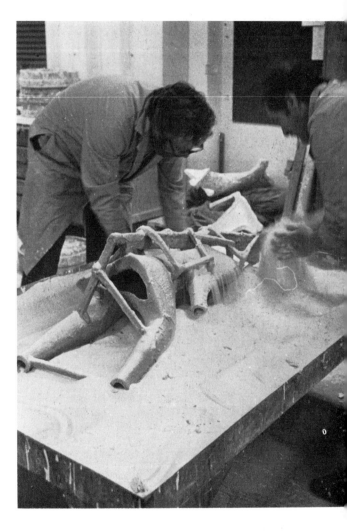

The wax now complete with pouring gate, is coated with resin by pouring and brushing. Care is taken to cover the surface completely

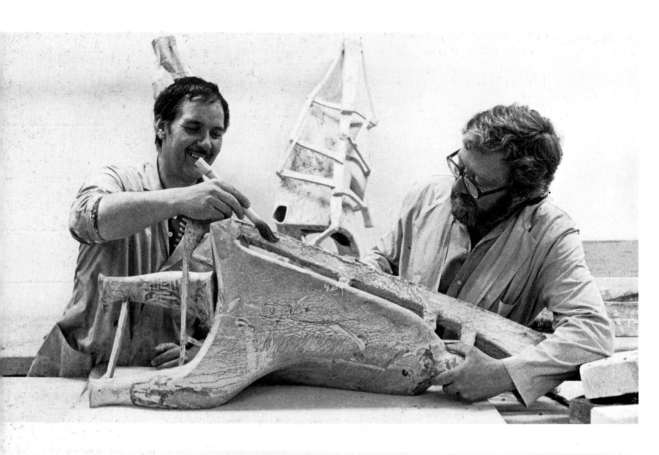

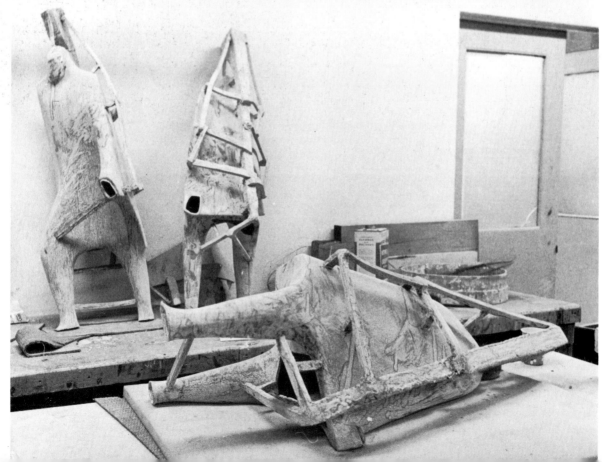

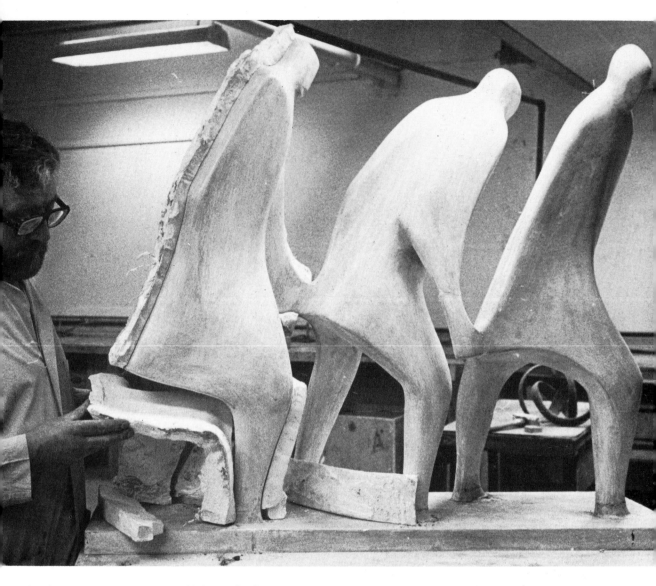

The plaster master being piece moulded to make the wax positive ready for investing

The completed investment of ceramic shell is shown ready to be poured; note the mould thickness

SELF-TAPPING
SCREWS

CAST SURFACE

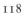

which it was designed. Cheaper large casting can be made by making the master cast in such a way as to make it possible to use an ordinary industrial foundry, and a simple sand moulding technique.

Sand is used for nearly all precision castings for industry, and the development of the methods used in this field over the past ten to fifteen years has been enormous compared with the comparatively little progress in lost-wax techniques. The method is as follows:

Make the master cast in such a way as to be virtually a collection of pieces that can be assembled to make the final work. Each piece is designed to have little or no undercut, and with a roman joint so that it fits exactly into place in the final assembly. This collection of pieces is then reproduced simply in the foundry by sand moulding front and back, and returned to the sculptor who then assembles them. The control of 90 per cent of the process is then in the hands of the sculptor. He devises the pieces, which can be made direct in plaster of paris, or can be cast from a clay original. The thickness of the final metal is determined by the thickness of the castings made at this point. The foundryman casts them simply by moulding front and back, making separate pieces for undercut shapes, which have been kept to a minimum. The sculptor reassembles the pieces, welding them himself or to his direction, or bolting the pieces together. Thus the final work is entirely of his own making and controlled by him. The master cast is retained from which any editions can be made, or any variants to the orginal idea. Further he has produced a sculpture which is durable and for a fair price, making any financial return equal to his work.

The pieces can be bolted together by tap drilling and the bolt head countersunk. Similarly, pieces may be secured together by drilling holes in the sections and fixing them by means of self-tapping screws, which cut their own thread as they are driven into the hole, drilled slightly smaller in diameter than the screw shank. The pieces can be welded, but as castings are amongst the most difficult items to weld, this is best done by a professional, especially if it is to be placed on a public site. Countersunk bolt or screw heads can be covered and disguised with a cold metal filler or by brazing metal over them. Cold metal fillers are basically a resin heavily loaded with metal of the same character as the casting. These fillers are used in industry in many diverse applications and may be considered equal to the old plugging mixtures, resorted to in the past by foundrymen: concoctions such as resin and wax with metal filings, lead and paint, solder and paint. There is no shame in using a filler. Sections of sand castings, or castings of any kind should fit well enough to be chased over and matted and disguised in this way, if they need to be disguised. This is ideal but not, however, always possible, and so a filler of one kind or another may be necessary, but should be used sparingly.

Illustrated are some angles for jointing patterns to be cast by the sand mould process. The angles are designed to facilitate drilling and fixing the pieces together with bolts or self-tapping screws. These joints could of course be welded together too

The *lost pattern process* now means that any material that will burn out at 600°C can be used to make a cavity mould in which molten metal can be poured to reproduce the original ie plastic models, wood, fruit, insect, etc. The vacuum cleaner should be used to make certain the mould cavity is clean after burning out such materials.

Expanded polystyrene is a pattern material extraordinary, because it volatises when heated, and disappears. The pattern for sand casting can easily be made from this resin, which can be bought from the manufacturers in sheets or blocks of predetermined size. The image can be made by cutting the material with sharp knives or with resistance wire cutters. A heated resistance wire cutter can be made from a small transformer producing an output of between 6 and 8 watts. Components can be cut and formed to be cast in metal. Once in metal they can be assembled by welding or bolting together. A special adhesive is required to stick expanded polystyrene components together, and this adhesive may leave a carbon residue in a sand mould, causing a flaw in the surfaceof the casting. If this is undesirable on the particular sculpture, it is wiser to put components together in the metal.

Casting the form in metal is for the founder a comparatively simple matter. The polystyrene pattern has simply to be invested with the sand moulding material. When the investment has hardened and is ready to receive the molten metal, this is poured directly on to the pattern. The appropriate pouring gate must be made to make the metal run freely and air and gases rise. This is also made from expanded polystyrene. The polystyrene simply volatises and disappears, and the metal then takes its place.

Before designing for this technique, however, discussion with the foundryman about using expanded polystyrene as a pattern would be wise, as from his experience he may know ways of bypassing faults.

Chasing All castings in all materials require some work done on them by the artist to reach the finished state. Castings in metal may need more, especially the sand castings made at an industrial foundry. 'Chasing', or working the final surface, is done with a series of fine, hard, sharp chisels and files, followed by matting and fine burnishing, fine abrading and polishing. The chisels are steel without wooden handles, and need to be of a sufficiently hard temper to cut the metal. Most sculptors forge their own with the necessary temper. A good substitute for home-forged chasing tools are good quality letter-cutting chisels, sharpened to a fine edge on an oilstone. Chisels with a tungsten tip are very good, too, but also very expensive. The files used vary from a coarse 'bastard' file to very fine-toothed pencil files. The shapes vary according to the sculpture. The student and sculptor is advised to collect as varied a range of files as possible, so that he can cope with any demand made by a particular sculpture. Aluminium can be filed easily with a 'dreadnought' file. This is a file made in the form of a series of hard cutting edges, cutting in one direction only, unlike a file which is made up of cross-hatching edges making hard points, which scratch away the metal. Matting tools are simply

punches, used to mat the surface of the metal when it has been cut and filed, to make a dense surface similar to the cast modelled surface. Matting tools aid the simulation of the modelled surface on the areas which have been filed or cut. These areas after matting are burnished with a hard metal burnishing tool, and may then be abraded with the finest of abrasives. These two final treatments are to enhance further the worked area to make it indistinguishable from the cast surface, or to achieve the final intended surface. These traditional skills can be assisted with electric grinders and accessories.

The bronze castings made during the Renaissance were invariably considered simply as an intermediary stage; the means only of putting the sculpture into a permanent material. All castings were worked and chased to achieve the final form and quality and all sculptors, properly trained, were capable of chasing and finishing a metal casting. Close study of the Renaissance bronzes reveals the amount of work done on the casting. The famous autobiography of Benvenuto Cellini gives an account of the casting, by the lost-wax method, of his renowned *Perseus* in Florence. But he also makes throughout the book constant reference to the work necessary on metal castings, and of course praises himself constantly for his own high standard of craftsmanship in that respect. Michelangelo, too, in his letters, mentions a great deal the worry and tribulation caused him by the necessity of working for eighteen months at Bologna on the bronze casting of the Pope.

Tools necessary for chasing and finishing non-ferrous castings include the following:

Tap and *die* used threading, including tapping and plugging small holes in the surface.

Hack saws of various sizes, to cut off runners and risers, etc.

Chasing tools As wide a selection as possible, to be able to work on almost any size casting.

Matting tools.

Burnishing and *scraping* tools.

Abrasives, including very fine files, emery cloth, and wet and dry emery paper.

An *electric drill* with various attachments, including grinders, buffers and polishers. Electric die grinder, and rotary files and burr.

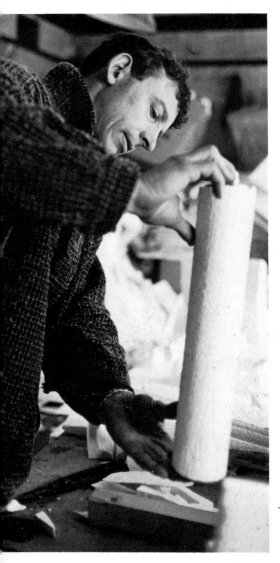

Geoffrey Clarke cutting an expanded polystyrene form to be sand moulded and cast in aluminium. He is using an electric resistance wire cutter

Aluminium sculpture by Geoffrey Clarke showing the texture of the cut expanded polystyrene
Photograph: Crispin Eurich

DIE

SPLIT —

TAP

Tap and die. These tools are used for cutting screw threads in metal. Used of course in many ways and for many purposes in sculpture. Pin holes in bronze castings are filled by means of tap drilling and plugging.
The die is basically a nut, of a predetermined thread size and type, split to make a cutting edge, then hardened. This is then held securely in a handle, and is used to cut the male screw thread.
The tap is a screw thread cut on a cylindrical piece of metal, which is then gashed along its length to form a cutting edge. This tool is also held in a handle, then rotated in a plain drill hole, which should be fractionally smaller than the tap, to make the female thread

CHAMBER OF FURNACE

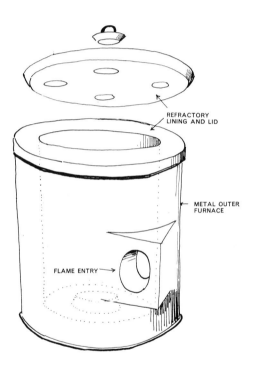

REFRACTORY
LINING AND LID

METAL OUTER
FURNACE

FLAME ENTRY →

Melting metals, furnace and equipment

To avoid the exorbitant costs of fine art lost-wax casting, some sculptors have taken to pouring their own bronzes, doing the whole job in their studio. This is not a thing to be taken on in a light-hearted manner, however, and unless you are confident that you can handle quantities of molten metal, or be concerned enough to concentrate on what can be a very arduous task in hot and dusty conditions, it is best left alone.

The basic equipment is a furnace in which the crucible containing metal will be placed. Heat must be of sufficient power and longevity to melt the required amount of metal, and foundry tools are necessary with which to handle the metal, both cold and molten.

A furnace is a kind of oven. It may be housed in a pit or in a metal housing. It must be lined well with a refractory cement, about 75 mm (3 in.), to retain the heat, and concentrate that heat on the crucible. It must have an opening through which the heating appliance can direct its flame. The opening introduces the flame at an angle to the centre of the furnace where the crucible is located. This preserves the crucible from the direct blast and circulates the flame around the crucible to obtain an even temperature.

Crucibles are specially constructed refractory vessels, made to withstand very high temperatures and to contain specific quantities of metal in a molten state. The crucible stands on small stilts in the middle of the furnace. It is wise to buy manufactured crucibles.

The source of *heat* may be gas, oil or paraffin. In the studio the heat source is commonly propane or a very large paraffin blowlamp, usually of 22 l (5 gal) capacity. Two of these blowlamps are admirable for melting a good quantity of metal, about 11–22 kg (25–50 lb), one blowlamp replacing another to maintain the heat for as long as necessary. Propane gives a hotter and more controllable heat.

The metal is best cut up into small pieces, pre-heated, and put into the crucible.

When made red hot, bronze can be broken with a hammer, heated aluminium can be broken in this way too.

Large lumps will, of course, take much longer to melt and will waste the heat generated; small pieces melt more quickly and more efficiently. The metal may be bought from a reliable scrap merchant, or new from a reputable dealer. The latter will be able to give the exact specification of the metal he supplies, ensuring the purity. This also assists in deriving a patinating formula, which is difficult if the various metals which make up the alloy are not precisely known. The manufacturers of ingot metals will provide with the purchase the specification for the particular alloy, including the pouring temperature. This

FLAME

Basic furnace showing the furnace and the placing of the flame entry. This is constructed from refractory material, such as Ciment Fondu *(aluminous cement), within a metal drum or container. The diagram shows also the placing of the crucible within the furnace upon a stilt or small platform to gain maximum circulation of heat around the crucible*

can be measured with a pyrolance in the crucible, is the safest way of determining this temperature and the subsequent good flow of metal. Before pouring some metals have to be de-gassed, aluminium and standard bronze for instance. The manufacturer will be able to supply information on this point and should be asked when ordering the ingot. One bronze that requires no additions is silicon bronze, used extensively in the United States, but needs to be made to order in the United Kingdom. This alloy is 96 per cent copper, 3 per cent silicon and 1 per cent manganese, and requires only melting, skimming and pouring at a temperature of about 11,000°C. This bronze flows freely permitting a simpler pouring gate, with the added advantage of being easily welded. When the metal is molten and the invested mould has been baked and prepared, and has been packed securely in a sand box with only the neck of the pouring funnel visible, the crucible can be lifted from the furnace and the metal poured into the mould. Before pouring, any dross which is on the surface of the molten metal must be removed. This dross results from dirt or other impurities collected on the outside of the metal ingot or piece rising to the surface.

The tools necessary to do this lifting and pouring are illustrated on page 110. Improvisations of such tools is unwise, buy or make the correct tools and risk less.

This method of melting metal applies to any high-temperature alloy, and should be thoroughly understood before being attempted. Molten metal can be a very dangerous commodity, and proper protective clothing should be worn when dealing with it. The radiant heat from bronze is very great and protective clothing must be worn, to avoid serious burns. Aluminium doesn't give off such radiant heat but still should be handled with care. Water must be kept well away.

Lead is perhaps the most common studio-poured metal, because its low melting point means that it can be melted easily in an iron saucepan. The principles are basically the same as for any other metal, however. It is what is known as a dead metal as it does not give off gases, and consequently it does not require an elaborate pouring gate with runners and risers. It is possible to invest a wax form, then make the investment mould hollow by melting out wax, or by splitting an ordinary waste mould and removing a clay form; then sealing the mould and heating it until it is completely and thoroughly dry, pour in the molten metal. For the prospective bronze caster making simple pouring gates (as for a metal of a high melting point, etc), would afford invaluable experience.

The melting points of metals commonly used in sculpture are:

Approximate temp

	°C	°F		°C	°F
Silicon bronze	1100	2044	Phosphor bronze	957	1920
Aluminium	631	1220	Copper	970	1980
Beryllium copper	795	1750	Gold	963	1945
Admiralty gunmetal	787	1715	Silver	880	1761
Yellow brass	780	1710	Iron (ingot)	1110	2795
Aluminium bronze	960	1940	Lead	279	620

Welding and brazing

Equipment

The most commonly used welding/brazing appliance is that with bottled gases, oxygen and acetylene, and this method is called gas welding or oxy-acetylene welding. The equipment is used for both brazing and welding, and consists of the following items: two metal cylinders (bottles), one containing oxygen which is usually black in colour, and the other, acetylene, which is usually red. Pressure gauges are fitted to the top of the cylinders to indicate the amount of gas in the bottles, and the amount being let out to the welding torch. The pressure gauges include a diaphragm control which governs the flow of gas to the blow torch. Hosepipes carry the gases to the torch (red pipe for acetylene, black for oxygen). The torch itself is the mixture control for the gases. It contains two valves which allow control of the flow of gas to the nozzle. The actual nozzle or outlet for the mixed gas can be varied in size of outlet, according to the metal gauge or thickness. Heavy gauge metal will need a larger nozzle, and vice versa. The welding torch is simply a convenient mixture control. A welding and cutting torch has an extra control, a lever which allows the sudden release of extra oxygen through the centre of the flame to blow away molten metal, thus cutting the metal in this way. Goggles or dark glasses must always be used to shield the eyes from the intense bright light at the welding nozzle during the welding. Without such goggles serious damage can be done to the eyes. Goggles should also be worn when simply watching a welding operation for the same reason. A flint gun with which to make a spark to ignite the gas mixture is the most sensible means of ignition. A naked flame, such as a candle burning in the vicinity of the gas cylinders, is not a wise thing at all, as any small leak of acetylene could cause a serious fire or explosion. Spanners are required to fit pressure gauges and hosepipes, etc, and these are usually supplied as part of the equipment. Other tools such as metal cutters, vice, anvil, hack saw and files, are common-sense equipment necessary in any working studio. Electric tools also are necessary equipment today and include grinding wheels of various kinds as well as drills and buffing attachments.

The oxy-acetylene welding torch is becoming more and more widely used as a means for making metal sculptures, and not simply a method for making stronger armatures or for repairing broken metal tools, castings, etc. The oxy-acetylene torch can be used to either weld or braze metal together. A weld is the fusion of pieces of metal (parent metals) one to another in a molten state. The welded joint has the same characteristics as the parent metal, being simply the contact of the pieces of metal brought to a molten state, thus causing them to fuse at that point. Brazing differs from welding in that it is simply sticking two pieces of metal together by means of a third. The third metal is an alloy applied from a rod at a much lower temperature than the melting temperature of the parent metals. Adhesion is caused by the alloy filling the pores of the metal which have been opened by the

heating of the two metals, thus becoming joined. A brazed join is as strong and sometimes stronger than the parent metals.

The student or beginner should get as much information from his supplier of welding and brazing equipment as possible. Often suppliers are very willing to come along and teach the rudiments of welding and brazing, and are willing too to give advice on specific problems which might occur. The beginner is well advised not to attempt to teach himself, but to get the advice and assistance of an experienced welder. Acetylene is a very combustible gas, and mishandled can be extremely dangerous. When taught properly the basic technique can be understood and practised very quickly. This has proved the undoing of a great many young sculptors who have been misled by the ease with which pieces of metal can be joined into believing there is nothing else to consider. Understanding of traditional crafts of sculpture and form is necessary to enable the welder to develop his own personality sculpturally, and not echo others by being trapped into just joining pieces of metal, which is a common fault.

Oxy-acetylene welding is done by igniting a mixture of oxygen and acetylene blown through a blow torch, to give a flame hot enough to melt the metal. This flame is directed at the metal to form a molten puddle. Mild steel, the metal most commonly used, becomes first red hot and then as it melts it glistens, and a puddle of yellow molten metal appears. The object is to move this molten puddle along the metal in front of the torch, adding to it by dipping into its centre rhythmically, a rod of the same metal. The torch is moved slowly in a circular motion or up and down across the puddle, and at the same time moved slowly forward. The metal rod is applied rhythmically, in relation to the movement of the torch, to the centre of the molten puddle. The torch and the rod are best held at angles of between 40° and 50° to the surface of the metal. By making a weld in this way a bead of metal will be formed, and make a trail of progress across the parent metal. Industrially the welder must make his bead even and accurate, so that maximum strength results and even stress throughout the weld. Sculpturally this is not so vital, and although the student should aim to be able to work an even bead trail, it is not always essential to achieve this on a sculpture. The secure fixing of one piece of metal to another, giving the sculptor as much freedom to manipulate the torch and metal as possible, is ideal. This will help to invent a personal torch calligraphy, making the welding individual, and not anonymous as in industrial applications.

The beginner is advised to learn to control the molten puddle upon a flat metal sheet approximately 12 gauge, moving the puddle and adding the filler to make a tracery of bead trails across the sheet. This helps to build confidence in the new medium, and control of the torch and filler rod. When this has been done, do the same thing again, but this time joining two pieces of sheet together by moving the puddle along their edges when put side by side. Welding two pieces together will require more filler rod than was used for the elementary bead trails. The weld, too, should achieve maximum penetration

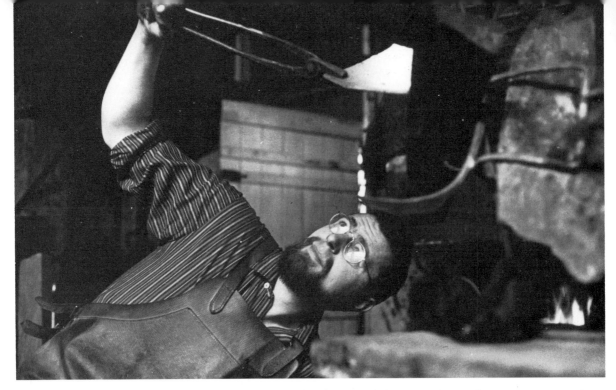

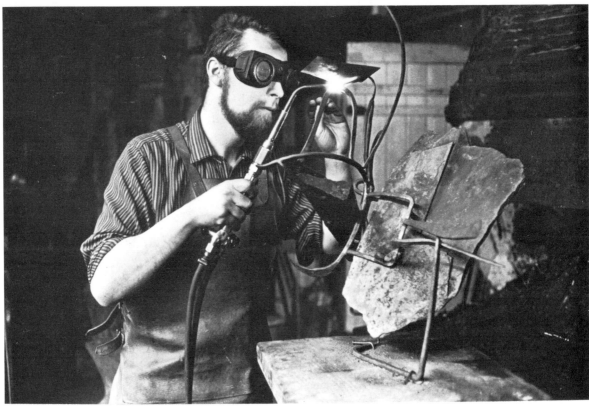

Bryan Kneale involved in the process of welding and
forging sculpture Photograph : Crispin Eurich

from the top surface to the bottom surface. The weld should be visible along the underside of the joint. It will be found that the best joint of two metal sheets is made by first tacking the ends of the run. If this is not done the joint will become wider as the torch and rod progress along the run. When the joining of two metal sheets has been learned, stand one piece of sheet on its edge on the surface of another, and attempt to weld this. Watch carefully for the puddle to occur, and try to control it so that the two adjacent surfaces become molten at the same time. This means directing the torch towards the larger surface; the larger surface dissipates the heat and so takes longer to melt. When joining metal in this way has been achieved, try welding iron rod together, then rod to sheet, in fact as great a combination of thicknesses of metals as possible.

It should be stressed that a text book can only give general information and serve to introduce particular skills; it cannot be a substitute in any way for practice and actual experience.

When basic exercises in welding have been carried out, a sculpture should be attempted and the inevitable involvement with indefinable problems experienced. One must stress the importance of planning and jigging (setting up) the metal components to be welded, and the cleaning of surfaces prior to welding. Time spent cleaning, and jigging the metal, is always time well spent and should not be slighted or given scant attention.

Brazing compared with welding is comparatively simple and is carried out in the following way. The parent metals are cleaned and prepared for brazing; any dirt or oil or rust is removed. The parent metals are then heated to just about red-heat, and to these metals, whilst they are red hot, a flux (basically borax) is applied. The flux is used to clean the metal, preparing it finally for the brazing alloy, and to cause this alloy to run quickly and freely over the heated parts of the parent metals. Only sufficient alloy to run over these heated areas is necessary. Adhesion is caused by the contraction of the pores of the parent metal upon cooling around the alloy, which has run freely into them. A brazed joint is as strong as the parent metals, but will of course become non-existent if the work is again heated up to the melting point of the alloy. A point to remember is that only those parts of the work which have been allowed to reach red heat will be brazed satisfactorily.

Arc welding is an alternative to oxy-acetylene welding/brazing. This appliance is electrical and uses no gas. It is expensive equipment. Arc welding is mainly used for welding thick metals together—anything from 6 mm ($\frac{1}{4}$ in.) upwards—or for welding castings of various kinds. Although there are now on the market small arc welding appliances which can be plugged into an ordinary household electrical supply, the best equipment needs an industrial supply, which puts it outside the range of most sculptors. It is best to take any arc welding required to a professional welding shop, which will be fully equipped to cope with almost any thickness metal you require.

A simple explanation of the principle of arc welding is as follows: electricity passing through the welding rod jumps from the rod to the

parent metal causing an arc. The heat energy of this arc penetrates and melts the parent metals at this point. Simultaneously with the striking of the arc, the heat penetration and melting, the rod deposits a bead of molten metal which joins the parent metals together.

'Coo Wha Zee'. Welded auto metal by John Chamberlain
By courtesy of the Leo Castelli Gallery, New York
Photograph: Rudolph Burckhardt

The basic equipment for arc welding is the appliance which transforms an electric current to the necessary voltage output required to create the arc. From the appliance run two leads, one for the electrode holder, and one for an earth clamp. The holder grips the specially flux-coated welding rod or electrode, and passes the current from the transformer to the tip of the welding rod or electrode. The parent metals to be welded must be earthed. Slag is formed also at the arc weld caused by the flex of the electrode. This has to be chipped away with the chipping hammer before further welding can be done. The hammer can also be used to clear the slag from the edges of metal which has been cut with a cutting torch.

The light which comes from the electric arc is extremely intense, more intense than from an oxy-acetylene flame, therefore a special mask of very thick, very dark glass is necessary. This mask also covers the whole face and head to protect it from the arc light, which can burn. Protective clothing is also required because of this heat, and leather and asbestos gauntlets are worn to protect the hands and arms. Arc welding, although very efficient, and indeed the best way of welding very thick metals together, is not the most convenient. A small appliance may prove useful for welding plates together without distortion, but generally what can be done on a small arc welding appliance can be done too with oxy-acetylene, by welding or brazing joints.

Argon arc welding is another specialised method of welding, mainly used for aluminium. This depends upon an inert gas, argon or helium, to shroud or protect the spot where the weld is being made. The torch holder contains passages for a cooling stream of water, and a stream of this inert gas plus the electric current to be carried to the place to be welded. This method is even more expensive than arc welding, and again a commercial welding shop will probably be able to weld with argon arc for you, should this be necessary.

The secret of welded sculpture, and the construction of welded sculpture, is in the jigging or placing of component parts to be in the most favourable position for welding or brazing. A well-jigged work is usually more successful than that which is not. Random welding, simply sticking one piece of metal to another, and having done so re-heating and fashioning this into some semblance of an image, does not very often pay dividends. Whereas the sculpture intelligently and sensibly planned and constructed is often most successful. This means that pieces are cut to fit, and edges are cleaned well enough at least to

make a secure bond. Pieces that can be pre-shaped are shaped before fixing. The whole sculpture is made secure from its roots—up and out —so that a sculpture almost grows into existence.

Refined welding, such as welding non-ferrous metals, requires an appliance which has a DC output, whereas ferrous metals can be handled by a less complicated and less expensive AC output. The handling of non-ferrous metal welding is best learned from a skilled and experienced operator, at a vocational training centre, for instance. Some suppliers of welding equipment actually run courses in the use of equipment, plus specialised application of welding and

Reg Butler at work with a welding torch and metal tool on a bronze figure 'The Oracle', the original of which stands in Hatfield Technical College Radio Times Hulton Picture Library

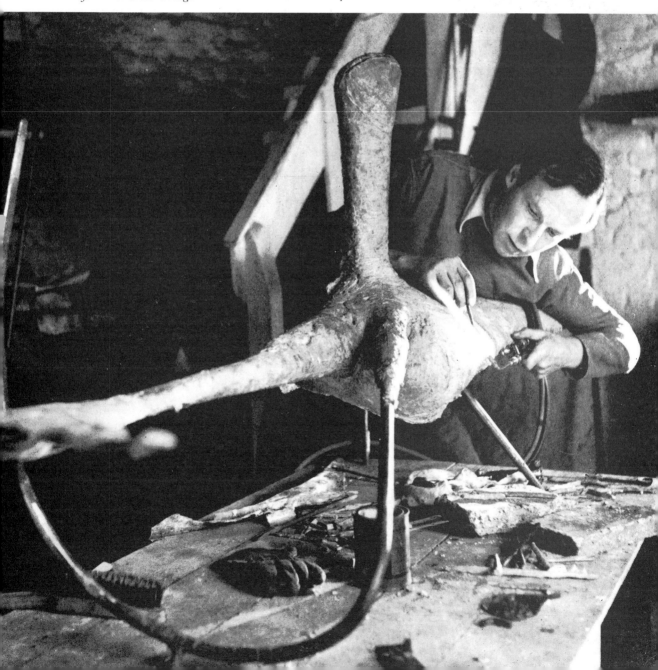

brazing. One can only advise the interested beginner to seek such professional commercial experience and become proficient in this way.

For those who either have no opportunity to do this, or prefer to plod a lone trail, I can only reiterate that the major part of learning welding and brazing lies in constant practice.

Nearly all metals can be welded to metals of their own kind. One must use the correct welding rod and flux and practise well before starting an actual work. The supplier will provide the correct rod and flux and relevant information if asked and given the technical specification of the metal to be welded. Apart from mild steel, which can always be welded with a common mild steel rod, pieces of interesting metal can only be welded if the nature of that metal is known.

A sculptor may become interested in combinations of various metals, which is in itself a fascinating medium, and find that although welding is impossible the problem can almost always be solved by brazing. In more ancient times combinations of metals were put together simply by riveting and chasing them, but the rivet was liable to break, and any other means such as inlaying was very difficult to accomplish and nearly always lost when one metal fell away from another, being merely pinned in position. Metals of various kinds and character can nearly always be brazed together. Bronze or brass can be fixed to steel, copper to stainless steel, copper to aluminium and so on. The brazing rod itself gives yet another kind of metal, so that the impact of colour and texture achieved by fixing two metals together may be heightened by the third colour and character of the brazing rod itself. It is not necessary to have oxy-acetylene equipment to do simple brazing, as natural gas such as butane or coal gas may be used. A brazing nozzle can be purchased at a reasonable cost to work from an ordinary household gas supply, which will produce sufficient heat for brazing. Students could be introduced to brazing with such a simple tool.

The items of equipment necessary for welding and brazing include the following:

The basic bottles of oxygen and acetylene, gauges, hosepipes, torch and selection of nozzles.

Cutting torch and a selection of nozzles.

Protective goggles.

Asbestos gloves.

Welding rods in various gauges.

Brazing rods in various gauges and the appropriate fluxes.

Spanners, wrenches, vice grips.

Anvil.

Asbestos sheets, and firebricks to weld upon.

Wire brushes.

A large selection of files and abrasive tools.

A selection of electric tools, drills, rotary wire brushes, grinders, buffers, polishers, etc.

Constructions

A form of sculpture which has increasingly developed over the last half-century is 'Collage' or 'Assemblage', the titles being self-explanatory. 'Collage' is usually used to describe an image made of items or objects fixed to a two-dimensional plane, and 'Assemblage' a construction of items to make a three-dimensional image. The operative words are, I think, 'Assembled' and 'Image'.

Obviously it would be foolish to try to advise on the process of collage or assemblage, because this depends entirely upon the components and the image to be worked. However, to be successful the assembled items must be fixed securely, without fear of falling to pieces. The usual and obvious methods such as drilling and screwing, drilling and bolting, threading and bolting are used very widely. Liberal use of modern adhesives is obvious and they should be used. The method of fixing, however, should not be too obvious. It must be secure but hidden, so that the most successful assemblages appear to be, quite simply, *together*. The skill in fixing contributes greatly to the success of the image and helps the aura or presence that a sculpturally-felt assemblage can have. Collages and assemblages usually include items of everyday life, *objet trouvé*, such as chair legs, picture frames, tables, chairs, etc, and the successful image usurps the identity of the origin of the component parts, so that a table can become an animal or two toy cars a chimpanzee. Any item can be fixed to another in some way.

This art form has a strange seductive quality and benefits a great deal from very interesting combinations of material. Images at once evoke their own character and nature, and at the same time are enhanced by sensual familiarity of items taken from the immediate environment. Assemblages are sometimes made by pressing various components into clay, then making wax castings from these clay negatives. The wax components are then very easily fixed together to make a specific image. The wax image can then be cast, via the lost-wax process, into a metal.

Metal components can be made by pressing various items into sand, and pouring the molten metal straight into this sand mould. These components can then be assembled by means of bolting, welding or brazing.

There obviously can be no rules or definable methods for making this kind of sculpture, but it should be part of the creative process, not one of calculation and forced usage of components. This use of odd items of stuff, assembled to make an image, was described to me by the late George Fullard who was at the time very much concerned with upon one by the very paraphernalia which one collects about one;

The late George Fullard making an assemblage sculpture
'The Infant St George' *Photograph: Crispin Eurich*

collected perhaps for reasons other than sculpture, or for no specific reason at all. The image is only successful, however, when it usurps the identity of the assembled components. The final sculpture must be well made.'

Recognition and understanding of the visual impact and stimulus of objects is a vital part of this kind of sculpture, and is also a most important aspect of any visual art form. Such recognition should be encouraged and exploited as much as possible.

Some exploitation of the impact of diverse objects is manifest in the form of a design called *objet trouvé*. This is simply the evocation of an image by presenting a found form, this found object requiring nothing more than presentation. Objects found on beaches have been the most common source of such *objet trouvé*, providing such things as tree roots, which have been washed and rubbed by the sea, and stones, weathered and worn, which by some quirk of fate have come to resemble particular figures. Man-made objects washed up on beaches after long periods of battering and abrasion by the sea provide interesting manifestations. Since an image no longer need be representational, found objects have come from a much wider source, industry providing a mainstream of stimulus for the assembler. Machine parts, and awareness of the beauty of an object designed purely as a functional item, have become yet another source of stimulus. Functional objects abandoned and left to the elements, acquiring fine patinas and interesting shapes by corrosion, have become another hunting ground of *objet trouvé*. The crushing machines now employed to squash whole automobiles into consolidated rectangular blocks have become tools of the trade, and the blocks made by these machines have been mounted and exhibited as interesting shapes and forms worthy of some consideration and study. I am sure the industrial scrap heaps of the world await further investigation in this way, providing differing sources of stimulus and form, some good, some bad, but all useful in that further freedom from academic thought and tradition is gained, enabling one to use traditional materials in a much freer way, seeing them again in a fresh light, clearing the air for a proper understanding of the importance of the image.

Simple constructions can be made, but suitable for interior application only, or for teaching basic design principles, from balsa wood. This material is often used solely for model making, but with the advent of collage and assemblage as an art form, I think it can be exploited to some value in many other applications, especially in conjunction with other materials. Its weakness is the most disconcerting factor of this material, plus the fact that it can be easily marked with the finger nail, or some hard edge or other. But used perhaps within a clear plastic, or under glass, there is no reason why it should not be entirely satisfactory. It is very easy to pin together or glue. It is

'Woman' by the late George Fullard. Wooden construction, a powerful image typical of Fullard's strong imagery Photograph: John W Mills

easy to cut and shape, and for certain applications it is an admirable
medium.

Expanded polystyrene is similar in character to balsa wood in that it is
light and easily marked. It can, however, be bought in much larger
blocks and found in an infinite variety of shapes. (It is used for packing
in almost every branch of the retail trades.) It has the added advantage
that any component made with expanded polystyrene can very easily
be turned into metal, then assembled.

Expanded polystyrene can be easily glued, using polystyrene adhe-
sive. Other ordinary adhesives cause the polystyrene to dissolve and
disappear as it has the extraordinary quality of volatising and dis-
appearing when heat is applied to it, either in the form of a naked
flame, as hot iron tools, or molten metal. This material can be cut with
a resistance wire cutter and in its various grades and types provides a
wide variety of forms and surfaces. Surface texture and design can be
exploited by engraving texture or pattern. This engraved pattern can
be filled with coloured resin to provide a final form. The engraved
pattern can be the negative mould into which any number of
materials may be poured to make positive castings.

It is possible to use a block made in this way as a printing or graphic

media. Prints can be pulled from the surface in the same way as lino-cuts or woodcuts.

Expanded polystyrene (*Styrofoam*) contains an exceptional hazard however, which is the fact that particles if inhaled remain in the body. No digestive acids break it down, and it floats on all liquids and therefore cannot be evacuated. It is essential therefore to wear a mask whenever using this material or indeed any foamed plastic, polyurethane or polystyrene.

Another plastic which can be assembled and constructed is acrylic resin, *Perspex* or *Plexiglass*. This can be bought in transparent colourless sheets or blocks, and also in a range of translucent and opaque colours.

This plastic can be cut and filed and carved into any form required. Carving can be done in the same way and using the same kind of sharp hardened chisel as for wood carving. A cut, scratched or filed line, will show up as a pale opaque mark. Such marks can be polished after if necessary to regain the original clear transparency.

Acrylic can be carved from the block or cut and built up from the sheet form. Pieces can be stuck together by simply using the same plastic in a liquid state. The liquid consists of the basic resin plus a catalyst.

Constructions or assemblages made from clear acrylic have a unique quality which comes from the transparency, and hence the refraction of light. Glass or crystal are the only other materials which have this quality, and they are not so easily handled.

Sheet acrylic can be softened by gentle heating and moulded into a shape or form whilst softened in this way. It can be softened using a shrouded electric element making it possible to form acute angles and a wide range of shapes. Being a thermoplastic, however, it can only be shaped when hot, it hardens on cooling.

Colour, too, can be used well with this medium because the basic liquid acrylic is in fact a fine medium for ordinary oil pigment. Colour can be mixed with this liquid and simply painted straight on to a perspex form. The colour will be as permanent as the plastic itself.

Acrylic, and most thermoplastic resins can be vacuum formed using a *vacuum forming process*, which simply means pulling softened plastic sheet quickly down over a pattern by means of a vacuum pump. The shape of the pattery being retained by the hardened resin. This process is explained further in my book *The Technique of Casting for Sculpture*, as is the forming process of *blow moulding*. This simply is placing an envelope of softened plastic sheet, fitted with an air valve, into a mould cavity and inflating it to take the shape of the mould when it hardens. Variations on these processes can be made by the enterprising and mechanically minded, but it is usually possible to employ an industrial service to make the forming according to your specification.

Armatures

Any sculpture built up in a malleable material requires an armature or support which is strong and secure. The armature is in some respects similar to the human skeleton inasmuch as it is the structural strength about which the softer amorphous material is disposed to make a particular image or form. It is as important as the internal structure of a building. Most constructions are as strong as their internal structure only.

Clay has no tensile strength, as I have said, and cannot be built to any height without a substantial armature. This armature must be capable of supporting solid or near-solid clay forms. Clay needs to be well consolidated about the armature to allow free working, and support must be offered for as long as possible. Time spent on modelling a clay sculpture may vary from a few days to months or perhaps years, before completion.

Plaster of paris is very brittle and liable to crack when hard, and so requires a firm armature. This material is strongest when made into hollow forms reinforced with scrim. Hollow plaster castings are stronger than solid casts. Armature for casting is described on pages 91–92. The armature made for a direct plaster sculpture should be constructed to allow and exploit the hollow structure.

When using any brittle materials for direct building, such as concrete or the various resins, you should follow the same principles as for direct working in plaster of paris.

Wax, being a light flexible material, requires little in the way of armatures except that described in the chapter on lost-wax casting.

Assemblages may be constructed from material which can be self-supporting, having good tensile strength, such as wood or metal. If they are made from materials which have no tensile strength, then a suitable armature must be made to afford the strongest support.

The following examples are given as a guide to providing suitable supports for whatever material is used. No predetermined pattern can be given. The special requirements of the projected sculpture create the need for a certain amount of invention in the matter of the armature as well as the form of the sculpture.

Clay reliefs Armatures necessary for a clay relief should be designed according to the height of the relief to be modelled. Basically all you need is for the clay to remain attached to the board. Small reliefs can be easily supported by simply hammering large-headed nails into the board and binding wire between the nails to form a key. This system will hold a substantial weight of clay. A relief up to about 15·24 sq m (5 sq ft) can be handled in this way. Larger works require of course larger and more substantial keying material. Wooden laths can be attached to a board and built up to provide adequate support. Laths can be built out to any thickness and will properly support the weight vertically. It is always best to model a relief in a position and light similar to that in which it will be finally seen. Butterflies made from two pieces of lath crossed and bound together with wire can be hung

from the background, too, to support a great weight. Armatures for reliefs have the advantage of gaining strength from the background which supports the armature.

Figures in high relief require a more elaborate armature. This armature gains its support by the very fact of being attached to the background, and so is best made from an aluminium composition which can be altered and shaped easily. The armature, being placed at the centre axis of any form, affords the greatest support.

Clay figures The armature should be as secure as possible; it should not whip or move loosely. An armature which is loose or whips under pressure is as impractical as a banker or stand which is not stable, and all these should be avoided. An armature must allow positive direct modelling, not modelling on the rebound. The armature must be constructed from material strong enough to take the weight of the clay that will eventually cover it. A basic support can be made from a suitable gauge mild steel, and cannot be bettered. Around this basic support are fixed malleable skeletal forms, which depend for their strength upon the mild steel. These skeletal forms are best made from a flexible material. In the past lead piping was used for this, but today a much cheaper material, and one which does not deteriorate in the same way, is an aluminium composition wire which is pliable and strong. It can be bought in various thicknesses. Although very pliable if twisted along its length, the tensile strength of this wire can be increased without losing the advantage of being able to alter the shape if required. It is an advantage if the armature can take up much of the bulk of the forms to be modelled. This may be done by wiring to the metal armature wood or cork, or expanded polystyrene, to take up the bulk and to make lighter the weight to be carried by the armature. In this way the steel support can cover a much wider area and the butterflies stop the clay from slipping. It is always advisable when building an armature to bind pieces of lath or wood of a similar size, to the metal of the armature. This helps to strengthen the whole frame when the moisture in the clay causes the wood to swell, making a tighter fit on the metal and providing a key to hold the clay in place, especially on long forms such as arms and legs.

The mild steel support may be located in the centre of the supporting forms of the sculpture, as for instance in both legs, or in one leg of a figure. Alternatively, it may be situated outside of the figure altogether, having a projection into the sculpture from which the skeletal forms, made entirely from malleable material, such as aluminium wire, can be hung. This is called a *back iron* and is often used in art schools for modelling from life. It has the advantage in that a firm armature can be built quickly, but a disadvantage in that the area into which the back iron protrudes cannot be modelled. The mild steel support running up the centre of the form is ideal, but more difficult to make. However, I think the effort is well worth it. If, for instance, one support is made very strong and is well anchored to the base board, all other forms can be moved about this support (opposite). In this way it is possible to overcome the extra problem of fixing all forms with the distinct possibility of miscalculating distances between

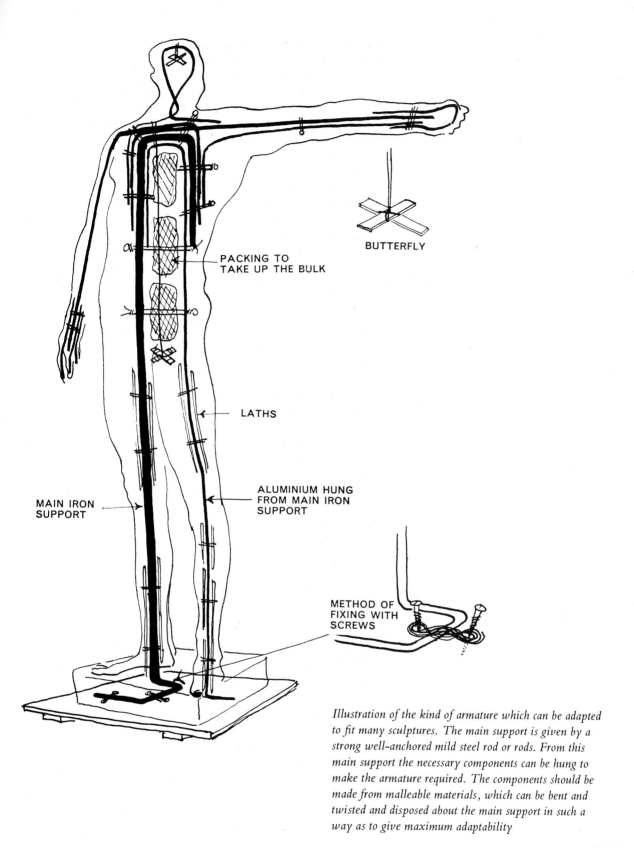

BUTTERFLY

PACKING TO
TAKE UP THE BULK

LATHS

ALUMINIUM HUNG
FROM MAIN IRON
SUPPORT

MAIN IRON
SUPPORT

METHOD OF
FIXING WITH
SCREWS

Illustration of the kind of armature which can be adapted to fit many sculptures. The main support is given by a strong well-anchored mild steel rod or rods. From this main support the necessary components can be hung to make the armature required. The components should be made from malleable materials, which can be bent and twisted and disposed about the main support in such a way as to give maximum adaptability

them. It is always advisable to be able to move the weight of at least one form at any time during the modelling.

All the above information is given for an armature of life size or more, but all smaller armatures may be derived from this, and the principles are the same. Much of the bulk support, the butterflies, etc, may be dispensed with, but the problem remains to make a stable armature around which to build the clay, and which will also support the clay.

Useful things I have found, which afford basic internal support, are steel piping with a thread at one end which is screwed into a flange which, in turn, is screwed or bolted securely on to a suitable wooden base board. These can be made by a plumber or gas-fitter if you cannot do it yourself. Ideally a range of sizes should be made, differing in gauge and length. For instance, a short pipe can be easily made into a head peg by cutting two lengths of aluminium wire, bending them double and slipping them into the neck of the pipe as far down as you can, leaving loops protruding from the pipe large enough to support the head you intend to model. The loops should be crossed. A large pipe may be made into a very strong back iron by simply wedging a double L-shaped pipe into the neck; from which the malleable skeletal wire can be hung. I have illustrated the traditional back iron and head peg, together with the method I use personally, so that the reader may select that which most suits him and the material available to him. Chicken wire is also useful in armature building to provide a shell form which can be bent and altered to suit the image required.

Armatures for clay are best constructed from easily assembled material, so that they can be removed without difficulty from the plaster mould during casting. Welded armatures are generally a bad idea for clay, unless they can be designed in components, which can easily be taken from inside the mould. If an armature protrudes, and is to be part of the final sculpture, it can be welded and included in the mould and casting. The protruding part may become part of the fabric of the mould, then simply chipped out to form part of the positive.

This method of leaving part of the other material, such as wood or bolts, nails, etc, can be used to considerable effect. Exposed aggregates can be carefully selected and placed in this way too (see page 92).

Armature and back irons: A An armature made from malleable wire, aluminium or lead composition, suspended from a back iron. This is basically the form that any figure armature may have, variation being of course made according to the position of the figure or figures and the size that it is to be made. Heavier gauge metal and wire, a more substantial back iron, the use of butterflies and laths, plus some packing to take up the bulk of the weight of clay, would be necessary for a figure of about life size

B Illustrates a back iron made by slipping an iron, of suitable shape and size according to the particular job, into a tube fixed to a base board. The tube is secured by means of a threaded flange screwed to the base board. C Shows an adjustable back iron, which can be made almost any size. The support from which an armature can be suspended is able to be moved up or down the main support. The main support is a tube secured in the same way as in B

Armatures for brittle materials, plaster of paris, concrete and resins

Armatures for these materials need to be exceedingly strong, to provide the necessary tensile strength lacking in the material.

For most forms, an armature constructed basically from mild steel rod, then covered with an expanded wire framework, is most suitable. The mild steel rod should be designed in such a way as to afford the basic direct strength to the form or figure. The rod needs to be fixed securely to a base. The base may be wooden and the rod simply screwed down to this. It may be of plaster or concrete and the rods cast into the plaster or concrete. To do this a shuttering of clay or wood should be made deep enough to make the thickness of the base. Into this shuttering the mild steel rods should be propped, then around these rods the plaster poured or concrete packed, and then left to set hard. If wood is used as the shuttering it should be painted with a release agent such as oil or a clay wash. When the base has set, knock away the shuttering, and the mild steel rod will be fixed well into this base ready to be built up further to form the armature.

To the basic mild steel supporting rods, which have been welded or wired together, you can now fix an expanded metal or chicken wire form on which the modelling material can be spread. The completed armature should be kept well below the surface of the modelling material, giving scope to build and add up to the final sculptured form. The armature for a brittle hard medium becomes more rigid when the material itself has been applied and is set. With concretes and resins, of course, the total strength must be worked out according to the final site, and extra reinforcement placed, if necessary, to give more support. Generally the rigidity of an inflexible material can strengthen an armature, so that the basic difference between an armature for clay, which never hardens, and an armature for a material which does, should be given great attention.

All mild steel or corrosive metal used in plaster should be rust-proofed by painting with brunswick black or with a wax and natural resin mixture.

Basic support to which the expanded metal or chicken wire is attached can be made from timber. This can be quite strong enough and has the advantage of being light in weight, and easily sawn, too, to make joints for the foundry.

Endeavour to develop a sense of structure. Most sculptors I know have a kind of sixth sense, by which they can detect a weak and vulnerable point in an armature. This sense comes from being familiar with the relative weights of the materials and the kind of pounding, hammering, scraping, etc, which the modelling materials demand. Everything is adjusted to this.

LOCKING WING NUT

Diagrams illustrating variations for an efficient head armature made from a pipe or tube, fitted to a base board by means of a flange and screws. The loops of armature, which describe the approximate shape of the head in the two profiles, front to back and from side to side, are slipped well down into the tube to gain the maximum support. The main tube should be long enough to make a bust, down to the waist or further. It may also include a cross member from which armature can be supported for arms

Direct media

Familiarity with the processes of working directly in any medium obviously makes you aware of what is required from an armature made to support that medium.

Clay, for example, is very heavy when wet, and so an armature for clay must be able to withstand the weight and the pounding necessary to consolidate the clay about the armature.

Plaster of paris is an intermediary material and a brittle one. The mixed plaster is applied to the expanded metal armature. To do this jute scrim is dipped into the plaster and laid on to the armature. This binds the plaster to the metal and stops it from simply dropping through. Newspaper dipped into the plaster in the same way does the same job. The image is modelled finally with plaster, using steel spatulas. When the plaster sets hard it can be carved, riffled, cut and chipped. Often all these methods are used. An amalgam of modelled and carved surfaces results, giving an appearance and feeling which is unique to working directly with plaster.

The armature must be constructed to withstand these techniques, so that the plaster is held firmly and does not fracture. The work must be kept damp so that moisture is not drawn from fresh plaster. The addition of poly-cellulose filler 1–1 with plaster helps to achieve a well-bound surface. Plaster of paris can be retarded by adding diluted glue size to the water in which the plaster is mixed. The more concentrated the size the longer the plaster takes to set. Vinegar and urine also retard the setting plaster. Plaster of paris hardening can be accelerated by mixing the plaster in warm water.

Concrete and resin are final materials which can be used in similar ways to plaster of paris, in so far as they are applied to the armature and allowed to harden and then chipped, carved and abraded. The armature must also be able to withstand transporting and abuse of one kind or another. This armature, therefore, must be designed so that all otherwise vulnerable parts are strengthened according to any transportation or abuse, such as being climbed upon by small boys.

Concrete can be built up around an armature with a trowel or a spatula. The armature needs to be sufficiently well keyed to allow the wet, heavy concrete to remain in position until it sets. Expanded metal is the most suitable material for this. To help the concrete mixture to hang together more easily, some loose chopped strand fibre-glass may be added to the mix. This helps the concrete to bind more readily and so stay in position.

Concrete can be poured between shuttered surfaces, similar to those used in the building industry. On large works this is an extremely simple and economic technique. The shuttering can be made from wood, clay or expanded polystyrene or any material which can be fixed in position, and sealed long enough for the concrete to remain

'The Arm' in bronze, modelled direct in plaster by
Pablo Picasso The Hanover Gallery, London

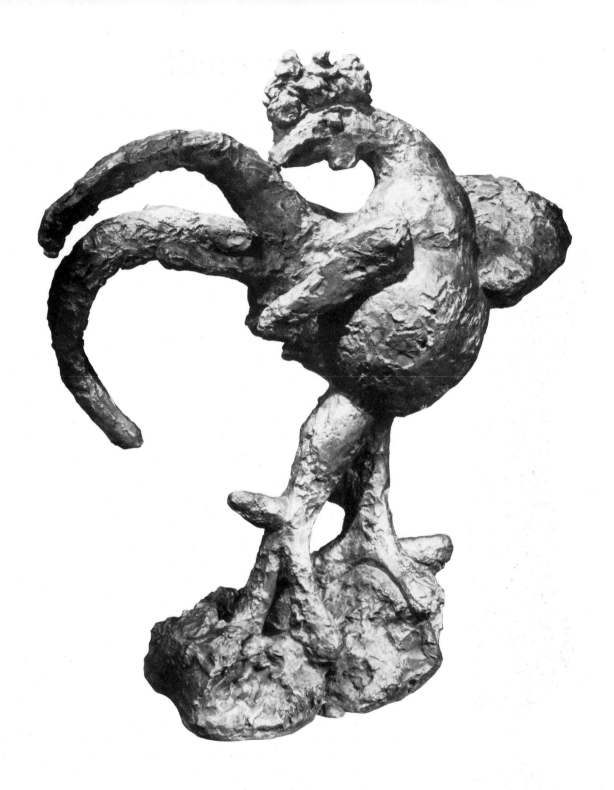

'The Cock' in bronze by Pablo Picasso. This was made
in direct plaster. The applications of wet material can be
seen clearly The Tate Gallery, London

in position and set. The shuttering is then removed, leaving the concrete shape. This concrete form can then be carved and embellished accordingly. Extra reinforcement can be placed between the shuttering to make a particular form as strong as possible.

Exposed aggregate finishes can be exploited by fixing various items, marble or glass, metal, plastic or resin inserts to the shuttering with a water-soluble glue which can be easily washed away when the shuttering is removed. The insert can then be treated in whatever way the sculptor wishes; polished, scraped or carved, etc. Some study of techniques of the building industry should be made by those interested in using concrete on a large scale.

Very large relief sculptures have been made directly in concrete, and the following method will give an idea of how direct this medium can be. The mould is made directly in a fine casting sand. The sculptor works the negative form. If the work is to be fixed in sections, as is usually the case, fixing and locating devices are placed along the edges of the sand mould to be cast into the final concrete thickness. The sand negative is well consolidated during the modelling so as to be able to stand up to the placing of the concrete.

The concrete is poured and packed carefully into this mould to make the casting. Reinforcement is placed in the thickness of the cast. The reinforcement is of cross-laced mild steel or high tensile steel, preferably to an engineer's specification. On a particularly large area, the advice of a structural engineer should be sought. He will be able to

Henry Moore at work on small studies and maquettes which later will be enlarged Photograph: John Hedgecoe

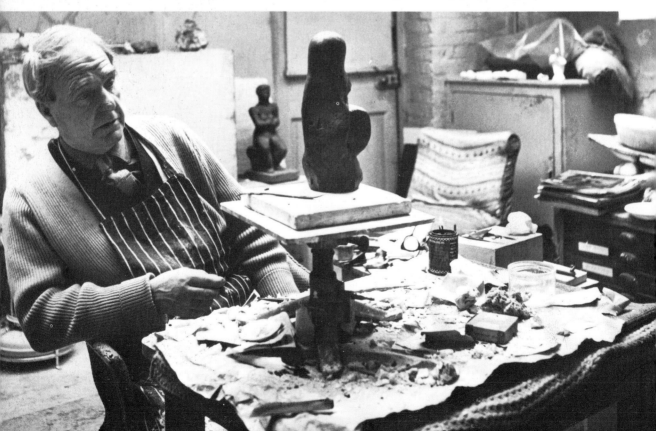

work out specific stresses and strains, and advise the kind of ratio of reinforcement necessary. When this has been carefully worked out to gain the greatest possible strength, it can be placed by being supported around the edges of the mould and held to hang in the centre, or where necessary, within the thickness of concrete, whilst the concrete is poured and packed. Alternatively, part of the thickness can be built up with concrete, and iron hooks placed in that concrete to which the main reinforcement can be welded. One can only advise some study of industrial techniques to help solve most of the difficulties encountered in dealing with a large surface area of concrete.

Surface areas up to about 15 or 18 sq m (5 or 6 sq ft) can be cast very satisfactorily using the method described for filling any mould, using laminates of concrete and fibreglass.

Casting from sand negatives gives a granular surface finish. This can of course be ground and abraded to a finer surface.

'Locking Piece' in the studio *Photograph: John Hedgecoe*

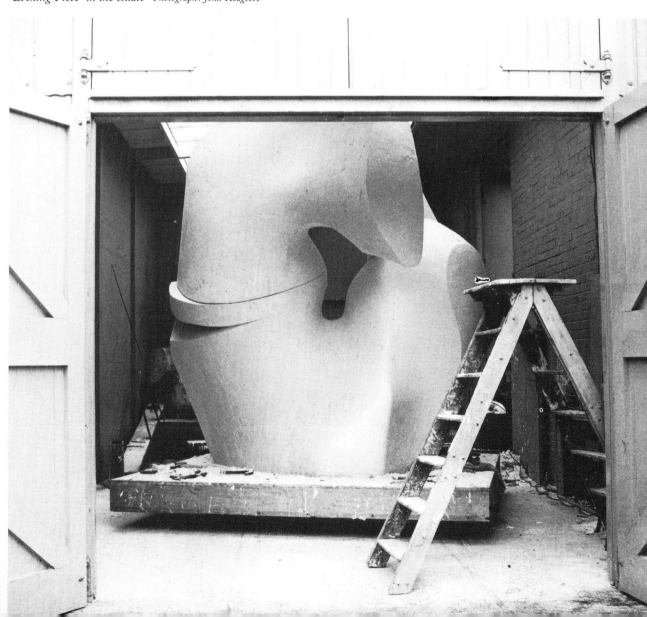

Working directly with resin can be done using similar techniques to building directly with plaster of paris.

The resin is a much more sticky material and can be harmful to the skin. Rubber gloves give good protection and are fairly easy to work in. Failing that a good barrier cream should be applied to the hands before using resin. Always wash off, with detergent, any resin that may get on to the skin before it sets.

To be able to work with the resin to build up around an armature, a filling of some kind must be used which will take up the bulk of the form yet be able to be saturated with resin. The best material for this is a glass fibre wool, such as that used for insulating house attics. This is similar to cotton wool in appearance. Hanks of this wool can be dipped into the resin-accelerator-catalyst mix, then applied to the armature to build up the form. Resins loaded with up to 80 per cent of inert filler will hold to near vertical surfaces, and if required a thixotropic resin can be purchased from any resin supplier or manufacturer, this is a highly viscous resin.

When set hard, and it is advisable to use quite a rapid setting mixture, the resin form can be filed, ground, abraded and polished to a final surface.

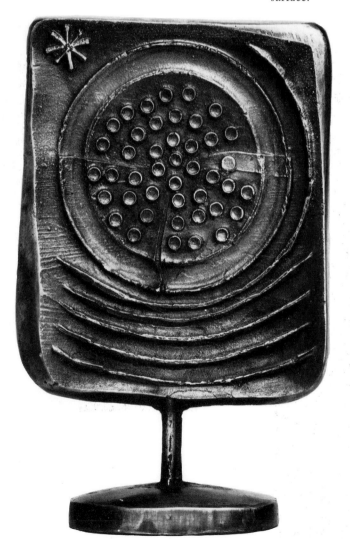

Sculptures by Canadian Don Wallace which illustrate some of the possibilities of making a negative in sand or clay, then making positive sculptures by casting directly from this Photographs: Ron Vickers

Continued experiment with the material is the only way to develop both a vocabulary of information and technical skill, and always be aware of recent research by the manufacturers so that new materials or methods can be added to your knowledge.

A direct method for making reliefs from various metals is by etching. Such metals as mild steel, copper, bronze and zinc can all be treated in this way. The principal is this: any part of the design which is to be lower than the surface of the original sheet or block must be exposed to an acid such as nitric acid. Those parts to be left are painted with a resistant wax or varnish. When these parts have been painted, including the reverse side, immerse the metal in a bath of acid. The longer the metal remains in the acid, the deeper the bite. The metal can be removed at intervals, and further parts stopped out to vary the relief. The acid must be washed off each time the metal is removed. The whole technique is similar to the graphic art of etching, but for a different end result. Study of etching techniques, however, would be invaluable to anyone wishing to develop this technique for relief. The final relief can be coloured by inking up the result as in printmaking, and wiping off the surplus colour. The metal can be revealed and polished to show through this, otherwise patination can be achieved in the same way as for any other metal sculpture.

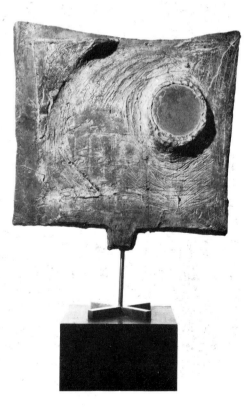

145

Finishes

The finish or patina given to a sculpture depends upon many things: the personal preference of the sculptor for a particular surface texture and colour; the final atmospheric environment of the sculpture, correlation with the colour and texture of an architectural setting; the nature of the material, and the range of effects which can be exploited, and which are inherent in the material itself.

Different materials have very different qualities, and often an infinite range of qualities are inherent in any one material. The artist and student is advised to try to ascertain these qualities whilst working with the particular media. It is generally not a good thing to try to impose a completely alien finish to a material if this can be better achieved in a more suitable one. Any applied finish should be considered during the making of the sculpture, so that a complete integration of form and finish is achieved, one coming directly as a result of the other.

The practical working sculptor, however, must know how to achieve many kinds of effect. He must be as aware as possible of the use of various media, acids, paints, etc, used to achieve a particular finish.

Stone of course is carved towards a very definite quality which results from the actual working of the stone. The natural finish achieved should exploit the inherent quality of the particular stone, whether it be consideration for a polished finish or not. If a specific colour is required, there is probably a stone of that colour to be found somewhere. On the whole stone is used for its own natural colour and quality.

There is no reason, however, why stone should not be painted. Nearly all ancient cultures have painted carved stone images to make a definite and particular effect, although the attractive examples we see have had their colour enhanced by weathering and time.

Personal experiment to find a suitable paint or colouring medium should be carried out. Most paints manufactured for outside paintwork can be used. Polyester resins, too, can be used, simply by mixing the desired colour of filled resin and applying this to the surface. This may be applied with a brush or built up in greater thicknesses to achieve a necessary effect.

Wood and its inherent qualities, in common with stone, must be carved with respect to these qualities being part and parcel of the actual carving technique, and the particular variety of wood being used. The variety of colour and textures in wood is enormous, and each sculptor will develop these to suit himself, so that a style develops which results directly from the carving.

Finishes such as waxing, oiling and polishing, which simply enhance the natural colour and grain, follow naturally the actual carving process.

Finishes applied to cover the grain and colour should not be an afterthought, but as far as possible part of the scheme of that particular

sculpture. Such finishes using paints or resins are similar to those for stone.

Polychrome sculpture is in fact almost always arrived at by similar means, ie paint or colour applied on top of a modelled or carved form. Paint for outside use suitable for stone will be perfectly good on wood. Resin inlays of various kinds and effects can be made on stone or wood, concrete or metal, and proper experiment will determine which is most suitable for any particular need.

The guiding factor of polychromatic sculpture is in the use of colour in relation to the form. One must complement the other. If the colour is badly applied or ill considered, it will destroy optically whatever form it is painted on. Stone which contains highly coloured particles may destroy the form, and so may the same kind of thing in concrete. Granite for instance often has specks of colour which can visually harm any carved form. I think those persons concerned with colouring a sculpture would be well advised to look at these things and further to study closely colour in nature. Colour can be an enhancement or camouflage of form in nature. On the one hand a particular form is embellished and made more attractive for various reasons, on the other, admirable optical disguise is effected, again for obvious reasons. The markings on a zebra, for instance, illustrate this point; optically, the same laws will apply to painted sculpture.

Non-ferrous metals are given a patina by various means. The most common is by oxidising the metal surface with chemicals to produce colours. The colour is in fact made by the corrosive action of the chemical upon the metal. These metals will be affected by the atmospheric environment into which they are placed, in the same way, because various chemicals in the atmosphere will oxidise and corrode the metal. This oxidising will be of a particular colour according to the dominant chemical in that atmosphere. Examples which spring to mind are firstly the atmosphere of industrial cities such as London, Leeds, or Turin, having a heavy sulphur element in the atmosphere which will make bronze turn almost black in colour; secondly a bronze sculpture sited near the sea will turn green because of the salt in the air. This green will vary according to the copper content of the alloy.

The exposure of metal to chemicals produces a film on the surface of oxides or sulphides. Producing this fine film of corrosion artificially is a very specialised and difficult job. No two persons using the same materials will usually obtain the same results. Many factors govern the art of artificial patination. They are temperature, control of the chemical, and the metal; purity of the chemical and the metal; clean working utensils and the nature of those utensils; care in preparing the metal, and the chemical formula, and cleaning the cast ready for patination. This is often done with ammonia to clean off any oil or grease. How the chemical is applied also conditions the nature of the patina. It may, for example, be brushed on or stippled on with a cloth dabber, or poured over the sculpture and allowed to run down.

Before taking on any kind of patination, a good look at the colour and state of the metal when it is first chipped out of the mould and

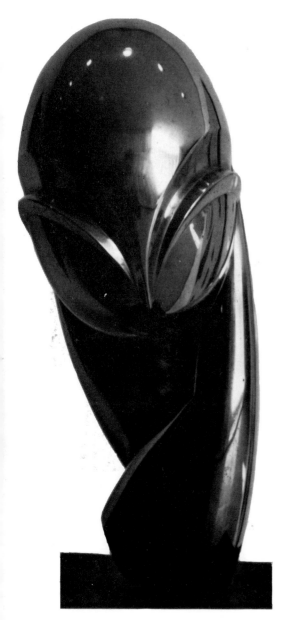

cleaned up may enlighten those used only to seeing bronze with an artificial patina. Raw bronze is a very fine colour indeed, and can be improved by simply giving a coating of oil. This natural colour varies according to the bronze formula.

The natural colour or colours of naked bronze can and must be preserved and protected from elemental oxidisation. This can be done by waxing the cleaned bronze with a good silicone wax. If the metal is heated, it will preserve a more durable amount of silicone in the pores of the metal. Another method is to apply a fine film of lacquer to the cleaned bronze surface. Lacquer will inevitably leave a shiny film which cannot be avoided, so the finer the film the less shiny and sticky will the surface be. Some polyvinyl resins can be painted to a bronze surface to protect the patina, and if these are rubbed over with appropriate thinners, after hardening, an attractive surface can be achieved. Advice should be sought from the resin manufacturers regarding a suitable resin for this.

These lacquers and resins can be removed from the bronze with the appropriate thinners or simply by heating and burning the lacquer or resin off. Heating will discolour the bronze, however, which will again have to be cleaned before commencing a fresh patina.

Polishing It is very common to see polished bronze and aluminium sculptures. This exploitation of the metal is probably more popular than patinated surfaces. See *Mlle Polgany* by Brancusi, (left). Polishing is not a complex problem, but one that requires care and patience. An electric polishing or buffing machine is used to best effect, electric hand drill will provide a useful substitute however. With these machines buffing mops made of linen or chamois leather or lambswool, are used with various rubbing compounds.

For bronze the following procedure, using an electric polisher is most effective: The surface must be hand finished as finely as possible, with files, emery cloth or wet and dry, and then dusted. Now using emery compound on a buffing head polish the surface. The emery will cut the surface and get rid of fine scratches. It will also round off sharp edges, a factor that may or may not be desirable. Deposits of emery must be washed off, when the surface is a smooth as possible at this stage. White spirit or ammonia can be used to do this. Another mop is now put on the machine and the polishing operation repeated using Tripoli compound, washing off residue after each buffing. Two further compounds are each with a separate polishing mop, these are White Diamond and Rouge compounds, used in that order. The surface will be as polished and brilliant as bronze will allow.

If you have to polish by hand because of the complexity of the work, the routing is the same, ie, emery-tripoli-white diamond-rouge. These are mixed as pastes beginning with powders of each compound. This process requires a great deal of effort as well as patience and care. For aluminium, use only emery. Wash off the compound residue, and buff with very fine steel wool. Finer rubbing compounds do very little to enhance the polish on this material, but experiment will allow

'Mlle Polgany in polished bronze by Constantin Brancusi
Collection of Albright-Know Museum, Buffalo Fine Arts Academy

you to judge for yourself and arrive at a personal treatment of surface commensurate with the forms you make.

Electroplating This is a method of applying a thin layer of metal to another metal surface, and can be a very effective treatment. It is possible to plate small items in the studio by making a small plating unit, but industry again can best deal with this requirement, and is equipped with the machinery and expertise to provide the best results. Cadmium, chromium, nickel, copper, bronze, gold and silver are the metals most commonly used for plating, and together with various finishes such as polishing or burnishing, they provide an interesting range of effects. Some resins can be plated and it will be worth consulting a good plating works to determine what they can deal with, and how best you can use their skills.

Anodising This is an electrochemical method for protective coating and colouring aluminium. The surface coating prevents corrosion by converting the aluminium surface to an oxide. A limited range of colour is possible.

Metal spraying is another method by which a metal surface can be applied to a completed form, but needs fairly sophisticated equipment and so again industrial assistance should be sought.

The simplest and oldest way of gaining a patina on bronze is to bury it in the ground for a long period of time. Antique bronzes have undergone this treatment and forgers have tried to achieve the same kind of effect as an antique bronze by burying the cast in a fresh manure heap to gain extra chemical corrosion, and quicken the process.

Sculptors, however, do not usually have the time necessary to earth a sculpture for long periods, or to put it in the sea, to gain more natural patinas. The most common patinations are artificial and are achieved by applying chemicals. These consist mainly of dark brown, nearly black colours, or shiny greens of considerable tonal range.

There are three basic methods of applying the chemicals. The first is done by heating the bronze with a blowlamp held in one hand, whilst the other applies the chemical to the heated area. The chemical may be applied with a brush or with an improvised dabber such as a pad of absorbent material on a wooden rod, which can be dipped into the chemical and dabbed on to the heated area. The bronze must be washed periodically so as not to over-oxidise the surface, as this can result in the loss of detailed modelling.

The alternative to applying chemicals to a heated surface is naturally the application of cold chemicals to a cold surface. This eliminates any great risk of over-oxidising the surface, but has the disadvantage of working much slower.

The third and most difficult method is placing the bronze into a chemically charged atmosphere. This provides the most even colour, and is the least damaging to the surface.

Green colours are achieved by many different chemical formulae, but

'Magister Ludi'. Chrome plated steel car bumpers by Jason Seley Private Collection, New York Photograph: Charles Uht

149

almost all contain a proportion of sal ammoniac (ammonium chloride). When used on its own, on copper or on bronze, sal ammoniac is perhaps too violent and should be diluted with water, or mixed with less violent chemicals. Here are some formulae for patinating allows with a fairly high copper content:

Apple green:	Ammonia	113 ml	4 fl oz
	Sodium chloride	142 g	5 oz
	Acetic acid (vinegar)	1136 ml	1 quart
	Ammonium chloride	142 g	5 oz

Multiply these amounts by whatever number you wish, to make a larger quantity of the same proportion.

Antique green:	Copper sulphate	14 g	$\frac{1}{2}$ oz
	Ammonium chloride	85 g	3 oz
	Water	1136 ml	1 quart

Multiply to make larger quantities.

Browns:	Potassium sulphide	7 g	$\frac{1}{4}$ oz
	Barium sulphide	28 g	1 oz
	Ammonia	56 ml	2 fl oz
	Water	2273 ml	3 quarts

Multiply to make larger quantities.

| Black: | Ammonium sulphide | 56 g | 2 oz |
| | Water | 1136 ml | 1 quart |

Multiply to make larger quantities.

These formulae are all best made with warm to boiling water, and will react quicker if applied warm or to a heated metal. The action of any of these formulae, when applied cold, can be speeded up by covering the metal casting with a plastic sheet.

Aluminium can be given a black patina by immersing the sculpture in a bath of solution made from the following chemicals:

Caustic soda	113 g	4 oz
Calcium chloride	28 g	1 oz
Water	1136 ml	1 quart

Multiply to make a larger quantity.

Personally I have found that attractive patinas can be best achieved on aluminium by using paint. Any colour can be applied. Further, if when the paint has dried you rub through this with wire wool to reveal the metal, then polish that metal with a metal polish and very fine wet and dry emery cloths, a very attractive patina can be achieved. The metal polish leaves a deposit in hollows, which can be brushed out if not wanted. The resulting patina, made in this way, is often much richer and more dense than can be achieved on aluminium in other ways. The patina can be fixed with a lacquer or resin application.

Most metals will respond favourably to a series of buffing wheels, and I feel that the inherent quality of the metal can be best exploited in this

way. Lead particularly responds to buffing and polishing. Fine abrasives can be used with these wheels to provide a finer polish, but should be carefully selected. Jewellers' rouge is the finest of the traditional fine abrasives. Today carborundum impregnated rubber and buffing and polishing wheels can be bought in various grades, and are very useful tools indeed.

Mild steel can be rusted either artificially or naturally. Rusted mild steel can be a very satisfactory material indeed. The difficulty with a polished shiny steel finish, unless it is stainless steel, is the problem of sealing completely from corrosion and rust. This can be done by applying very carefully a lacquer or resin. But if there should be a tiny part missed by the brush or spray gun, rust will get in and spoil the colour. I feel that the nature of steel is to rust, and to use this characteristic is good sense. Rusted steel sculpture takes a proper place in the open air, for instance, which a polished steel form often does not. Rusting can be hastened by the application of:

> Hydrochloric acid 1 part
> Water 50 parts

The rusted surface can then be sealed with lacquer or resin, and this will give a richness to the colour, and a depth of tone which will help the three-dimensional form to read properly.

Fake metal patinas for plaster of paris and concrete

When a sculpture has been conceived for a particular metal, for various reasons the sculptor may need to make the plaster or concrete intermediary look like that metal. The reason may be to show a client what the effect of the metal will be. It may be to show the foundry the colour required, or it may simply be to gain a better idea of what the light, colour and tone, may be expected to be and do in the final metal castings.

Imitating a metal appearance on any material may be done in any of the following ways:

Fake bronze or copper Seal the material by first applying a solution of shellac and methylated spirit. The shellac can be charged with a bronze powder, or a dense black such as graphite. If it is put on to a white or pale coloured surface, it is best to cover this surface completely, so that it will not be revealed by subsequent polishing. Over this first coat of shellac paint a second, this time heavily loaded with a selected bronze powder. This powder can be obtained from a reliable paint manufacturer or metal powder manufacturer, and can usually be purchased in any variety of shade of bronze or silver, or whatever metal you wish to simulate. Paint this second coating of shellac and powder to a dense smooth surface without brush marks. Brush marks ruin the whole illusion. When this is dry, it leaves a painted surface which is, to all intents and purposes, a metal casting which has now received a patina.

Patination colour can be achieved in several different ways. The most simple is by painting whatever colour of natural bronze patina you

wish to simulate. The medium for this paint should not be the same as for the shellac and methylated spirit. When painted over shellac and methylated spirit, the paint must have, for instance, a turpentine or water medium. This prevents removing the shellac. Blackboard paint is a very satisfactory paint to use over a metallic painted base. The matt black helps make a fine dense bronze patina. The paint is simply brushed on and left till tacky, then removed from high points, etc, with a rag to reveal the bronze. If it is allowed to dry and harden the bronze can be revealed by applying a wax polish which will remove the turpentine-based paints in parts to reveal the bronze. A good stiff polishing brush will help in this patination and will polish the wax, too, to fix the patina.

As an alternative to a painted patina you can apply a further coat of shellac and bronze powder to the metal-painted surface. This time the shellac must be very much diluted with methylated spirit to about 30 per cent shellac to 70 per cent meths, and applied quickly but only when the first and second layers are very hard. This third coat of shellac and bronze can now be patinated by painting on a chemical to oxidise the bronze powder. This oxidisation can then be fixed with wax or lacquer in the usual way. These chemicals must be applied warm, even near boiling point.

Another patina can be achieved by painting over the bronze layer a coating of low viscosity resin. This will seal the bronze surface completely, and when the resin is hard a painted patina can be effected. This patina is very suitable for placing outside for short periods. The resin will protect the plaster, or whatever material is used, from attack by weather corrosion. This is most useful for storing work in the open. Work can be placed in the open air to discover more about that form in the open and the most effective patina, and this can be temporarily protected by a coat of resin.

Another way of applying the bronze to the surface of whatever material is being faked is to mix the highest quality metal powder into a low viscosity resin, generally up to 85 per cent powder to resin can be used. Paint this resin mixture on to the work, having mixed in the correct amount of promoter and catalyst. Paint as even a surface as possible, and when set hard this surface can be patinated with paint. It can be patinated, too, by rubbing the surface with fine wire wool and applying warm chemicals to oxidise the bronze particles.

On all patinas and fake patinas the shine, and degree of shine achieved, is entirely the choice of the artist. Generally an eggshell shine is most suitable, as this allows the form to be read without reflecting too much light and consequently destroying optically the form. Wax polishes are usually the best finishing media. The harder the wax polish the better.

Fake aluminium or silver patinas can be achieved in exactly the same way as described for fake bronze, but using an aluminium or silver powder.

An alternative surface can be achieved by painting a layer of aluminium or plastic metal, thinned with amyl acetate, or with whatever solvent is recommended by the manufacturer. A porous surface is best

for this method. The thinned plastic metal will form a fine metal film on the surface of the sculpture which when hard can be buffed and polished to a final patina.

Cement and concrete casting can be made to simulate metal by brushing a layer of whatever metal powder you wish on to the surface of the mould. This metal powder will be picked up by the cement and become part of the surface. When the cement has hardened and cured, a patina can be made by oxidising the metal powder. The sculptor must be extremely careful when packing the cement. He must avoid the cement pushing the metallic powder along the mould, then skipping over it, forming little bronze crawl marks.

Castings of cement or concrete can have a very wide range of finish and colour which comes from the actual casting process. These finishes range in kind and effect and are achieved according to the method of manufacture, such as the colour of the mould, the colour of the cement and the grade of aggregate used. For instance, with fine aggregates a very dense finely detailed surface is achieved which can easily be made to simulate a metallic finish. I think, however, that it is wise to exploit the finish which comes directly from the material, in which case a fine natural patina comes from the colour of the cement and the colour of the bloom left by the plaster mould (a fine film of plaster which adheres to the cement cast). The combinations of these two elements—the cement and the bloom—can produce a very pleasant and fine patina, which is peculiar to the material and method. The bloom can be varied by colouring the first coat of plaster in the mould. Earth pigments painted on to the mould or even on to the original clay surface can be effectively used. This colour will be picked up by the cement permanently, and will combine with the cement's own colour to give an interesting range.

Interesting exposed aggregate effects can be achieved by casting the form, being careful to place large pieces of aggregate, or glass or pieces of metal. These carefully placed items can be revealed by abrading the cast form, rubbing through the cast skin to expose the aggregate. These finishes can be very exciting indeed and infinite in variety, according to whatever is used as an additive. You must, however, take into consideration any visual harm a misplaced piece of aggregate may do to a form.

Plastic materials have, in nearly every case, qualities which arise from the actual working. The marks of the very tools used and the exploitation of these marks produce a fine range of surface and texture. Nearly all of them can be polished to a very high degree of surface shine. Colour can be added in paint form, of course, but most manufacturers can supply plastics in a very wide range of tone and colour. These plastics, used in clear liquid form, can all be coloured by simply adding one of a mixture of the wide range of dyes available for the particular resin.

Acrylic resins are amongst the most versatile in that they can be carved from a manufactured block, which can be coloured. Such carving can exploit the very fine light-refracting quality of this material. It can be assembled and constructed into an image. By such construction a

very great range of effects can be achieved, using such effects as embedding items in clear blocks or sheets, assembling these by sticking them together with the same acrylic resin, and mixing components made in this way with other items made from the same resin. An effective liquid cement can be made by dissolving shavings of acrylic in commercial chloroform. Surfaces on these can be cut and textured, polished, or painted with pigment mixed with the liquid resin. In this way the image made is of the same material throughout. It is difficult to describe or give specific examples of the material, because so far it has not been used to any great purpose. Those artists who have used it have been concerned simply with the sticking together of clear rectangular or near rectangular shapes or simple geometric shapes. This material has still an enormous potential, I think, and is being exploited now to good effect.

If *wax* is used as a final material it will usually work to its own kind of patina. The colour, etc., may be varied considerably by the addition of wax dyes or colour pigments very finely ground. There is little that can be done apart from painting to change the final colour. The wax can be painted to any final finish. It is soluble in turpentine, and so any paint which is also soluble in turpentine must be used most carefully.

It is, of course, possible to use a wax form made over a basic plaster form. The two layers, plaster and wax, can then be dipped and generally built up with polyester resins to build a final form; colour, etc, can be achieved in the final resin or in the wax under a clear resin. This method, I think, would only be suitable for sites not open to elemental conditions.

Miscellaneous thoughts on patination

Other patinas can be achieved, on many other materials by smoking the work, making a deposit of soot which can then be fixed with wax, or shellac or PVA medium. This process can be done effectively with a rag soaked in paraffin and ignited, and the sculpture held in the smoke from the flame. A quicker method is to lay a deposit of soot by directing an acetylene flame, unmixed with oxygen, at the sculpture and then fixing that layer of soot. This is a most efficient method for making a large figure black.

I have seen a most effective patina made upon a porous surface such as concrete or a dull or poor quality stone, achieved simply by painting that material with a metallic paint, painted thinly so as to penetrate into the pores of the material. The resulting surface is then abraded down to the stone with a fine abrasive to make an interesting patina. A useful item to have about the studio when making patina is french chalk. On white plaster a fine tactile surface can be attained by dusting the sculpture with this chalk, the surface can then be rubbed and polished with a soft cloth, resulting in a smooth eggshell shine which is very pleasant to the touch. French chalk dusted on and polished can enhance any patina. If, for instance, this is dusted straight on to a

diluted paint application and then polished, a very interesting colour and texture results. I often use this method on porous material, particularly on a rather ginger terracotta, by painting a diluted solution of black paint and turpentine all over the surface. Whilst this is wet I dust french chalk vigorously on to the surface, then polish the result with a fine polishing brush. The colour is an interesting, dull bone colour, according to the density of the black, plus the polish and pleasant touch which comes from polishing with french chalk.

Another patina can be achieved by painting on to a coloured surface of any material a solution of whiting and milk. This leaves a chalky colour and texture which breaks up any high polish. The density is determined by the amount of whiting used. This white colour can be tinted and altered by the simple addition of other powdered colours. The milk fixes the colouring and gives a patina which will stand up quite well in the open air. Wax polish can be applied to this surface and polished to shine where needed; for this clear hard polishing wax is the best.

It is clear that there is practically no limit to the patinas or finishes possible on sculpture materials, but it should always be remembered that the image which is a marriage between idea and material is the only successful one, and that the patina must always be in keeping with this.

'Horse and Rider' in bronze by Marino Marini *The Tate Gallery, London*

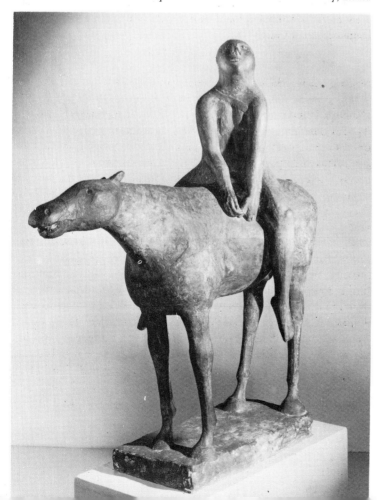

Presentation

When a sculpture is completed in any form or material, be it simply a maquette or large completed work, there comes the problem of presentation and the method of fixing.

Presentation is the placing of the selected work on a plinth, base, or pedestal in such a way as to present the work to its best advantage both in itself and in relation to its site. The position of the sculpture in relation to the spectator is most important. Rodin maintained that a sculpture must direct the passage of the spectator's eye across its form in relation to, and to emphasise, the ideas of the sculptor. The presentation of the sculpture is part and parcel of this directing the onlooker's eye.

Ideally a base should not be more dominant than the image. An enlightened tutor (when I was a student) once described a good base as being similar in disposition and proportion to a shadow cast by the sculpture under a top or near a top light. I have always worked with these words in mind and have found this a most interesting point of reference and departure, when making the base.

The plinth provides the means of using the eye level of the spectator. Generally the work is placed off the ground to establish the impact of the form of the sculpture in space. The sculpture is raised to achieve whatever visual effect is desired and intended by the sculptor. Once the bulk of the form is above eye level, an immediate sense of weight and scale is achieved, relevant to the power of the form. One can only advise those unfamiliar with salient facts of presentation to experiment and to look hard, especially in galleries and museums which now employ consultant designers to arrange sculpture, etc, at the heights most advantageous to their weight and points of emphasis. In Italy especially, the presentation of works of art and archaeology in museums is of such a quality and sensibility as to allow the work every advantage, enhancing and giving the work's own merits maximum impact.

The predominant virtue of nearly all good presentation is the simplicity of the final effect even when, as sometimes happens, complex structures are required. Usually a simple plinth cut with hard sharp corners retaining the directness of the block supporting the sculpture at the correct height offers the most satisfactory presentation. The material for the plinth should be selected with care to enhance the final form, patina and colour of the sculpture and not fight with it visually, creating such discord as to ruin the whole work. I think that plinths made from simple blocks or combinations of simple blocks are most successful. Fussy or complicated structures should be avoided. Again it is a matter of personal choice and preference.

Stone bases can be bought, cut to order, from stonemason's yards. There is usually a pile of off-cuts in a corner of the yard, and it pays to

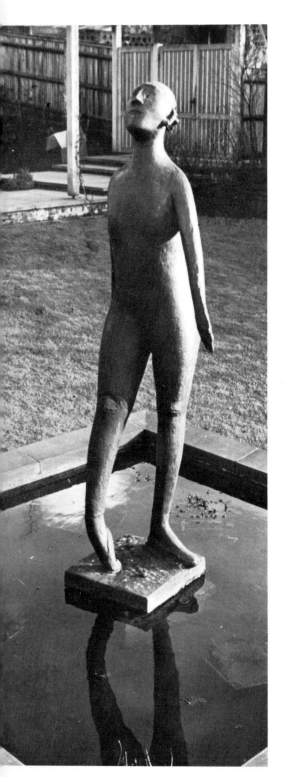

'Dancer' by Marino Marini well presented by the owner,
M Goldman, who designed the setting

rummage around and buy a few likely pieces of stone and marble to keep as a store.

Another satisfactory way of providing bases is by casting. *Concrete* cast against plate glass moulds yields a very fine polished surface. The colour, etc, can be controlled according to the cement and the aggregate used. Plate glass is most suited to this purpose because of its strength. Ordinary window glass will crack under the strain and heat of setting. *Metal* casts in a sand mould can be made to produce a base fairly cheaply. *Wood*, of course, can be made to any size and in any number of colours and surface textures. It can be carved from the block or jointed and so built to whatever size is required. Colour will range from the natural colour of the wood to any painted surface or colour.

Presentation of a maquette to an architect may involve more than just mounting the work on a base or plinth. The architect and client are interested to see how the work will look *in situ*. This may be conveyed by means of drawings, plus the mounted maquette, but often a scale model of the work and its setting will best express and portray the idea and intentions of the sculptor. Such models should be made with every care to detail: the effect of lighting, texture, etc. The object being to convince the architect and his client that you have taken every possible aspect of the work and site into consideration. This helps instil confidence in the sculptor's abilities and the wisdom of the choice of the sculptor.

Fixing the work to a plinth or architectural site is a crucial matter and must be dealt with in close consultation with the architect or engineer concerned. There are, however, certain points and methods of fixing work which come into everyday working in the studio, and are generally as follows:

Portrait heads can be securely fixed to the base by placing a rod or long bolt in the casting which can be inserted into or through a hole drilled in the base. When the rod is cast into the thickness of concrete or plaster or resin, the correct angle should be indicated in the clay before moulding, which can be done as a scored line. If the head is modelled over an armature built on a metal tube, the tube itself can be used as a template in the mould to lay the rod at the correct angle. The rod can be a long coach bolt projecting into a clearance hole in the base and secured with a countersunk nut and washer from underneath.

Metal castings can usually be fixed by drilling and threading a hole in the metal. A bolt is then screwed into this to secure the sculpture to the base through a clearance hole. This principle is basically the same for fixing any metal casting to a base. Non-ferrous bolts should be used, as iron bolts will eventually corrode and become ineffectual.

Concrete and resin castings can be secured by casting into the thickness of casting material a large nut into which a coach bolt of the desired length can be screwed. The bolt should protrude from the casting and be dropped into predetermined holes in the base or setting. These holes are made in the base by making a template from the sculpture, indicating the position of the bolts and the direction of

the sculpture on the base. Cement placed into the holes before placing the sculpture will set and secure the work. Alternatively, one can cast metal rods as part of the iron reinforcement in a cast, leaving metal projecting to be fixed into a hole cut into a base.

Wood carvings can be secured to a base by simply screwing a coach screw securely through clearance holes in the base. A coating of vaseline on the screw will help against corrosion and make it possible to remove the screw later, should this be necessary.

Stone carving can be secured by drilling into the carving and into the base, and fixing into these two aligned holes a single-keyed metal rod (non-ferrous), and fixed with cement. When the cement has hardened the sculpture will be secured.

The principles and methods already mentioned are those most commonly used, but it is important that the fixing of any large sculpture, whether on a building or on a public site, be considered with the architect or engineer, so that specific problems of weight or projection can be satisfactorily solved.

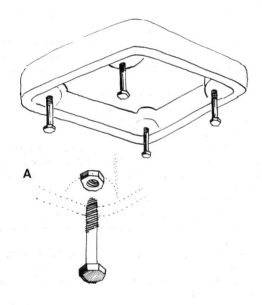

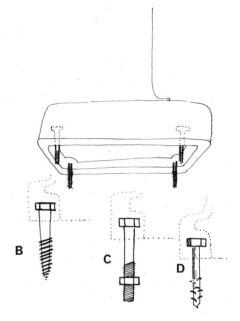

Illustrated are a number of alternative bolt fixings for setting into castings of plaster of paris, concrete or resin:

A Illustrates a nut set into the casting, into which can be screwed the necessary coach bolt. This is useful for fixing the work to a stone or concrete plinth. Holes, into which the bolts can be set, are made to a template the correct depth, etc, during the making of the plinth.

B and D Illustrate coach screws or rag bolts cast into the work, dropped and set into the necessary hole made in the plinth. C Illustrates the reversed coach bolt. The head of the bolt is set into the casting, this can then be passed through a clearance hole in the base or wall and secured

by means of a nut and lock, from the other side.

Metal castings, of course, are tap drilled and secured by bolting into the threaded hole. The principle of fixing is the same as any of the above-mentioned methods.

Non-ferrous bolts or galvanised metal should be used for fixing especially if the work is exposed to the weather. Alternatively a good coating of brunswick black paint gives a fairly reliable protection against corrosion.

Corrosion of the fixing may cause discolouration of the base or wall surface, quite apart from in time being weakened and unable to support the weight of the sculpture

Glossary of terms

Abraded Rubbed smooth. Part of the technique of making images in stone practised by the Egyptians

Accelerator The additive chemical to add to polyester resin to speed hardening. Sometimes called promoter

Adze A tool like an axe with the blade set at right angles to the handle and curving inwards in the handle. Used for roughing out wood carving

Aggregate The inert granular material mixed with cement to make concrete

Alloy A combination of metals

Armature The internal support

Assemblage Three-dimensional assembly of various materials to make an image

Back iron The external support from which malleable armature can be hung

Banker A bench to support large pieces of stone or wood or a large clay work. Sometimes made with a turntable top

Base The portion of the work on which the sculpture rests. It can be an integral part of the work, or a plinth of another material

Body A kind of clay, eg a stoneware body; an earthenware body

Bouchard A stone carving tool: a hammer with head faces cut into regular teeth for striking and breaking down the stone surface. Sometimes called a bush hammer

Brazing Joining two metals together with an alloy of brass and zinc

Bronze An alloy of copper and tin, sometimes with other metals added, such as lead and zinc

Bronzing Applying an imitation fake patina to a material other than bronze, to make it look like bronze

Bruising Stunning the stone, caused by using a punch or chisel at the wrong angle to the surface. This appears as a white opacity, usually on alabaster or marble

Brunswick black A paint applied to internal mild steel reinforcement to prevent it rusting

Butterfly A wooden cross suspended within an armature horizontally to support large clay masses.

Calipers Measuring compasses

Caps The small sections of mould removed from the main mould to facilitate removing clay, etc, and the placing of the filling medium

Carborundum A crystalline compound of carbon and silicon used for polishing and for sharpening tools

Case The form into which pieces of a piece-mould are fitted to be held in their proper place

Cast A work that has been produced by moulding. The positive

Catalyst A chemical additive for polyester resins. This causes a cross-linking of the molecular structure to form a three-dimensional solid

Cement The binding material with which concrete is made

Chasing The finishing of a metal surface

Chipping out The act of removing the waste mould

Chisel A metal carving tool made from steel with a hard cutting end and a blunt end which receives the blow from a mallet or hammer

Chopped strand mat Matting made from random glass fibres, not more than 50 mm (2 in.) in length

Claw A toothed chisel used for stone carving

Clay Tenacious earth which can be modelled

Collage Two-dimensional assembly of various materials to make an image

Compressive strength Ability to withstand compression

Concrete A mixture of cement, sand and aggregate

Crawl Marks caused by a molten material chilling too soon during a pour

Crazing Small cracks caused by uneven shrinkage and expansion through the thickness of the material

Crowbars Strong metal levers

Crucible A vessel of refractory material in which metals can be made molten in a furnace

Draw The taper which enables a piece of mould to draw from the cast surface and from the mould case

Earthenware A low-fired baked clay, less dense and hard than stoneware

Engobe A white coating of pipe clay over a terracotta body, as used in the sculptures from Tanagra

Etching Engraving by eating away with acid to make an image or pattern

Exothermic Heat set up during the cure of polyester resins

Feathers and wedges Curved pieces of metal placed in drill holes in stone. Wedges are hammered between these to split stone

Fibreglass Very slender fibres made from glass

File An abrading tool made of metal

Firing The action of heating a kiln to bake clay

Flash The cast line of the seam

Flask The metal ring in which sand mouldings are packed

Flux The substance mixed with metals for welding, brazing, etc, to promote fusion and free run of the molten metal

French chalk Powdered talc or magnesium silicate

Furnace A structure consisting mainly of a chamber to contain a crucible which is subjected to prolonged intensive heat

Gaiter The system of placing irons to reinforce a hollow casting

Gelatine Jelly made from stewed bone-matrix. Used for making flexible moulds

Gel-Coat The first application of resin to a mould which makes the reproduction of the surface. It is allowed to gel (semi-set) before further applications

Gouge A kind of chisel with a curved cutting edge used mainly for wood and soft stone carving

Graffito Scratching through a superficial layer of clay (slip) or glaze to reveal the colour of the body underneath

Graphite A crystalline form of carbon. Also called black-lead or plumbago

Grog Ground fired ceramic to add to plaster of paris, cements and clay. Makes a material refractory

Hardwood Timber from deciduous trees

Head peg Sometimes called a bust peg. The main support of an armature upon which a head or bust can be modelled

Hygroscopic Absorbs moisture from the atmosphere

Igneous Formed by the action of fire

Intaglio A technique of incised relief

159

Investment The mould for casting metal sculptures. Made from refractory materials such as plaster and grog sand.

Irons The term given to reinforcement made from mild steel for moulds and casts

Jigging The preparation of metal components to be joined together

Key The method of making perfect registration; the exact locating of one piece to another, as in moulds and roman joints

Kiln A furnace or oven for baking clay.

Kiln-dried Artificial seasoning of wood.

Laths Small strips of wood, approximately 25 mm × 6 mm (1 in. × $\frac{1}{4}$ in.)

Leather hard The state of clay before it becomes dry and dusty. It is best burnished at the leather hard stage

Life size Equal to life in all proportions, etc

Lost wax The art of producing a bronze casting from a wax positive. The wax is melted from between the investment and the core; the resulting space is then filled with the molten metal. Called also *cire perdue*

Main mould That part of the mould which contains the bulk of the form to which the caps or sections of mould are fitted

Mallets Wooden hammers

Maquette A three-dimensional sketch

Medium The word most frequently used when referring to materials (*Media*: plural)

Metamorphic Formations which have been changed by heat and pressure and chemical reaction

Mild steel Steel containing just a little carbon. Not easily tempered or hardened

Modelling stand A tripod support with a turntable top which can be adjusted to any height. Used for modelling work under life size

Mortar A mixture of sand and cement

Mould A negative shape or form from which a positive cast can be made

Pack The action of placing a filling into a mould

Parting agent Material painted to surfaces which are to be parted (release agent)

Patina The colour of the surface of a sculpture (specifically the treatment of metals)

Patination The applying of paint or chemicals to make a patina

Piece-mould A mould made in sections or pieces to produce more than one positive cast

Pins The iron nails which are placed through the investment mould into the core to retain the space between the two when the wax is melted out

Pitcher Steel tool used for removing large pieces of stone; striking from a flat surface

Plaster of paris Fine white powder which sets hard when mixed in water. Made from gypsum. Used for mould-making and working direct

Plinth A support or pedestal which displays the sculpture at the correct height and position

Point A simple pointed metal carving tool used for roughing out

Polychromatic Coloured sculpture, using many colours

Polyester resins Synthetic resins

Portland cement A type of cement, simulating portland stone

Pour The action of filling a mould with a liquid or molten material

Pumice A material used for smoothing and polishing. Made from lava, which has been aerated by escaping gases

Punch A broader point used for roughing out softer stone

PVA Polyvinyl acetate

PVC Polyvinyl chloride

Pyrometer An instrument for measuring intense heat such as in a kiln or furnace

Pyrometric cones Ceramic cones designed to collapse at a predetermined temperature, indicating the temperature at that point. Used in kilns

Rag bolt A textured bolt for making a fixing into a wall or other surface

Rasp A coarse metal file with sharp pyramidal teeth

Release agent (see Parting agent)

Relief A design made on or into a flat surface

Rifflers Tools with curved file surfaces used on stone, wood, plaster of paris, metals and resins

Risers The channels made in an investment mould to allow air and gases to escape. Core must be vented in this way too

Roman joints Joints devised and made to produce section of cast which fit with perfect register

Runners The channels made in an investment mould through which the molten metal runs to fill the mould (*see* Sprue)

Sand box A box of sand used to cushion small pieces of stone to carve them

Saw bench A bench or frame for holding timber securely to be sawn

Scrim A course woven fabric, usually made from jute. Used to reinforce plaster of paris

Seam The division between pieces of mould

Sheer legs Three legs of wood or iron bolted together at the top to form a tripod. Pulleys and tackle are suspended from the apex. This makes a very versatile, movable lifting tackle

Shellac A varnish made from the resinous secretion of an insect, the lac

Shim The brass fencing used to make the divisions of a waste mould

Short The term applied to a clay body which is not tenacious, and is liable to break while modelling

Shuttering A mould constructed *in situ*, usually of wood, into which concrete can be poured to make a casting

Slag Foreign substances separated from the pure metal when molten. (This must be removed before pouring.)

Slip A semi-liquid material made of finely ground clay, mixed with water to a creamy consistency. Used for applying a layer of different coloured clay to another and for decorating clay forms

Soft soap A semi-liquid soap, used as a release agent

Softwood The timber obtained from coniferous trees

Spatula A simple tool of wood, ivory or metal, flat and elongated in form. Made in many various modifications of form and size

Sprue This is the term given to the main runner of the pouring gate, usually the thickest runner. 'Spruing up' is

the phrase often used by American sculptors for making the system of runners and risers (the pouring gate) on the wax image prior to investment

Squeezing The method of fixing a cap to the main mould by laying a thickness of material at the seam edge, then squeezing the cap into position

Stoneware A hard dense fired clay ware made from very siliceous clay and fired at high temperature

Tactile Pleasant to the touch (pertaining to the sense of touch)

Tamping The act of consolidating a granular material such as concrete or sand

Tap drill To make a threaded hole in metal

Tempering The process of hardening a metal tool

Tensile strength Ability to withstand the tension of stretching

Terracotta Baked earth

Turntable A platform mounted upon another, and able to rotate on a peg or bearing

Vents Channels made in investment moulds to allow the escape of gases

Vibration Vibrating a mould encourages the escape of any air that may be trapped in the material

Viscose A syrupy liquid, or a cellulose made thinner

Waste mould A negative mould which is chipped away from the positive cast; made waste

Welding The joining together of two metals by causing the the edges to become molten by electrical or oxy-acetylene apparatus

Wetting down Spraying a clay sculpture with water to keep it moist. Making a stone wet to see what colour the stone will be when finished, and to discover any veins or speckles in the surface

Suppliers of tools and materials

All sculptors' tools and materials
Alec Tiranti Limited, 21 Goodge Place, London W1 and 70 High Street, Theale, Berkshire

Acrylic resins
G H Bloore Limited, Honeypot Lane, Stanmore, Middlesex
Imperial Chemical Industries, Plastics Division, Welwyn Garden City, Hertfordshire

Balsa wood
Balsa Imports Limited, 38 Bow Lane, Cannon Street, London EC4

Bronze (standard ingot)
Frys Metals, Tandem Works, Christchurch Road, London SW9

Ceramic fibre
Morganite Ceramic Fibres Limited, Tebay Road, Bromborough, Wirral, Merseyside, L62 3PH

Ceramic shell
Nalfloc Limited, P.O. Box 11, Mond House, Winnington, Northwich

Clay
The David Ball Company Limited, Huntingdon Road, Lolworth, Cambridge, CB3 8HB
Fulham Pottery Limited, 210 New Kings Road, London SW6
Podmore and Sons Limited, Shelton, Stoke-on-Trent, Staffordshire

Dyes for resins
Reeves and Sons Limited, Lincoln Road, Enfield, Middlesex

Expanded polystyrene
Baxendale Chemicals, nr Accrington, Lancashire
Shell Chemicals Co Limited, 15 Great Marlborough Street, London W1
Venesta International—Vencel Limited, Erith, Kent

Fibreglass
Fibreglass Limited, 63b Piccadilly, London W1
Bondaglass Limited, 55 South End, Croydon, Surrey
Strand Glassfibre Limited, Williams Way, Wollaston, Wellingborough, Northants.
(Strand supply all needs for fibreglass reinforced polyester resin casting and forming.)

Foundry supplies
Hasneit, Denbigh Road, Bletchley, Bucks

Metal powders for fillers added to polyester resins
Fry and Co Limited, 6–9 Whitecross Street, London EC1

Plaster of paris
Gyproc Limited, Ferguson House, Marylebone Road, London NW1
(Or from any reliable builders' suppliers. The type most commonly used is fine white plaster)

Polyester resins
Bakelite Limited, 12 Grosvenor Gardens, London W1
British Resin Products Limited, Devonshire House, Piccadilly, London W1
W A Mitchell and Smith Limited, Church Path, Church Road, Mitcham, Surrey

Resin casting
Specialised Mouldings Limited, Huntingdon

Silica flour and grog
A L Curtis Limited, Westmoor Labs, Chatteris, Cambridgeshire

Silicon bronze
Landseer Bailey, Landmetalle, Willow Lane, Mitcham, Surrey

Silicone moulding compounds
Midland Silicones Limited, 68 Knightsbridge, London SW1

Stone and marble
Consolidated Stone Limited, 1a Harpenden Road,
London SE27
Fenning and Co Limited, Palace Wharf, Rainville Road,
London W6
Frank England Limited, Thames Works, Thessaly Road,
London SW8

Tools
Buck and Ryan Limited, Tool Merchants, 101 Tottenham
Court Road, London W1

Vina mould material and melting equipment
Vinatex Limited, Station House, North Street, Havant,
Hants

Wax
Pothe-Hill and Co Limited, Mill River Wharf, Hunts
Lane, Bow Bridge, Stratford, London, E15 2QD

Welding and brazing equipment
British Oxygen Co, East Lane, North Wembley, Middlesex

Some suppliers of materials in the USA include the following:

Ceramic shell
Avnet Shaw, 91 Commercial Street, Plainview, NY 11803

Dyes for plastics
The Haishaw Chemical Co, 1945 East 97th Street,
Cleveland, Ohio

Foundry supplies
Industrial Equipment, Minster, Ohio 45865

Glass fibre
Ferro Corporation, Nashville II, Tennessee Huntingdon
Beach, California
Miami Flats, Miami
Modiglass Fibers, Brennen, Ohio

Microcrystalline waxes
Bareco Division, 6910 East 14th Street, P.O. Drawer K,
Tulsa, Okla 74115

Plastics (complete details)
Modern Plastics Encyclopedia, Modern Plastics Executive
and Editorial Offices, 770 Lexington Avenue, New York 21,
NY

Polyester resins
Mobay Chemical Co, Penn-Lincoln Parkway West,
Pittsburgh 5, Pennsylvania
Acme Resin Corporation, 1401 Circle Avenue, Forest Park,
Illinois
Allied Chemicals Corp, Plastics Division, 40 Rector Street,
New York 6, NY

Polystyrene
Shell Chemicals Co, Plastic Division, 110 West 51st Street,
New York 20, NY

Silicone moulding compounds
Reed Plastics Corporation, One Rartana Road, Oaklands,
NY

For information regarding other materials refer to
Where to Get What: a directory of suppliers, published by
Penland School of Handicrafts, Penland, New Carolina.

Other suppliers
Sculpture Associates, 114 East 25th Street, New York, N.Y.
10010
Sculpture House, 38 East 30th Street, New York, N.Y.
10016
Sculpture Services, Inc., 9 East 19th Street, New York,
N.Y. 10003
A. I. Friedman, Inc., 25 West 45th Street, New York, N.Y.
10036
Art Brown, Inc., 2 West 46th Street, New York, N.Y.
10036

Some recommended books

The Materials and Methods of Sculpture, Jack C Rich, Oxford
 University Press
Michelangelo 4 volumes: The Complete Works, Charles de
 Tolnay
Stone Sculpture, Mark Batten, Studio
Sculpture Inside and Out, Malvina Hoffman, Allen and Unwin
Michelangelo's Models in Wax and Clay, Phaidon
Rodin, R Elsen, Museum of Modern Art, New York
Auguste Rodin, Phaidon
Sculpture Casting, Dennis Kowal and Dona Z Meilach,
 Crown, New York
Studio Bronze Casting, John W Mills and Michael Gillespie,
 Elsevier
The Technique of Casting for Sculpture, John W Mills,
 Batsford
The Sculptures of Marino Marini, Eduard Trier, Thames and
 Hudson
Henry Moore, A Zwemmer, Lund Humphries
New Materials in Sculpture, H M Percy, Alec Tiranti
Sculpture in Ciment Fondu, John W Mills, Contractors'
 Record
The Technique of Pottery, Dora Billington, revised by
 John Colbeck, Batsford
Glass Fibre for Amateurs, C M Lewis and R H Warring,
 Technical Publications
Figure Sculpture in Wax and Plaster, McDermott, Richard,
 Watson-Guptill Publications, New York
Plastics for Kinetic Art, Rourkes, Nicholas, Watson-Guptill
Publications, New York
Sculpture in Plastics, Rourkes, Nicholas, Watson-Guptill
Publications, New York

Index

Figures in *italics* refer to illustrations